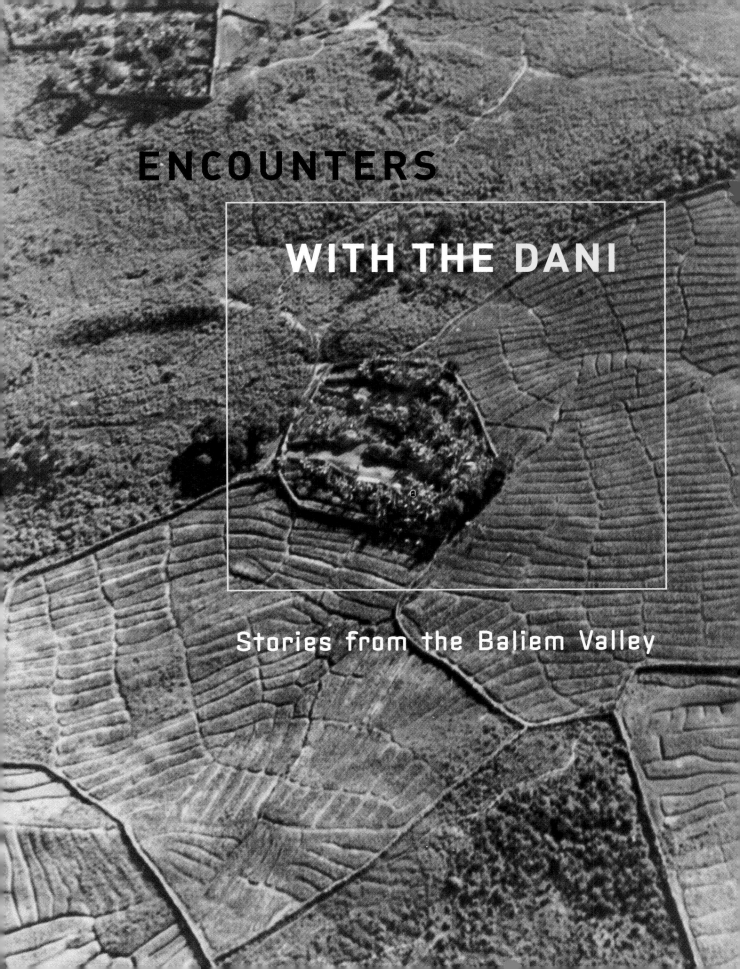

ENCOUNTERS

WITH THE DANI

Stories from the Baliem Valley

In the beginning was The Hole.

Out of The Hole came the Dani men.
They settled in the fertile lands around The Hole.

Then came pigs. The Dani took the pigs
and domesticated them.

Next came women, and the Dani took the women.

Then from The Hole came other men—Portuguese,
Spaniards, Dutchmen, Englishmen, Japanese, Americans.
There was no room for them around The Hole,
so they spread out over the face of the earth
in search of land as good as Dani land.

But they never found it.

To which legend the Dani today
add a last triumphant line:

"Now they are coming back again."

—Dani myth. Retold by Peter Sutcliffe in
"The Day the Dani People Become Civilized,
the Sun Will No Longer Rise," *Papua New Guinea
Post-Courier*, 1972.

ENCOUNTERS

WITH THE DANI

Stories from the Baliem Valley

SUSAN MEISELAS

ATIONAL CENTER OF PHOTOGRAPHY, NEW YORK / STEIDL VERLAG, GERMAN

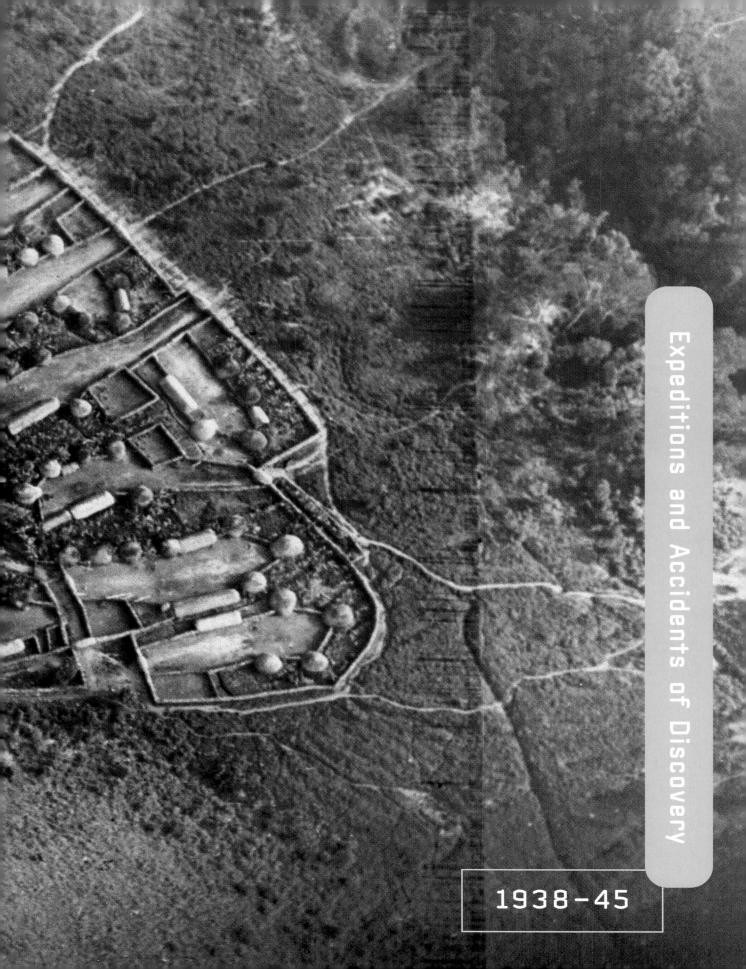

1938-45

BIOLOGICAL EXPLORATIONS

THE AMERICAN MUSEUM OF NATURAL HISTORY

CENTRAL PARK WEST AT 79TH STREET

NEW YORK, N. Y.

1938 NEW GUINEA EXPEDITION
RICHARD ARCHBOLD, LEADER
A. L. RAND, ORNITHOLOGIST AND ASSISTANT LEADER
WM. B. RICHARDSON, MAMMALOGIST
L. J. BRASS, BOTANIST
RUSSELL R. ROGERS, PILOT
GERALD D. BROWN, FLIGHT ENGINEER
RAYMOND E. BOOTH, RADIO OPERATOR
HAROLD G. RAMM, RADIO OPERATOR

FIELD HEADQUARTERS:
HOLLANDIA,
NETHERLANDS NEW GUINEA

August 6th 1938

Lieut Van Arcken

We delivered food to Capt Terrink today he is in the Grand Valley about
half way to your meeting place. XX Please answer by signal if you want
food now or on the 9th. If you wnat food on the 9th give the signal four
five if not till the 12th give the signal 12 . We find the lake is to small
small unless trees are cut from both ends

Archbold.

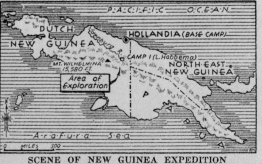

SCENE OF NEW GUINEA EXPEDITION
The party led by Richard Archbold of the American Museum of Natural History plans to spend two years in a study of mammals, birds and plants in the unexplored mountainous region indicated on the map. Mr. Archbold and five companions in their seaplane alighted on and took off from Lake Habbema, 11,000 feet up in the heart of the unexplored area.

In 1938, the wealthy American explorer Richard Archbold led an expedition into the unmapped highlands of Netherlands New Guinea for the American Museum of Natural History, searching for new varieties of flora and fauna. Archbold's plane, a customized U.S. Navy model, could land on and take off from water, allowing him to explore areas earlier explorers could not reach. On June 23, 1938, while surveying the highlands from his plane, Archbold spotted the fertile, cultivated valley where the Dani live, which he called the "Grand Valley." As far as historians can tell, he was the first non-Papuan to see it; certainly he was the first to document his "discovery."

Archbold Expedition (1938)

[6]

A porter carries 40 lbs. of food and if he goes inland 26 days he has eaten it all and arrives at his destination with nothing. If only half of the porters carry food and the rest equipment, the party can go only 13 days before all of the food is gone, leaving nothing for the return trip to the coast. Five or six days, therefore, is the limit which can be worked without using successive relays of boys, the inland relays being proportionately smaller as the food stores are reduced: a costly and unsatisfactory system at its best and the biggest factor in keeping New Guinea a primitive, unknown land. With new methods of transport: the airplane, parachute and radio, all the fastnesses of New Guinea will soon be explored by white men looking for gold as well as for birds and mammals.

—Richard Archbold, American explorer, and A.L. Rand, Canadian ornithologist. "With Plane and Radio in Stone Age New Guinea," *Natural History*, 1937.

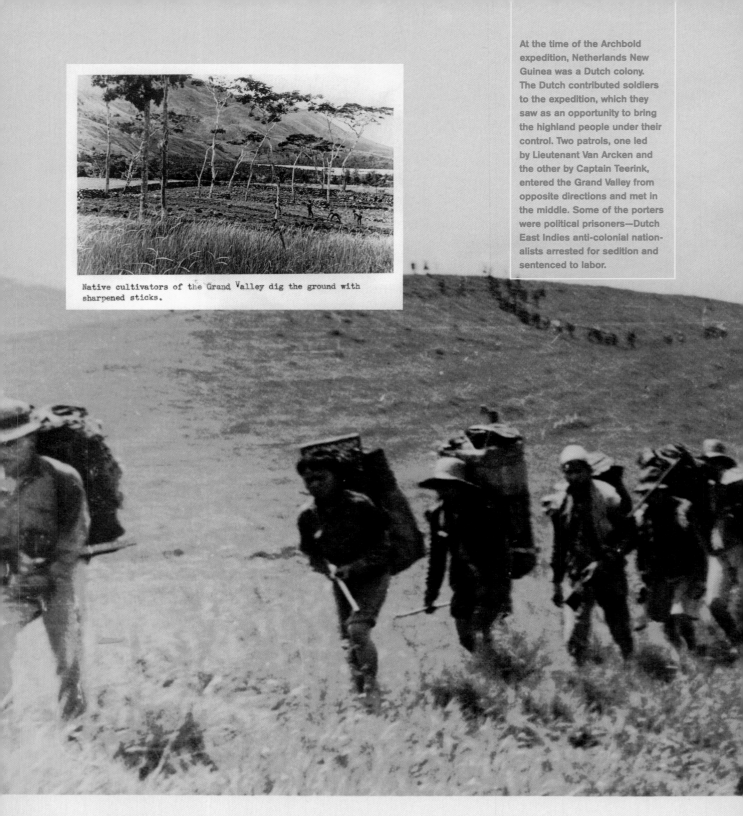

Native cultivators of the Grand Valley dig the ground with sharpened sticks.

At the time of the Archbold expedition, Netherlands New Guinea was a Dutch colony. The Dutch contributed soldiers to the expedition, which they saw as an opportunity to bring the highland people under their control. Two patrols, one led by Lieutenant Van Arcken and the other by Captain Teerink, entered the Grand Valley from opposite directions and met in the middle. Some of the porters were political prisoners—Dutch East Indies anti-colonial nationalists arrested for sedition and sentenced to labor.

On the march in the Grand

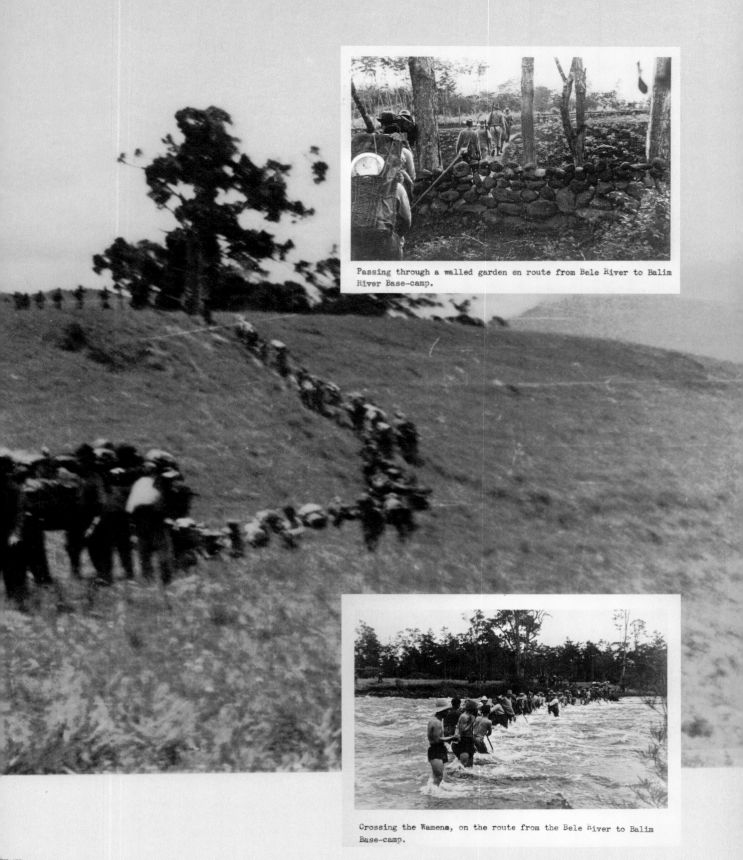

Passing through a walled garden en route from Bele River to Balim River Base-camp.

Crossing the Wamena, on the route from the Bele River to Balim Base-camp.

Valley.

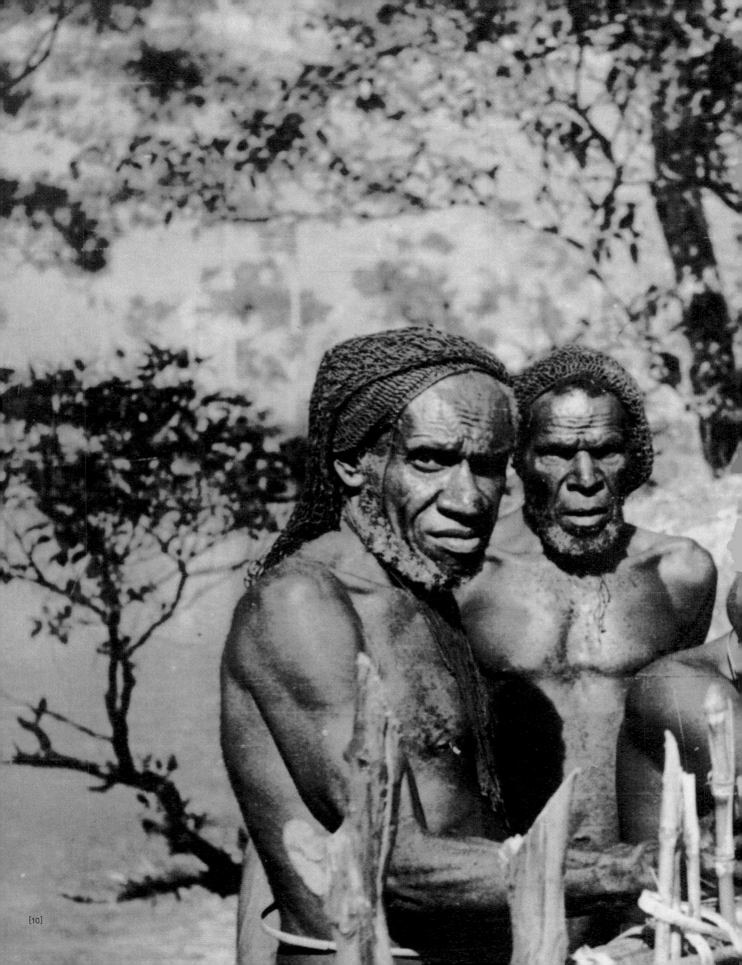

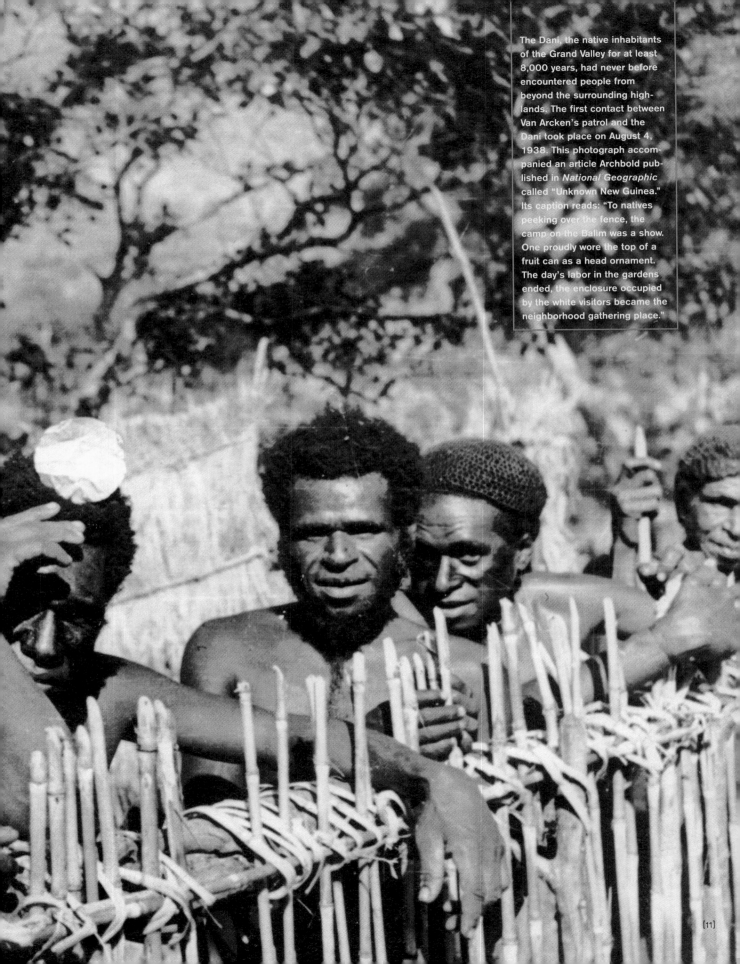

The Dani, the native inhabitants of the Grand Valley for at least 8,000 years, had never before encountered people from beyond the surrounding highlands. The first contact between Van Arcken's patrol and the Dani took place on August 4, 1938. This photograph accompanied an article Archbold published in *National Geographic* called "Unknown New Guinea." Its caption reads: "To natives peeking over the fence, the camp on the Balim was a show. One proudly wore the top of a fruit can as a head ornament. The day's labor in the gardens ended, the enclosure occupied by the white visitors became the neighborhood gathering place."

August 9: From 6:30 marched further along a good footpath. We are hiking now over a mountain ridge overgrown with rhododendrons, ferns, raspberry bushes, etc., the typical N. Guinea high moorland landscape that is not encountered further north....

This is our first penetration into one of the large, thickly populated valleys of central N. Guinea. Everywhere there are small villages with beautifully laid out garden plots. We were pressed to stop and share in a pig feast, but we did not have time for that....At around 11:00 we left this friendly region to march further through abandoned, unirrigated fields, no-man's-land.

Very quickly evidence of the local population could be heard, now not the "wa,wa,wa" call, but a yelping cry. They approached in large numbers, armed with spears and bows and arrows, but did not appear interested in friendly contact. We apparently were not to be trusted because we had come from the direction of enemy territory. That attitude persisted until we produced the cowrie shells....

Four Papuans came to the camp after dark with a request that they might sleep among us. These gentlemen were sent packing, after a shot in the air to scare them off.

Cartridges fired: 1

Incidental reports: none

Om 12.00 bereikten we de waterscheiding. Hoogte ongeveer 1800 m.

Hier ontmoetten we een Papoe die op weg was naar den Hablifoeri, maar genegen was om ons naar de Hoejivallei te begeleiden. Te 14.00 waren we in ladangterrein. Om 14.30 in bivak aan de Idaäb ongeveer 1700 m. Het is hier een ander volkje, dan wij tot nu toe ontmoet hebben. Veel grooter, beter gevoed en er loopen goed gespierde types tusschen. De groote haarnetten worden niet meer gedragen, wel kleine netjes, hoofdversieringen van koeskoesbont en veeren. Bij sommige zijn een paar vingerkootjes afgekapt. Deze kleine vallei, omgeven door kalkruggen, schijnt vruchtbaar te zijn, want we worden overstelpt met ketella. Hier heeft men in de tuinen met platte steenen 30 - 40 cm. diepe goten gegraven om het water af te voeren.

De bevolking kent de Baliemrivier die Z.W. van hier moet stroomen; waarschijnlijk de groote rivier in de hoogvlakte waar Kapitein Teerink ontmoet zal worden. Ze zijn hier muzikaal, we worden op gezang vergast. Hoeaaa, ooooooo is het meest geliefde deuntje.

V.P. Coene.

B.M. Coene.

Te 6.30 langs een mooi pad verder gemarcheerd. We loopen nu over een bergrug begroeid met rhododendrons, varens, framtozen, etc., het typisch N.Guinea hoogveen landschap, dat Noordelijk nog niet werd aangetroffen. Ook de wilgachtige boom, die als groenbemester dienst doet, komt hier voor. Hier liggen de kampongs (4 - 6 huisjes) dicht bij elkaar omgeven door een hooge pagger.

In flink gezelschap doorgemarcheerd en na een uitlooper van het gebergte te zijn gepasseerd, bereikten we te 8.30 de eigenlijke vallei. Hier voor het eerst een van de groote, dichtbevolkte valleien van midden N.Guinea. Overal dorpjes met mooi aangelegde tuinen. We werden dringend uitgenoodigd om een varkentje te komen eten, maar dar was nu geen tijd voor. Het rondreizende circus had weer niet over gebrek aan belangstelling te klagen. De Papoes loopen hier met lansen wel twee maal zoo groot als een athletiekspeer. Te 11.00 verlieten wij deze vriendelijke streek om verder door oud ladangterrein te marcheeren, Niemandsland.

Z. van de Hoej ligt de Goemboel Ambera, een grauw kalk massa met een kale kam van meer dan 3000 m. hoogte. Tegen de helling steken hier en daar de kalkpegels boven de boomen uit.

De Hoej stroomt hier, gedeeltelijk ondergronds, door een kloof met loodrechte wanden.

Naar het W. zijn weer ladangs te zien. Te 15.00 in bivak aan de Dzjinggi.

Al gauw werd bevolking gehoord, nu niet het wa, wa, wa, maar een keffende roep. In grooten getale kwamen ze aanloopen met lans en pijl en boog. Ze wilden geen kennis komen maken. We werden blijkbaar niet vertrouwd omdat we van de vijandige kant kwamen. Dat bleef een tijdje zoo tot de schelpjes te voorschijn kwamen, toen plots een rush naar het bivak.

Er bleef een zenuwachtige stemming heerschen. Plotseling werd een parang gerampast van een veroordeelde en weg was het grootste deel van de bevolking. De parang werd al gauw netjes terug gebracht en ook de Papoes keerden weer terug. Even later kwam de Papoe, die de parang gerampast had, met een lans aanrennen, maar ging scheldend naar huis toen hij tegen de ka-

In het donker kwam een viertal Papoes naar het bivak met verzoek om bij ons te mogen slapen. Deze heeren naar huis gestuurd, na ze even een karabijn te hebben laten hooren.
V.P. 1.
B.M. Geene.

Te 6.30 v.m. het pad langs den beneden stroom van de Hoej, de Marok (Warohop), gevolgd. Op een open plek wachtte de bevolking ons op met een tweetal varkens. Om ze gerust te stellen werden deze beestjes hier geslacht. Het opensnijden werd hier aan ons overgelaten.

Met een groot aantal Papoes verder gemarcheerd. Het pad loopt nu eens onder de tjimara's langs de Marok, dan weer door ladangs of alangvelden. Links en rechts dorpjes, zwaar ompaggerd. De stemming was uitstekend; steeds meer Papoes kwamen toegeloopen; gezamenlijk werden liedjes gezongen, vrouwen kinderen, alles liep mee.

Te 11.00 bereikten wij een dorp waarvan de bewoners ons langs een speciaal pad tegen de W. helling van de Marok wilden laten opklimmen, terwijl rechtuit een pad naar de Baliem liep. Dit pad werd vlak voor onze neus dichtgegooid met boomtakken, waarachter eenige knapen met lansen stelling namen, zoodat met de karabijnen gedreigd moest worden. De colonne passeerde verder ongehinderd, maar de korporaal, die met een militair achteraan liep, werd door 2 Papoes van achter vastgegrepen. Toen de soldaat hem te hulp kwam wilde een van de Papoes den korporaal met een lans steken, waarop deze Papoe door den korporaal werd neergeschoten. Dit "hands off" kon m.i. zelfs door de Papoes niet misverstaan worden, zoodat dus maar doorgemarcheerd werd.

Om 13.00 de Baliem bereikt, een ongeveer 20 m. breede kali met een ongeveer 60 m. breed bandjirbed. Ze is maar op enkele plaatsen te doorvaden. Langs de Baliem gekapt naar het ontmoetingspunt met de patrouille van Kapitein Teerink, de uitmonding van de Warok in de Baliem, elwaar te 14.00 in bivak. Van de patrouille van Kapitein Teerink waren nog geen sporen te vinden.
V.P. 1.
B.M. Geene.

August 10: Right in front of our faces this trail was closed off with tree branches, behind which some youths with spears took cover, so that we had to threaten to use our rifles. Our column passed through without further hindrance, but the Corporal, who was bringing up the rear with a soldier, was seized from behind by two Papuans. When the soldier came to his aid one of the Papuans wanted to spear the Corporal with his lance, whereupon said Papuan was shot by the Corporal.

Cartridges fired: 1

Incidental reports: None

Aant.Det.Cdt.
M.i. blijft dit doodelijk schot te betreuren; korpl. Pattisina had het hier met een schot in de lucht moeten probeeren. Mijn ervaring is, dat zulks bij deze stammen reeds voldoende uitwerking heeft. Verzoeke Uw manschappen in vorenstaanden zin te instrueeren.
Det.Cdt.
w.g. T.

Accoord, maar hier stond de papoea misschien met zijn lange lans al te dicht bij en is het wel heel gevaarlijk om dan nog een schot in de lucht te mislecten!

11 Augustus:

In my view, this fatal shot is to be regretted; Corporal Pattisina should have fired a warning shot first. It has been my experience that with tribes like this, a warning shot is usually sufficient. It is requested that you issue instructions to this effect to your men.

Commanding Officer
signed: T.

Agreed. But in this case the Papuan was perhaps already too close with his long spear. Under those circumstances it is certainly dangerous to risk only a shot in the air!

signed: S.

Met 4 karabijnen een verkenning verricht stroomafwaarts. De overigen opkappen van een afwerpterrein. Op circa 6 kilometer van het bivak werd de eerste kampong van de Baliemhoogvlakte aangetroffen. De ontmoeting was allervriendelijkst. Toen de Papoes ons zagen aankomen, waschten ze eerst netjes hun handen.

De kampongs zijn hier groot en flink ompaggerd. Een vijftiental huizen met varkenskralen en tuin neemt zeker wel eenige hectaren in beslag.

Om de kampongs liggen uitgestrekte ketellavelden. Hier zonder drainage goten.

De Baliem stroomt hier door een kleibedding en is met prauwen bevaarbaar. De bevolking maakt gebruik van vlotten van boomstammen.

Een dertigtal Papoes ging met ons mee naar het Baliembivak.

Voor dit bivak hadden in de morgenuren een paar honderd Papoes met lansen en pijl en boog gedemonstreerd. Na veel geschreeuw waren ze weer weggetrokken.

WEEK

times news dispatch for immediate release and rewrite by
passed) marked the completion of the milatary survey of th
lake habbema and the idenburg camp also the establishing
lations with the natives along the route stop two units ma
meeting in the newly discovered grand valley luit van arc
one unit started inland from the idenburg camp on aug 25 a
difficult section haveing to traverse a mountanious count
red with tropical forrest sparsely poupulated and with fe
the less he succeded in arriving at lake kadie a new lake
on one of the survey flights of the GUBA by aug 4 which wa
of schedualed time stop here he rested until aug 6 when t
and delivered food enough to last till he arrived at the
stop captain teerink started on a ug 1 from lake habbema
arrived at the edge of the population stop from there he
into the grand valley finding travelling good but the xuna
a hindrence with their xwithxthe hospita
each village that he passed triedto xx disuade him from p
the next with whwhom the natives weremon unfriendly ter
on the flight of aug 6 the plane dropped by parachute 8 da
we delivered food to both parties on aug 13 at the meetin
located in the north west end of the valley stop the plan
13 after circling ha bbema and dropping the mail we follo
course of the grand valley to thesouth with the dualpurpo
a possible landing site and in assertaining where it flow
landing sites were spotted just xx befor beforxth
almost a gorge here was a suprise the population instead
continued as numerous as ever with symetrica ly layde out
xxilterraced and walled with rock bringing to the incredi
sides of the valley stop the river was followed as far as
onthe south coast but further progress was barred by the
being covered/inclouds stop captain teerink having been ir
radio of the landing site the GUBA brought in a load of f
18 to habbema camp xx and on the 19 landed on the river
captain teerink stop the natives lining the bank hikcrest
every advantage point at first showed tendencies to bo
plane took off on its xxxxx thirdxtripxthexplane ferry
 between the river
a nd habbema but in the end stayedto watch stop on aug 20
van arcken from kadie lake to the idenburg kamp winding
ssful survey with no sickness or accident stopthe scienti
the passed month a t lake habbema and is now ready to move
objective mt willema stop the ha bbema camp has beeb exta
productive in rare and previously unknown material

 archbold

PHILADELPHIA, PA., BULLET
AUGUST 26, 1938

NATIVES FRIENDLY ARCHBOLD FINDS

Explorers in Dutch New Guinea Complete Survey

BY RICHARD ARCHBOLD

(Special Radio Despatch to The Bulletin)

Hollandia, Dutch New Guinea, Aug. 26.—The past week marked the completion of the Archbold expedition's survey of the route between Lake Habbema and the Idenburg Camp and also the establishing of friendly relations with the natives along the route. Two units made the survey, meeting in the newly discovered grand valley.

Lieutenant Van Arcken, leading one unit, started inland from the Idenburg Camp on July 25 and had the most difficult section. He had to traverse a mountainous country covered with tropical forest, sparsely populated, and with few trails.

Captain Terrink started on August 1 from Lake Habbema and in two days arrived at the edge of the native settlement. From there he moved slowly out into the grand valley, finding traveling good but the natives a hindrance with their hospitality. Each village that he passed tried to dissuade him from proceeding to the next village, with whom the natives were on unfriendly terms.

On August 6 the flying boat Guba dropped by parachute eight days' supply of food. We delivered food to both parties on August 13 at the meeting place located in the northwest end of the valley. The plane, after circling Habbema and dropping the mail, followed the course of the grand valley to the south with the dual purpose of locating a possible landing site and ascertaining where the river flowed. Several landing sites were spotted just before the valley became almost a gorge.

Here was a surprise, as the native settlements, instead of decreasing, continued as numerous as ever, with symmetrically laid out gardens, terraced and walled with rocks clinging to the incredibly steep sides of the valley. The river was followed as far as the foothills on the south coast but further progress was barred because the southern plains were covered with clouds. On August 19 the plane landed on the river and picked up Captain Terrink and his party.

The natives, lining the bank and every vantage point, at first showed tendencies to bolt when the plane took off on its ferry trips between the river and Habbema, but in the end they stayed to watch.

The scientific party spent the past month at Lake Habbema and is now ready to move on to its highest

Idenburg riv.

Voorm. Prauwenbivak ☒

M e e r v l a k t e

Tegelew loop

Idenburg riv.

Oude loop 1914

+ 3550
DOORMANTOP

Bernhardkamp
v.A. 25/7

Dika
Timorini

v.A's radio defect ; teruggezonden

3950 + ANGEMOEK

Meervlakte

Swart riv.

+ 3100

Sahoewéri

27/7 Eerste aanw. met half d. bergen,
meest steenwerk; enk. parangs

Vivres opv.
afd. v.A. 29/7

Koeboe

Vivres aanw. v.A. 6/8, deze
terug p. vlgtg. nr. Bernh. kp. 10/8

± 1700: nieuw meer Kadier
op 4/8 door v.A. bereikt
7/8 vertrek

Hablifoeri- of Kadie riv.

+ 3300

Kalk

Modderras
Eerste contact goud. 5/8

Route Kremer-v. Arkel 1921

3390 + v. ARKEL TOP

+4000

Rotsen
+ 1600 m.

Kalk + 2500

scheiding v. N. en Z. N. Guinea

Kalk

13/8 Kap. T. en v.A
vereenigd in Baliemkamp

3000
+

Baliem

Goemboel Wambera

Kalk

10/8 Plaats waar 1 Papoea
sneuvelde bij lansaanval

Djoe

+ 3160

T. dozi

v. Arcken vivres 13/8
per parachute

1600 m.

Baliem hoogvlakte

Kap. Teruk.
naar landingsplaats 19/8

Kap. T. vivres aanv.
per parachute 6/8

2000

Brug + 2200

3850 Top bestaat niet

Kap. Teruk.
naar landingsplaats "vanwaar"
op Baliem.
terug. vliegen naar
Habbema meer

Geheel bewoond dwarsdal Sneeuwketen

+ 3550

+ 3150

+ 3600

+ 3350

+ 3720 + PIRENERI

+ 3350

+ 3320

Baliem

+ 3250

+ 3500

Kap. T. 1/8

Habbema-meer

S N E E U W G E B E R G T E

4157 + EMMA TOP

ROTSPLATEAU

47304 + WILHELMINA TOP

4200

PR HENDRIK TOP + 3945

RUMPHIUS
KETEN

Quarles-meer ⊙

K.

4070 +
3565 +

Hier op bestaande
kaart geen toppen
en geen gebergte-
arceering

+ 3517

+ 3326

+ 3950

3699 + + 3542
TWEELINGEN

+ 3151

0 5 10 15 20 25 km.

[15]

Crash in "Shangri-La" (1945)

The Americans took New Guinea from the occupying Japanese during World War II and used it as a base for their Pacific operations. Troops stationed there made pleasure-flights over the Baliem Valley, sometimes swooping down very low to scare the Dani and watch them run and hide. In 1945, a plane of soldiers out on one of these daytrips crashed in the mountain pass leading out of the valley. Out of the twenty-four passengers, three survived—Lieutenant McCollom, Sergeant Decker, and WAC Corporal Hastings. Filipino paratroopers dropped into the valley to build an airstrip, so a glider could land and take the survivors back to the base.

I think our virtual inaccessibility and the difficulty of the rescue really dawned on me when Capt. Walters explained to McCollom, Decker and myself that we were in an area simply designated on all maps as "unknown."

—Margaret Hastings, American WAC corporal. "Shangri-La Diary," *Chicago Herald-American*, 1945.

Lieutenant McCollom pasted newspaper clippings and photographs into scrapbooks as souvenirs of the plane crash.

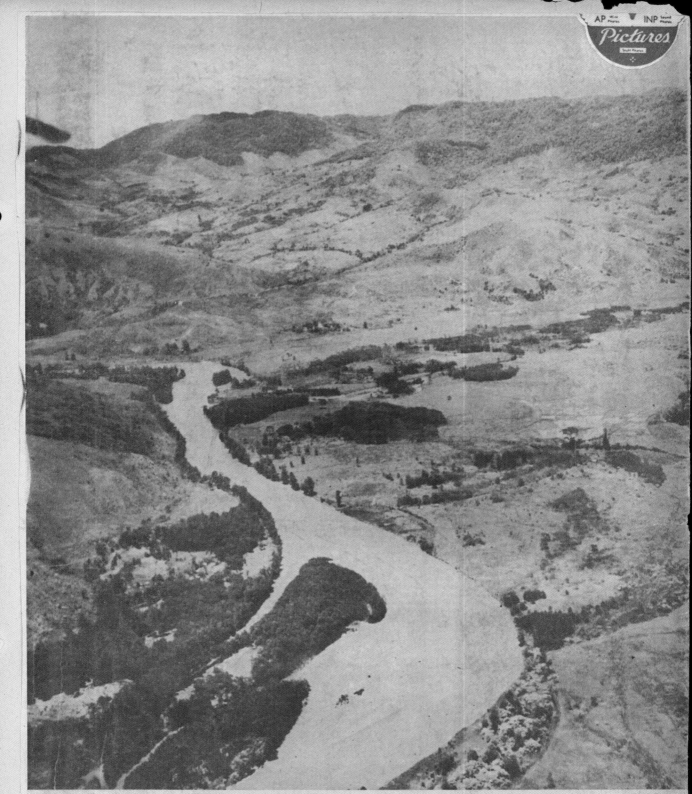

VALLEY OF WONDROUS BEAUTY—AND DEATH . . .

It was this breath-taking view of Shangri-La that caused WAC Cpl. Margaret Hastings to exclaim, "I want to see it again!"—only a moment before huge transport plane crashed into side of mountain, carrying all but three to a flaming death. What appears to be sky above rocky range is in reality a fine white mist that obscures other and higher peaks with which plane collided. This is the first of a series of hitherto unpublished pictures of Shangri-La to appear EXCLUSIVELY in The Herald-American. They were taken by M/Sgt. Morris Weisman, U. S. Air Force photographer whose home is at 3717 Broadway, Chicago. WATCH FOR MORE SENSATIONAL PHOTO GRAPHS IN TOMORROW S HERALD-AMERICAN!

[17]

Shangri-La Diary — Survivors Battl

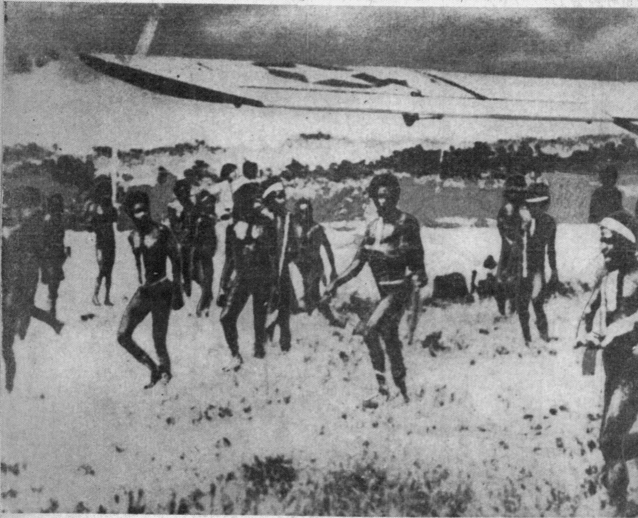

NATIVES OF THE HIDDEN VALLEY ARE CURIOUS BUT CAUTIOUS AS THEY INSPECT G

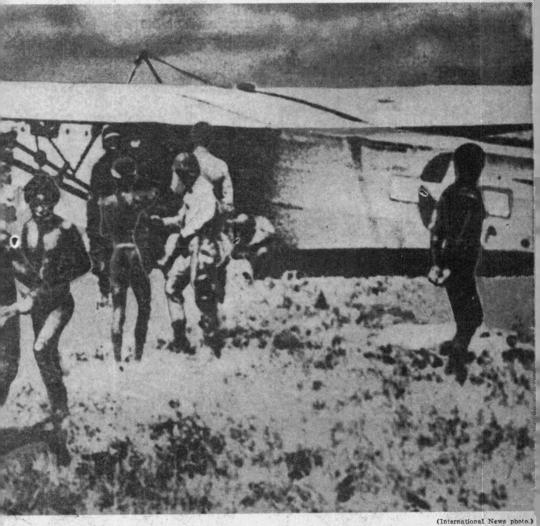

(International News photo.)

WHICH RESCUED THREE SURVIVORS FROM THE IMPENETRABLE JUNGLES

Smiles Sway Native Tribe

WAC Heroine Describes Meeting With Savages

Two days of perilous descent brought three weakened survivors into the valley of Shangri-La from the New Guinea mountainside where their airplane had crashed, killing 21 persons. WAC Cpl. Margaret Hastings and her two companions, Lt. John McCollom and Sgt. Kenneth Decker were resting from their ordeal when they heard a strange chant, heralding the approach of the valley's natives. Unarmed except for a jackknife, the three waited for the savages, their only defense a broad grin of friendship. **(Synopsis on Page 8.)**

Chapter 8

By Cpl. Margaret Hastings, WAC.

(Written exclusively for International News Special Service. World Copyright and all Rights Reserved.)

OWEGO, N. Y., July 28.—Gradually the natives slipped out of the jungle. They were still making that yapping sound.

Now they began to advance toward us in single file along a trail. There were about 100 men. They were jet black and over their shoulders hung stone axes.

They were an ominous sight to three persons armed only with a jackknife. A smile seemed a thin shield against such men and so many. But McCollom hissed again:

"Smile, damn it!"

So Lt. McCollom and Sgt. Decker and I stood as straight as we could and we smiled so hard that for two days the muscles of our faces ached.

We held out our hands, filled with the hard candy. And I am afraid mine shook a little. The bottom had long since dropped out of my stomach.

Twenty-five yards away, on a knoll opposite ours, the natives paused. Just as suddenly their yapping stopped. It was replaced by an excited jabbering, accompanied by much gesturing.

We couldn't tell whether that was good or bad. We could only fasten the smiles on more securely.

Suddenly a man whom we soon recognized as their chief, stepped forward. He beckoned for us

Continued on Page 8, Column 1.

For 47 days American newspapers headlined the story of the pretty WAC and her fellow survivors' dramatic rescue from the "Hidden Valley."

Continued From First Page.

to come to them. He beckoned again, this time more imperiously. McCollom said:

"I think we ought to go. We'd better humor them."

But that was the point at which I rebelled. If I was going to end in a jungle stew-pot, the natives would have to come and get me. I wasn't going to deliver myself up.

More important still, only a fallen log connected our knoll with theirs. My feet and legs were now so painful I could scarcely stand. I knew I could never negotiate that jungle trestle. I said:

"Honest, McCollom, I can't walk it, truly I can't."

"I know, Maggie, let 'em come to us."

So we began gesturing for them to come over to us. There was another excited pow-wow, and then the black men began to advance across the log bridge. The chief, whom McCollom nicknamed Pete, led the way.

Our smiles by this time had the fixity of granite. And each of us afterward confessed to wondering if we had survived the crash and the nightmare trip down the mountain only to meet death in some savage jungle rite.

About 15 feet from us, the natives stopped and clustered around.

Pete was talking 60 to the second. All were staring at us in a manner we couldn't interpret.

We smiled and smiled and smiled until I thought my face would fall apart. Suddenly Pete stopped talking. He and his followers just stood and stared. Their silence

seemed a thousand times more sinister and threatening than their yapping or their chatter.

Pete stepped a little closer, staring at us searchingly. We tried to thrust the candy and the jackknife out a little further.

"Smile," ordered McCollom between grinning lips. So we stood there, smiling like idiots at Pete and his followers. Pete came a step closer. His look grew sharper.

And then, Pete's ugly black face crumpled into a broad and beaming smile. It was the most beautiful smile in the world. It was reprieve. It was friendship. It was life.

Clasp Seals Friendship

Pete stepped up to McCollom and held out his hand. McCollom, weak with relief, grabbed it and wrung it.

The black man, who never before had seen a white man, and the white man, who never before had met a savage on his own ground, understood each other. The smiles had done it.

"How are you? Nice to see you," McCollom kept saying over and over, as if Pete could understand him.

"Here! Meet Cpl. Hastings and Sgt. Decker," McCollom added, indicating us.

Pete pumped our hands, too, and we realized that even among the most primitive men, a handshake is the universal coin of friendship.

Then Pete's followers stepped up to shake hands, and there on the knoll we held as fine a reception as any ever given by Mrs. Vanderbilt.

Now that the nervous strain had drained out of us, we took our first good analytical look at Pete and his followers.

It suddenly came to the three of us that the natives were more afraid of us than we of them! I exclaimed:

"Why, they're shy!"

."Sh-h-, don't tell 'em so!" Decker said crossly.

Belie Their Reputation

Far from being seven feet tall, they average from five feet four inches to five feet seven inches in height. And certainly, on close observation, they didn't look very fierce.

They were black as the ace of spades and naked as birds in feathering time. Their clothing consisted of a thong around their waists, from which a gourd was suspended in front and a huge, tropic leaf hung, tail-like in back.

Some wore bracelets above their elbows. There were two kinds of bracelets, those woven of fine twigs and those made of fur.

I never saw a live animal all the time I was in Shangri-La, except pigs. And where the fur for the bracelets came from, I can't imagine.

But I even saw a few fur hats, like Russian shakos before I left the valley. It was a short brown fur like our beaver.

All but Pete, the chief, wore snoods suspended from their heads and hanging far down their backs. At least, they looked like snoods. They seemed to be made of heavy string, like a shopping bag.

In these snoods, the natives tucked anything they had to carry. After all they didn't have any pockets.

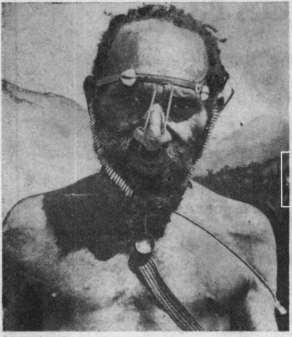

NATIVE of Shangri-La. He's a "boy from the country"—lives two valleys away from the capital. (INP photo.)

Alex Cann worked in Hollywood before he became a war correspondent cinematographer attached to the Netherlands Indies Film Unit during the fighting in the Pacific. He dropped into the valley with 4,500 feet of film, which he afterwards edited into a documentary called *Rescue from Shangri-La*. McCollom added Cann's photographs to his scrapbook.

Alex Cann

who parachuted into Shangri-La to take these pictures

Alex was slightly drunk when he landed.

I don't know whether I jumped or was pushed at the "go" signal. But I felt a sudden heavy jerk as the chute opened and I started shooting pictures of the descent. Then I landed unhurt, flat on my back in some bushes.

The natives at first were terrified of us and our equipment but the Filipino paratroopers gradually won their confidence. The natives brought us presents of vegetables similar to sweet potatoes and wild pigs. The American Army dropped small shells for us to trade...[and] a ton and a half of food and much equipment, all of which was left behind including a dozen colored parachutes, canned foods, carbines and tommyguns.

...Personally, I should like to return in six months and see what use they made of our foodstuffs and equipment.

—Alexander Cann, "Describes Valley of 'Shangri-La,'" *Boston Daily Record*, 1945.

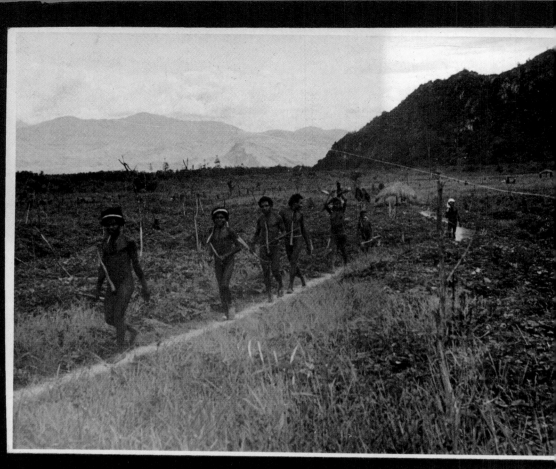

Cute aren't they ?

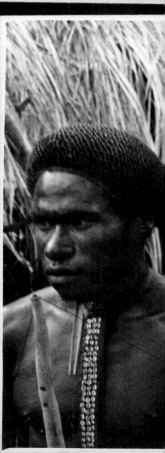

When he came face-to-face with the first natives,
he raised his hand, like in cowboy and Indian movies
and said, "How!"

—Jane Deuser, daughter of John S. McCollom. Letter to Susan Meiselas, 2003.

The queen of
Shangri-La comes
to visit us.

In her "Shangri-La Diary," which newspapers published in installments, Hastings wrote that the "natives" wore "a thong around their waists, from which a gourd was suspended in front." This hollowed-out gourd, known as a *holim*, is worn over the penis, attached with string. Every man has several, of different lengths and shapes, sometimes ornamented with fur.

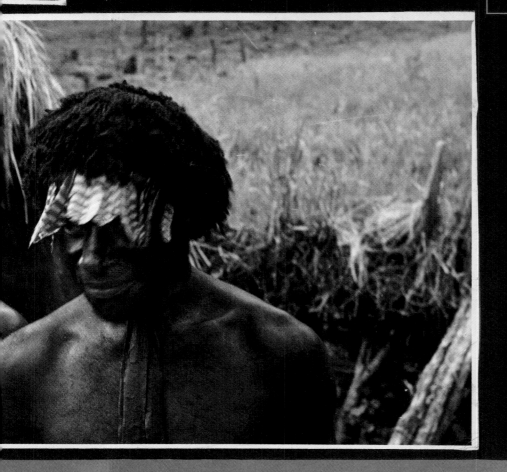

The three survivors, along with the medics, paratroopers, and the war correspondent covering the story, were flown out by glider to Hollandia, the capital of Netherlands New Guinea on the northern coast of the island, 150 miles from the valley.

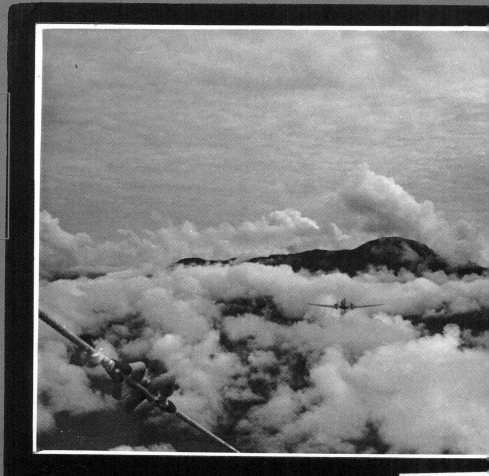

Decker, Maggie & I just after our return to Hollandia in "Fangless Faggot a CG-4A

Back to Hollandia
over the Orange
Mountains

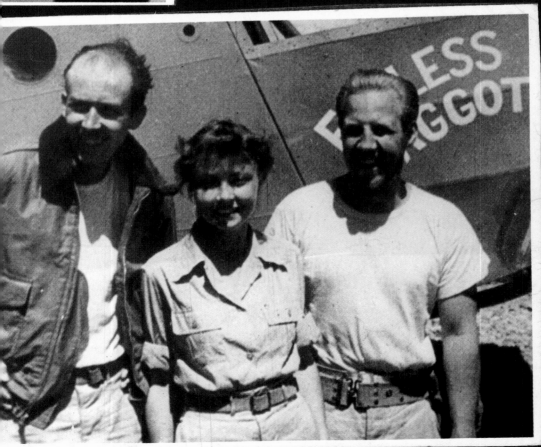

We should all have been as happy and content
as kings in this lotus land.

Instead, we were wildly impatient to escape
from paradise.

—Cecil E. Walter, Jr., commander of U.S. rescue team.
Rescue from Shangri-La, 1997.

WAC in SHANGRI-LA

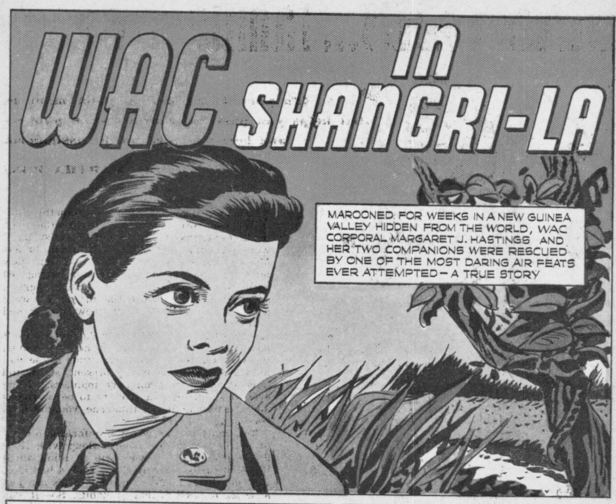

MAROONED FOR WEEKS IN A NEW GUINEA VALLEY HIDDEN FROM THE WORLD, WAC CORPORAL MARGARET J. HASTINGS AND HER TWO COMPANIONS WERE RESCUED BY ONE OF THE MOST DARING AIR FEATS EVER ATTEMPTED — A TRUE STORY

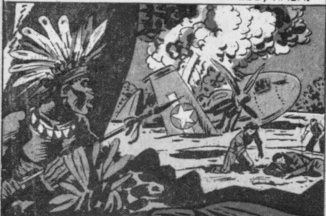

ON MAY 13, 1945, AN ARMY TRANSPORT PLANE WITH TWENTY-FOUR ABOARD CRASHED IN THE ORANJE MOUNTAINS IN DUTCH NEW GUINEA. THE THREE SURVIVORS WERE WAC CORPORAL MARGARET J. HASTINGS OF OWEGO, N.Y., LIEUTENANT JOHN McCOLLUM OF TRENTON, MO., AND TECHNICAL SERGEANT KENNETH DECKER OF KELSO, WASH.

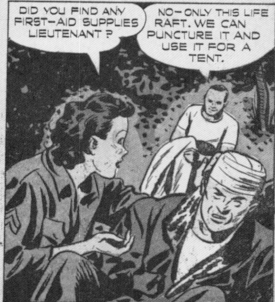

DID YOU FIND ANY FIRST-AID SUPPLIES LIEUTENANT?

NO — ONLY THIS LIFE RAFT. WE CAN PUNCTURE IT AND USE IT FOR A TENT.

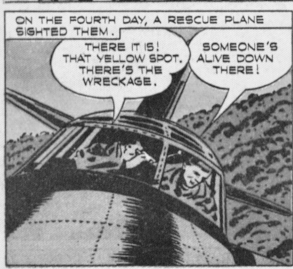

On the fourth day, a rescue plane sighted them.

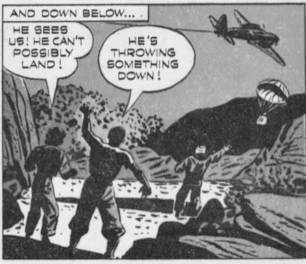

And down below...

From the skies came their first food in four days, medical supplies, and a walkie-talkie by means of which they could talk with the plane.

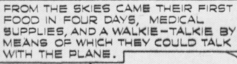

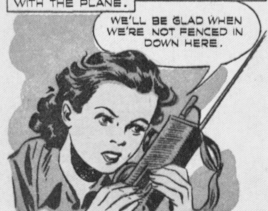

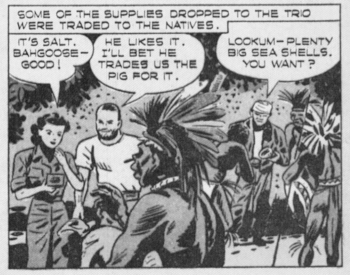

Some of the supplies dropped to the trio were traded to the natives.

MEANWHILE, BACK AT HOLLANDIA, THE ARMY WAS WORKING OUT A DARING RESCUE SCHEME.

WE CAN'T GET IN WITH A PLANE, BUT A GLIDER COULD BE TOWED INTO THE VALLEY...

AND WE'D FLY LOW AND PICK IT UP!

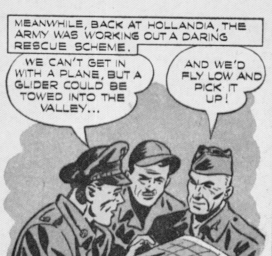

A CAPTAIN AND FILIPINO PARATROOPERS WERE DROPPED INTO THE VALLEY TO BUILD A GLIDER STRIP.

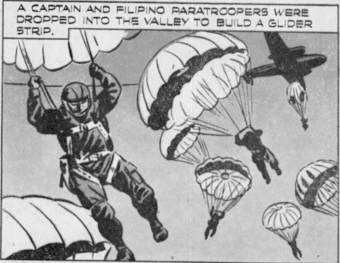

WHILE THE STRIP WAS BEING BUILT, THE THREE CEMENTED THEIR FRIENDSHIP WITH THE NATIVES, WHO WANTED TO MAKE MARGARET QUEEN.

FROM NOW ON, YOU TWO COULD ADDRESS ME AS "YOUR ROYAL HIGHNESS"!

YOU'RE JUST A CORPORAL TO ME, HASTINGS.

A WARLIKE NEIGHBORING TRIBE ATTACKED THE FRIENDLY NATIVES OF SHANGRI-LA.

BOY, THIS IS ONE WAR I DON'T WANT TO FIGHT!

STILL WANT TO BE QUEEN, QUEEN?

I'LL ABDICATE RIGHT NOW!

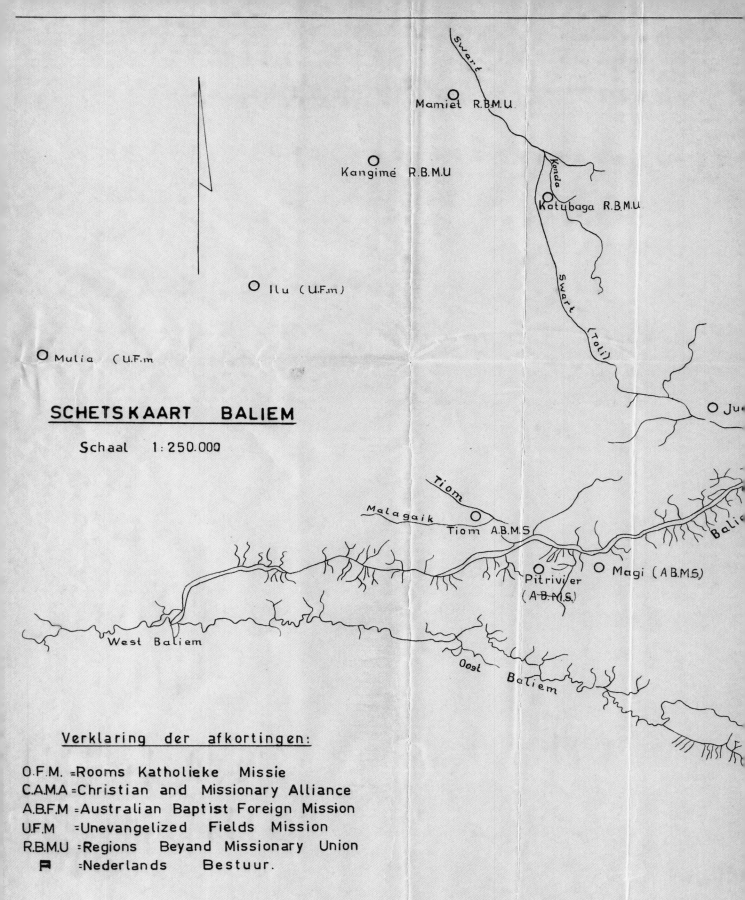

SCHETSKAART BALIEM

Schaal 1:250.000

Verklaring der afkortingen:

O.F.M. = Rooms Katholieke Missie
C.A.M.A = Christian and Missionary Alliance
A.B.F.M = Australian Baptist Foreign Mission
U.F.M = Unevangelized Fields Mission
R.B.M.U = Regions Beyand Missionary Union
⚑ = Nederlands Bestuur.

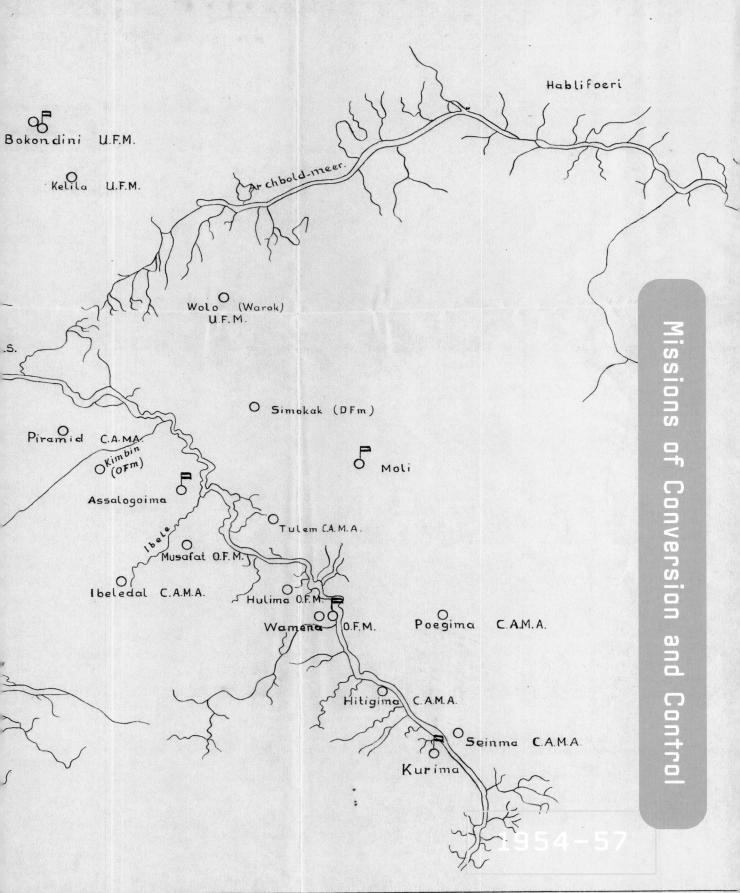

Missions of Conversion and Control

1954-57

Missionary Arrival (1954)

Christian missionaries had worked in
New Guinea for about a century before
they came to the remote Baliem Valley.
In 1954, the Christian and Missionary
Alliance (CAMA), an American evangelical
organization, established the first mission
in the valley. In this first team were three
American men, Rev. Einar Mickelson, Rev.
Lloyd Van Stone, and the linguist Myron
Bromley, and Elisa Gobai, a Mee pastor
from a part of New Guinea where CAMA
missionaries had been active since the
thirties. The first attempt to study the
Dani was made to serve missionary aims:
Bromley was brought in to learn the
Dani language in order to bring them
the Gospel.

For years, perhaps out of habit from the
war years or perhaps out of respect for
the Bible's spiritual warfare metaphors,
we had talked and prayed about the
Baliem entry in terms of "invasion," of
"establishing a beachhead," of being
God's "invasion force."

–Edward W. Ulrich, American missionary and pilot.
Out There Beyond Beyond, 2000.

It was on April 20, 1954, that Einar Mickelson set out by plane for Shangri-La. As he was about to take off, a Dutch official said to him: "I wouldn't go into that valley with anything less than a regiment of soldiers. Damned if I can understand what drives you missionaries!"

Mickelson just grinned. "No need to be damned," he replied. "You could find the answer in Christ's commission to those who try to follow Him: 'Go ye into all the world.'…

Obtaining an entry permit from the Dutch colonial government was not so easy. On its maps, the whole Dani area was ominously marked "uncontrolled." In its scant files the Danis were described as crafty and treacherous, cruel and vindictive. When, in the summer of 1952, permission was finally granted, the Dutch government said, "Understand, you're on your own!"

Mickelson had already made two attempts to reach Shangri-La overland, and each time had been stopped by hostile tribesmen. Realizing the futility of this approach, he asked the C&MA [CAMA] for an amphibian plane, an expensive request. The problem was finally solved by taking it to the Alliance membership, and the funds, mostly in small gifts, were quickly subscribed.

…At the amphibian's controls was Al Lewis of Hamilton, Ontario, a former Canadian Air Force ace. Also aboard were three Kapaukus—a pastor named Elisa, his wife Ruth and their two-year-old baby. Mickelson's reasoning: since the Kapaukus were a family, their presence would assure the Danis that the invasion was a peaceful one.

Lewis let the plane down on the Baliem River. In 20 minutes the five passengers and supplies—food for 30 days, tents, lamps, radio—were unloaded, and the plane headed back.

Mickelson and Van Stone set up the radio and called their base at Sentani Lake, "We're here!" they exulted. "Thank God!"

But where were the Danis? For a whole day none appeared.

—Clarence W. Hall, "The White Man Comes to Shangri-La," *Reader's Digest*, 1957.

[35]

Our Objectives

PIONEERING:

Frontier fields

Neglected peoples

Unreached tribes

EVANGELISM

not institutionalism.

Regeneraion

not civilization.

THE PRINTED PAGE:

Translation

Publication

Distribution

A NATIVE MINISTRY:

Bible-trained

Spirit-filled

Soul-seeking

AN INDIGENOUS CHURCH:

Born again believers

Scripturally autonomous

Spiritually progressive

●

CAMA bought the Sealand aircraft with which the missionaries entered the valley. CAMA was financed, for the most part, by "missionary pledges" from American evangelical Protestants. Promotional pamphlets were central to their fundraising efforts.

There's a Light in this Valley

But not until the following day did the Danis approach the camp. Then, abruptly materializing out of nowhere, a large group was before them—15-foot spears extended, stone-headed battleaxes on their shoulders, bows and arrows in hand. Suddenly their leader gave a hoarse order, weapons were lowered, and the whole group surged forward with smiles and cries of "Nahp!

The Danis were insatiably curious. They crowded close, pinching the white faces and arms, rubbing them almost raw to see whether the "paint" would come off. The white man's gadgets, too, were an endless fascination to people who had never seen metal of any kind, nor a wheel, nor glass. Given small mirrors, they gazed entranced at their reflection, marveling that their "spirits" (which they believe to exist in the ether outside their bodies) could be captured visibly...

In turn, the missionaries marveled at the Danis' intelligence and ingenuity. With only stone tools and sharpened sticks they had managed to create well-irrigated gardens, lushly full of yams, taro, spinach, beans, cucumbers, bananas. From vines, bamboo and lumber split by stone axes they had build ingenious suspension bridges, sturdy thatched houses. They had worked out a currency system using the little cowrie shell, brought in from the coast in some long-forgotten era....

...The Danis had no gods, no forms of worship. They feared only "evil sprits" inhabiting the air, trees, rocks. Nothing other worldly was good, only evil. And evil spirits often vented their spleen with visitations of sickness.

—Clarence W. Hall, "The White Man Comes to Shangri-La," *Reader's Digest*, 1957.

I was on the second flight of our team into the Baliem....It was only a number of months later that we found out that "Nahp" was not a word in the local language, but rather a greeting in the Nduga language that the Archbold party had picked up from Nduga men they encountered. The local men had heard it from the Archbold party and thought they were greeting us in our language! It was clear that we were being warmly received.

—Myron Bromley, American missionary and linguist.
Email to Susan Meiselas, 2003.

GOD CAN

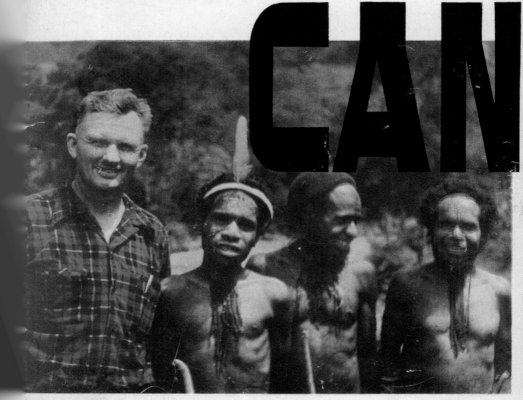

Yours E. H. Mickelson

God can and has supplied Pioneers for the opening of the interior of New Guinea to the gospel. The efforts of these pioneers have not been in vain. Let us consider what God is doing now in the interior of this land.

A pioneer evaluates and decides on factors that may be serious or trivial. This may be while facing hostile men having their spears poised for throwing or when deciding whether an old rattan bridge would be strong enough to carry his or the weight of his carriers. He needs the wisdom that only the Lord can give.

It is noteworthy that Alliance missionaries in New Guinea have done a great deal of pioneer exploratory work. They have gone over trails seldom if ever traversed by white men. They have faced dangers among natives of various tribes; yet, not one of our missionaries has died at the hands of hostile men....

A spiritual harvest is taking place in various parts of the world. In New Guinea it is harvest time. It is a time of rejoicing. Souls are being harvested for the Master.

It seems only such a short time ago that the interior of New Guinea was opened to the Gospel. All who have done pioneer work among primitive peoples know the toil that precedes the harvest. The heartaches, discouragement, illnesses, tears, and dangers encountered are not in vain. Some of those who sought the lives of early New Guinea pioneers are now bowing in allegiance to Christ.

A missionary feels well repaid for the difficulties connected with pioneering when he witnesses the first native of an area turn in repentance to God, seeking mercy and cleansing for sin. It has occasioned tears of gratitude to flow....

One of these days the last tribe will be reached with the Gospel. God will trouble the sleep of godly saints for the last time calling them to prayer. He will speak with others about being faithful stewards or about surrendering wholeheartedly to Him for the last time. One of these days the missionary will be bruised by hostile natives for the last time. The bridge will be completed. The last tribe shall have been reached and the Master will have come. We will not be sorry then that we helped in making it possible for this to be achieved.

—Einar H. Mickelson, American missionary. *God Can: Story of God's Faithfulness to a Pioneer Missionary Explorer in New Guinea*, 1966.

CONTENTS

First Primer

On the smeared pages of a field notebook marked "number one" are early attempts at writing some Lower Grand Valley Dani words: *hubako*, night; *supuru* sweet potatoes; *yage* stone adze; *weñam* in sight....The writing in field notebooks gradually shifted from rough phonetic script, fraught with all the inaccuracies of early hearing, to a more consistent semi-phonemic script.

—Myron Bromley, American linguist and missionary,
Language, Culture, Society and the Modern World, 1977.

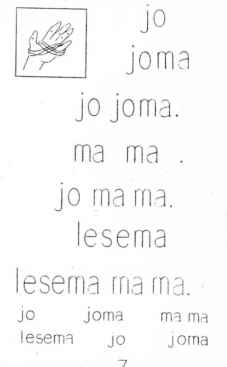

wa	greeting or thanks
waga	has come (third person singular)
ma	down
sa	who?
sa waga	who has come?
he waga	a woman has come
he wagama	a woman has come down
jo	spun string or the material for spinning it
joma	here
jo joma	(this is) string here
ma ma	down here (or there)
jo ma ma	(that is) string down there
lesema	in the long house

…Our main goal was not to give them things, though we did barter for food and help, or to try to remove their style of clothing or covering, or just to do things for them, though much later we were able to get funds to help them build steel cable bridges. We were sharing Good News about Jesus, who wanted to receive them in a way that would change their lives.

[A]ctually the crucial turning point for local faith did not come through our language learning, though that was absolutely essential. It came when the Good News was carried on brown feet and shared in local idioms.

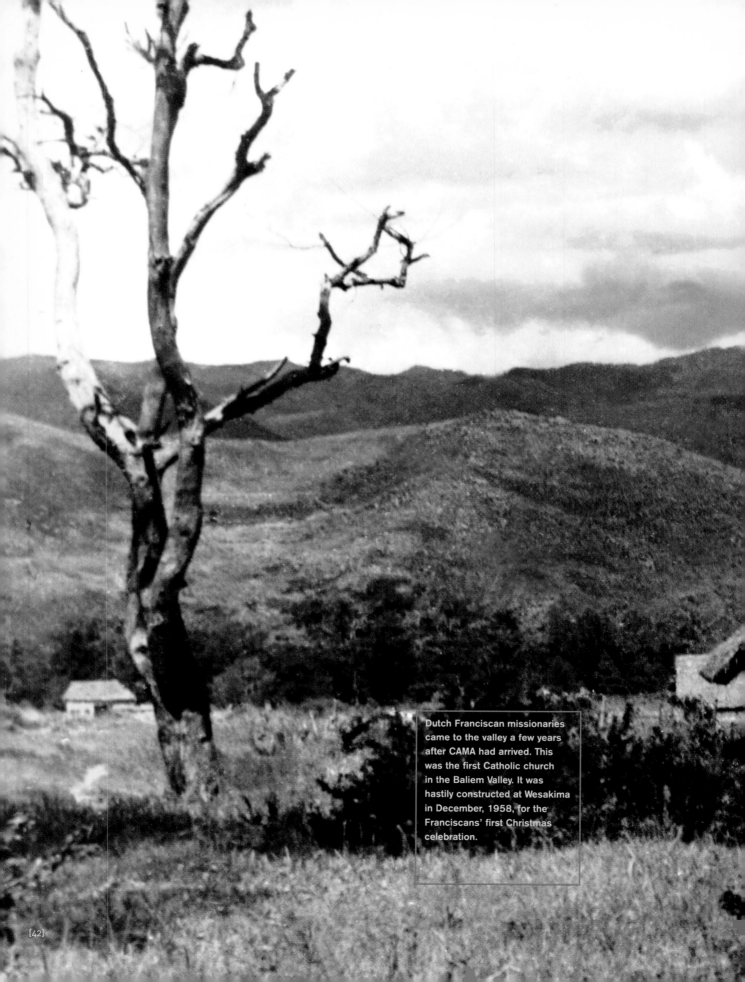

Dutch Franciscan missionaries came to the valley a few years after CAMA had arrived. This was the first Catholic church in the Baliem Valley. It was hastily constructed at Wesakima in December, 1958, for the Franciscans' first Christmas celebration.

My early thought at the moment of the landing, when the door of the plane had been opened and I saw all those naked people, shivering in the morning dew, was: So, these are the people I went to New Guinea for, for them I had gone to the Mission College of the Franciscans, for them I had studied philosophy, theology; had read so many books about anthropology, but, thank God, had also followed lessons on healthcare and wound dressing at the Medical Mission Course.

It is difficult to draw a sharp line between the way of working of the Catholic Mission and the CAMA, but in that first beginning my impression was that our first priority was the physical health and safety of the people, whilst our colleagues in the CAMA were more concerned with their spiritual well-being.

—Nico Verheyen, Dutch missionary. Unpublished memoir, 1999.

The Dani hope that despite your white skin, despite your relations with the powerful administrators in Wamena, that you will join them like a fellow villager, and not look down on them from the heights in judgement. They therefore expect that you will not refuse their perhaps somewhat chewed cigarette butt, nor the lump of pork that is offered after having been passed through many hands, that you will not put on a look of horror when they peel a hot yam for you with their teeth, or press their grease-smeared bodies against you in a well-intended embrace....

Thus they ever again accept your insufficient attempts at their language, and extend to you the trust that we so desperately need. Without that trust we will accomplish nothing. But with that trust we can lead them from barbarism to good humanity and Christianity by the quickest path.

—Nico Verheyen. "Living with Baliemers," 1964.

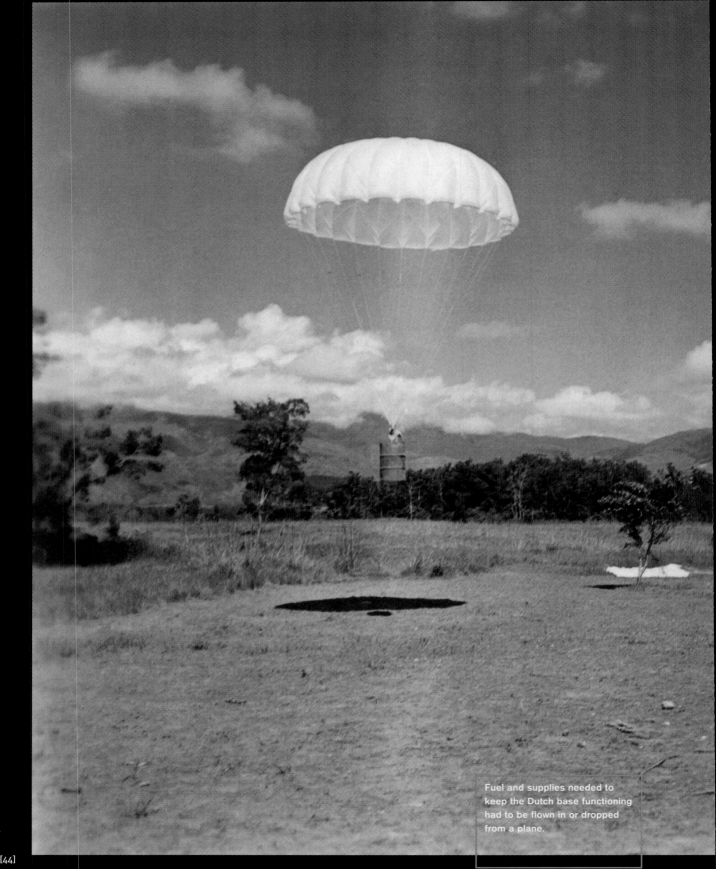

Fuel and supplies needed to keep the Dutch base functioning had to be flown in or dropped from a plane.

Raising the Dutch Flag (December 13, 1956)

The Indonesian nationalists' decades-long struggle for independence ended after World War II, when the Dutch East Indies became the Republic of Indonesia. The Dutch maintained possession of Netherlands New Guinea, but had little effective control over large sectors of the territory. Stories filtered out through the missionaries about tribal warfare in the Baliem Valley and became an embarrassment for the Dutch government. Frits Veldkamp was sent out to be *controleur* of the Baliem, to make preparations for the establishment of order in the valley. He set up a post on the Wamena River, a tributary of the Baliem River, and raised the first Dutch flag in the valley in December 1956.

It will not be easy…to understand the "ambiance" in which the [opening of the Baliem] took place.…It was a time of enthusiasm and optimism.…The Netherlands had resolved to speed up the development of this last remaining overseas territory and prepare it for some form of self-government. That was no easy task in view of the extremely difficult geography, and a population spread over an impossibly wide area, closely attached to their own traditions, and with no concept whatsoever of central authority.

—Frits Veldkamp, Dutch *controleur* of the Baliem Valley between 1956 and 1958, "Administrative Dilemmas During the Opening of the Baliem," 1996.

It now became clear that the settlement of the American missionaries in the Baliem, which had been such a worry to the administration, also had its advantages. The practical-minded Americans had with them a trained anthropologist/linguist, Myron Bromley, who had assembled an impressive quantity of basic information in a short time. Very quickly there developed a working relationship between the administrators and the missionaries which served the interests of both sides. Bromley furnished me with a schema of the Dani language, with some vocabulary lists, and, most important, a sketch of the social structure of Dani communities....With the aid of Bromley's information we succeeded in sufficiently mastering the language in the space of a few months that we were able to communicate with the people living in the area....

One day we went with Myron Bromley to the area where the American World War II airplane crashed. There we found a small cave in the mountain where the local people had hidden some remnants from the collision and the ensuing rescue operation—an American helmet, buckles, parachutes. All these objects had been gathered and declared *wesa* (taboo, sacred) by the Dani. Understandably, they seemed to attach magical or spiritual meaning to all these mysterious matters and people coming to the Baliem in such an astounding way, like by airplanes flying in from a completely unknown outer world.

—Frits Veldkamp. Interview with Susan Meiselas, 2001.

Ex-Shangri La

The Government of Netherlands New Guinea plans to establish a permanent centre of administration in the previously little known Baliem Valley.

The Baliem Valley gained worldfame and was compared with an elusive Shangri La when in May 1945 a C-47 Dakota of the American Air Force crash-landed in the extremely narrow valley and the survivors established the first outside contact with the completely isolated tribe in this "garden of Eden."

A group comprising an administrative officer, a wireless operator and fifteen members of the New Guinea Police Force has recently been flown to this valley.

①

Myron Bromley, the missionary linguist, gave Veldkamp his first lessons in Dani language.

Zendeling/linguist Bromley leerde mij eerste Dani-woorden.

Eerste Kamp Wamena, Wesaput.
Een paar tentzeilen over ruwe boomstammen.

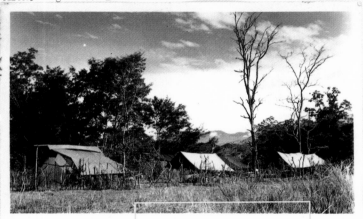

Eerste bestuursbivak, Wesaput, Wamena, aan de oever van de Baliem, december 1956.

First government post at Wamena on the bank of the Baliem River.

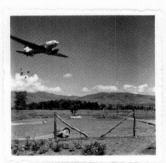

Dropping
Zo worden we in de eerste maanden bevoorraad.

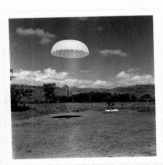

Dropping
200 liter- drum aan parachute.

Uitzicht vanuit ons bivak op het „niemandsland".

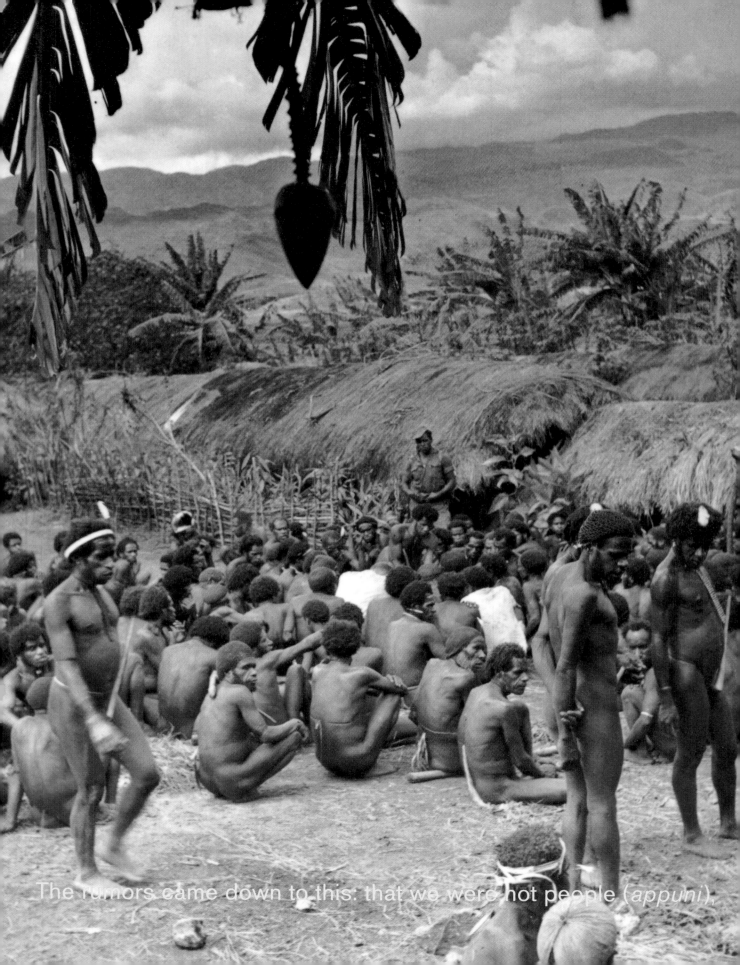

The rumors came down to this: that we were hot people (*appuni*),

Werk vliegveld Wamena.
Met eenvoudige gereedschappen
moet een vliegstrip van
600 meter aangelegd worden.

**Work on Wamena airstrip:
a 600 meter airstrip is built
with primitive tools.**

Bevoorrading door Gibbes-
Cepik - Airways
Omdat „de kroonduif" niet
wil vliegen i.v.m gevaar
is een Australische
„bush vlieger" gecharterd.

**In his "Werkplan Nieuw Guinea
1954–56," Governor Jan van
Baal, the top administrator in
Netherlands New Guinea,
ordered that a post be estab-
lished in the Baliem Valley by
1956. In 1957, he came to
check on Veldkamp's progress.**

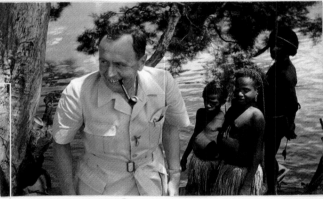

Bezoek Gouverneur van Baal. 1957.

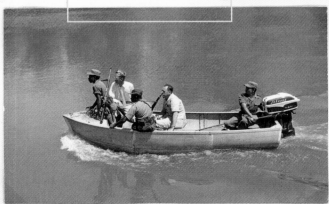

Gouverneur van Baal wordt over de Baliem gevaren.

Eerste landing op ons
eigen vliegveld, 25 juli '57.

but spirits (*mokkari*), who were out to do the Dani harm.

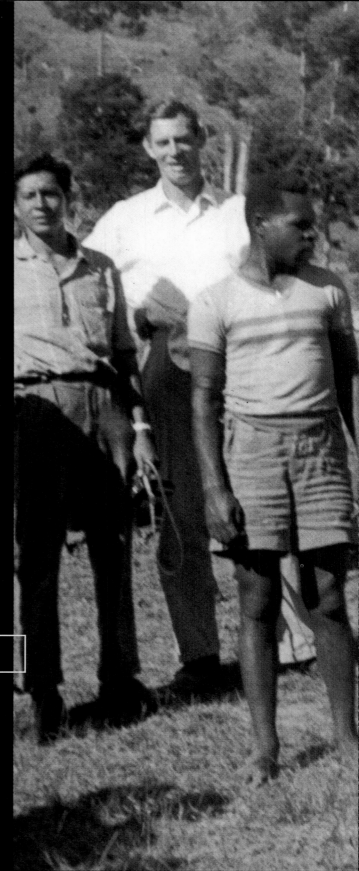

The visit by Governor Jan van Baal [of Netherlands New Guinea] to Wamena did not have any particular purpose other than offering him the opportunity to see how the first government post in this difficult area was getting on.

The Netherlands in those years were under continuous criticism and attacks in the United Nations Assembly, particularly from Indonesia and its allies, concerning the Dutch policy in this former part of the Dutch East Indies. Having promised to escalate the development of this backward part of their former colony, the Dutch could not afford to let the densely populated interior go on without administration for much longer. On the other hand, they hardly had the means to tackle this huge task effectively— still recovering from World War II and five years of German occupation. Also, in that period the highlands of New Guinea were regularly in the focus of international publicity, pictured as a romantic part of the world where people still lived in the Stone Age, Shangri La, the land beyond a lost horizon.…

…Moreover, there were disturbing stories filtering back to the outside world through the CAMA about bloody inter-tribal warfare. No self-respecting administrator could tolerate this. And what would The Netherlands look like if something happened to one of these American missionaries?

So van Baal personally instructed me before I left for the Baliem to be very, very careful, and to avoid clashes with the Dani. Easier said than done, as part of our task (apart from making contact with the people, learn the language and make a preliminary study of the culture) was to build an airstrip right in the middle of a tremendous no man's land, where the Dani only came to fight each other, and consequently were not over-interested in building an airstrip.

…The rumors came down to this: that we were not people (*appuni*), but spirits (*mokkari*), who were out to do the Dani harm. Each time these stories made the rounds, we let it be known again that we too were people (*appuni-at*), but apparently we were unable to convince them, as it would soon appear. Unfortunately the founding of the administrative post coincided with a period of drought in the Valley, which had caused considerable damage to the yam harvest. The connection was easily made: the strangers were responsible for the drought!

—Frits Veldkamp. "Administrative Dilemmas During the Opening of the Baliem," 1996, and emails to Susan Meiselas, 2001 and 2003.

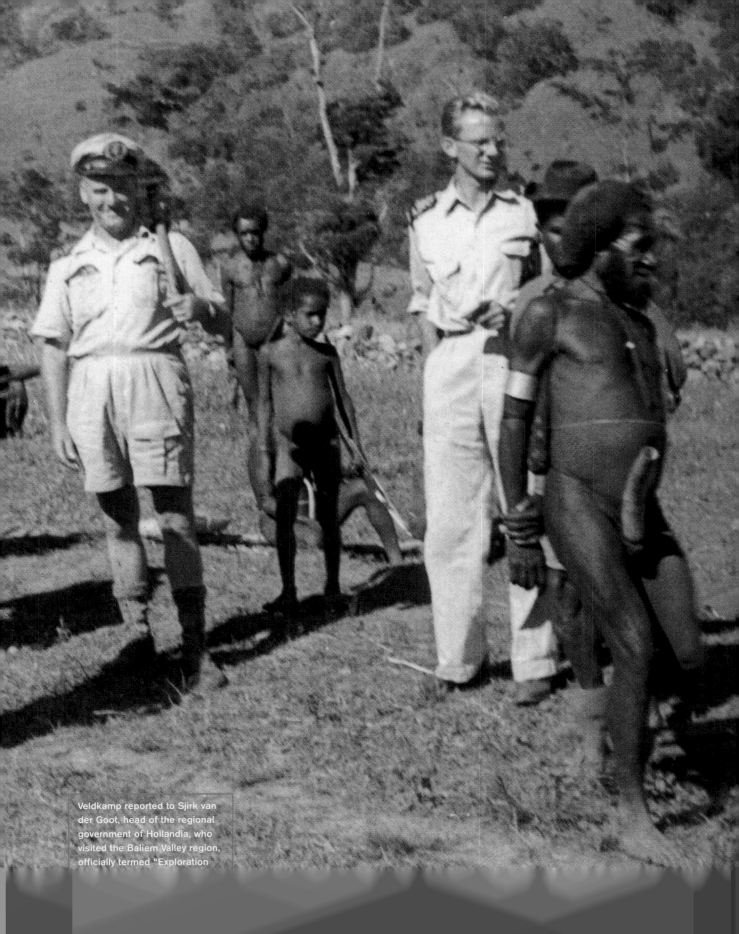

Veldkamp reported to Sjirk van der Goot, head of the regional government of Hollandia, who visited the Baliem Valley region, officially termed "Exploration

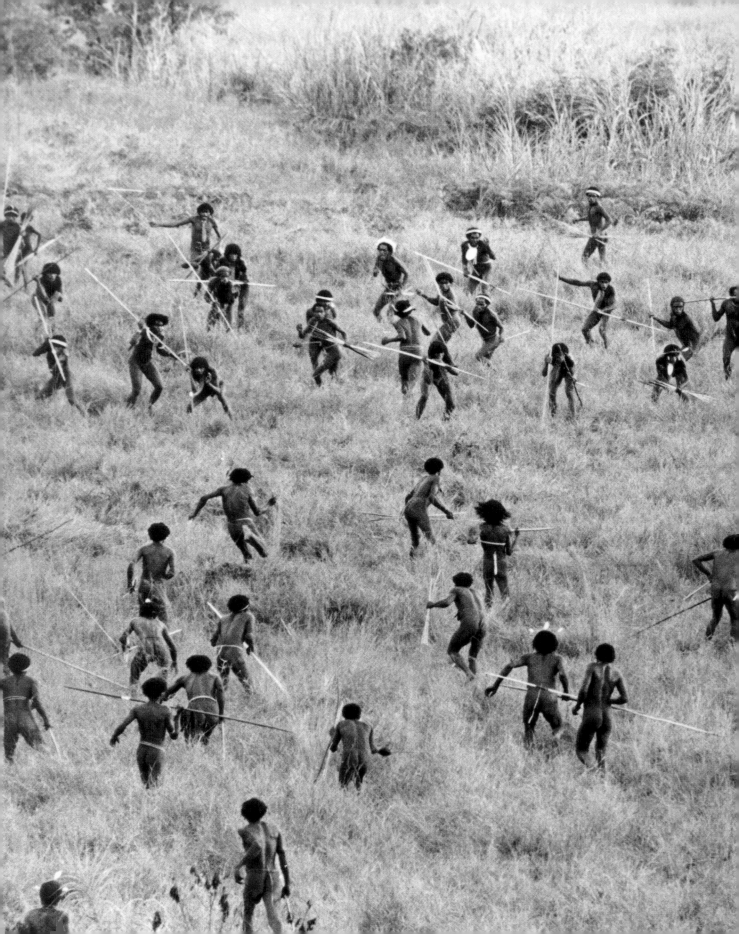

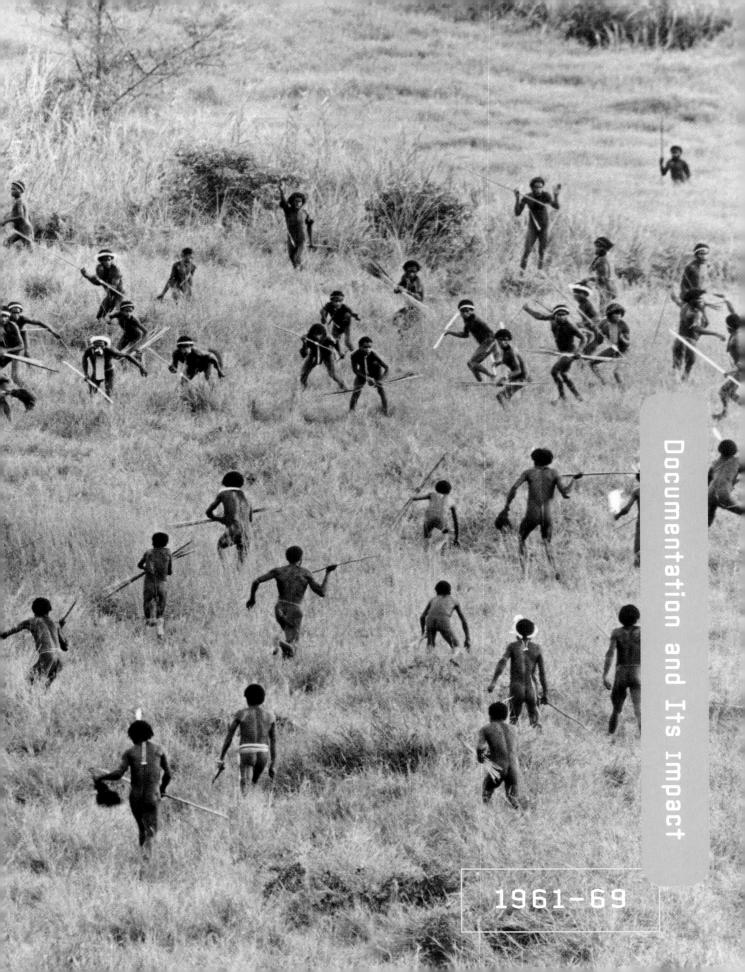

Documentation and Its Impact

1961-69

Harvard Expedition Discovers A Tribe of War in New Guinea

By HOMER BIGART
Special to The New York Times.

HOLLANDIA, Netherlands New Guinea, March 27—A Harvard anthropological expedition, led by Robert G. Gardner, has discovered in the heart of Dutch New Guinea a savage tribe whose culture is focused on war —the Willigiman-Wallalua people in the lofty Baliem Valley.

The tribe's warriors' are judged by the number of enemy slain, the number of pigs stolen and the number of wives captured. Apparently they have no qualms about killing enemy women and children; these seem to add as much to their prestige as a slain male adult, according to Mr. Gardner.

Even their music is unconsciously aggressive. A good deal of it consists of grinding their teeth in harmony.

Michael Rockefeller, youngest son of Gov. Nelson Rockefeller and a member of the expedition, will make sound recordings of the teeth chatter and also of war chants, a medley of hoots and rumbles accompanied by an instrument resembling a jew's-harp.

Mr. Gardner and Jan Broekhuyze, a Dutch anthropologist, found the Willigiman-Wallalu on March 6. They were lookin[g] for a people called Kurelu in a[n] uncharted part of the valle[y] Mr. Broekhuyze, in a previou[s] attempt to reach the Kurel[u] had been frustrated by inhosp[i]table natives. But this tim[e] they were provided with se[a] snail shells, on which the Balie[m] Valley tribes set great store.

"We were on the edge of [a] swamp when we first saw th[e] natives," said Mr. Gardner, wh[o] is director of the Film Stud[io] Center at Harvard. "They we[re] observing us from watchtowe[rs] twenty feet off the groun[d] which they had built by lashin[g] some long thin trees together

"They climbed down from th[e] towers as we approache[d] Broekhuyze, who speaks th[e] language of the Dani grou[p] quite well, began to talk [to] them. He opened with a trad[i]tional greeting and then e[

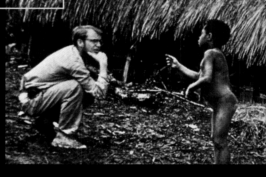

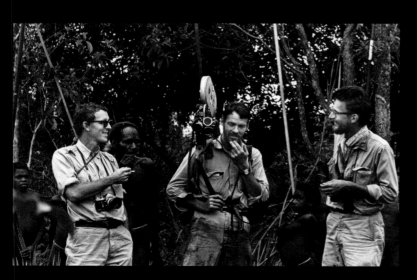

Jan Broekhuijse, an anthropologist working for the colonial government, photographed the novelist Peter Matthiessen, the filmmaker Robert Gardner, and the anthropologist Karl Heider during a pause in a Dani battle. Heider remained in the valley to finish his fieldwork after the others left.

lained why we were there. "The men became curious and put down their fifteen-foot spears. We crossed a swamp up to our knees in muck to some high ground where they were standing. There were about fifty warriors, some of them magnificent specimens six foot three inches tall.

A Warriod Led Them

"We found that they were not of the Kurelu, but an allied people. We explained that we wanted to live with them, and motioned to three or four hamlets we had observed up against a hill. We talked for half an hour. Finally, a young warrior who was acute enough to realize he had much to gain — we had shown him the seasnail shells — led us to one of the hamlets."

Mr. Gardner and Mr. Broekhuyze pitched a tent, but there was little sleep for them the first night. The front of the tent was open and Mr. Gardner was acutely conscious of perhaps fifty pairs of eyes that followed his every move.

He heard a hissing intake of breath as he removed his shirt.

"I think they were amazed that my whole body was white," he said.

Tooth-Music Passes Time

He stayed two weeks, then returned to Hollandia to meet Michael Rockefeller and Karl Heider, another Harvard anthropologist, who reached Hollandia today.

Mr. Gardner recalled that when he first heard the teeth grinding he was unable to understand what the noise was. Then he noticed that the warriors were waggling their jaws in unison, like stenographers with chewing gum. "It wasn't very musical," he said, "but it helped them pass their time."

Mr. Gardner said that the men wore nothing but a loin covering made of gourds and the women were clad with the skimpiest of fiber skirts.

He found that the people were agriculturalists with a good diet. Besides vegetables, they ate crayfish and pig. Their leaders were men who had distinguished themselves in war and were wealthy in wives, pigs and shells.

The men adorned themselves with pig grease and soot. Great gobbets of fatty soot hung from their hair and faces.

The sleeping arrangements were odd. All the men slept on a sleeping platform in a round house. Women, pigs and children slept in another common house. All mingled in a third house, which the natives called Ebe-ai.

This moment in the valley may not be so unlike the last years of the 18th century on the Great Plains of America. Here, now, there is a culture that lives according to the customs and codes of preceding centuries. They are not remarkably more or less advanced today than they were a hundred years ago. Change has not been a factor in the living out of their lives because influences that might have engendered change have not penetrated the isolation of the Dani. The discovery of this Valley by Richard Archbold in the late thirties and the entry of missionaries beginning soon after the Second World War have been a source of considerable blight for the indigenous cultures. But in Kurelu until a scant few weeks ago most of the hundreds who dwell here had never seen white skins and never heard foreign languages. Now they can listen to Dutch, Malay, English and even an assortment of other strange tongues coming from the four or five transistor radios that have accompanied the missionaries and ourselves.

—Robert Gardner, American filmmaker and anthropologist.
Unpublished journal, 1961.

Victor DeBruyn, director of the Netherlands New Guinea Bureau of Native Affairs, knew that traditional life in the Baliem Valley was changing and asked Robert Gardner, a filmmaker at Harvard's Peabody Museum of Archaeology and Ethnology, to undertake a study of Dani culture. In 1961, the Harvard-Peabody Expedition—Gardner and an interdisciplinary group of anthropologists, photographers, and writers—set up camp in an area of the Baliem that had not yet come under the influence of missionaries or colonists. They stayed there for about six months, documenting Dani life in photographs, films, and books. Their work often emphasized the ritual warfare that first spurred Gardner's interest in the Dani.

Harvard-Peabody Expedition (1961-68)

Arriving yesterday was like coming to an unknown and possibly unfriendly place and being grateful for whatever shelter is offered. It should also be remembered that our movements are to an important extent influenced by what sort of arrangement we can make with our new Dani acquaintances. The next few days should tell us more about our chances in this respect. For now, it is probably wise to look around in ways it was unthinkable to do upon first encountering this extraordinary place. So during the afternoon, we visited many of the villages within 20–30 minutes by foot.

In the 1960s, the same decade when most of the world watched a man walk on the moon, the Grand Valley Dani still raised their sweet potatoes with fire-hardened digging sticks, made houses for themselves and their pigs with stone adzes, and fought wars with wooden spears and featherless arrows.

—Karl G. Heider, American anthropologist. *Grand Valley Dani: Peaceful Warriors*, 1997.

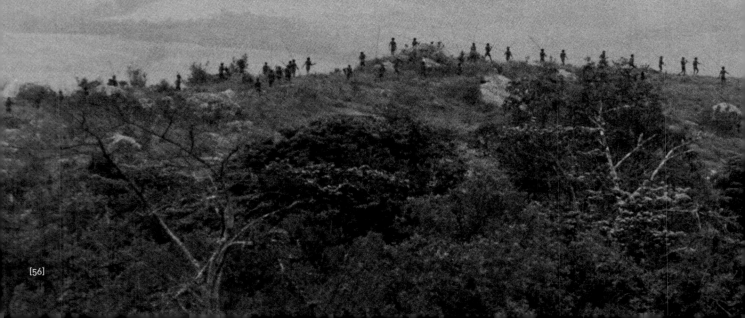

Saturday, March 4, 1961

The morning began somewhat tardily due to the dreariness of the weather. By 10 a.m., however, Wali, one of the *kains* [important men] who had offered us a pig, came to say we should go to his *sili* and attend the preparations for the feast. On the way there, I was struck by the thought of how incomprehensible any explanation would be of why we had come and what vast expense of money and effort had been involved. But the gesture they had made to share one of their precious pigs seemed to justify all that had been spent so far.

...We declared that in exchange for this exceptional gift of estimable pig meat, we wanted to give them some shells. We told them we had come a long way to visit them, and that we wanted to stay. We told them our desire was to see how they lived and that we would never interfere with their lives. We went on to say we hope that eating their pig meant we were already friends and that we would become better friends if we stayed with them. Finally, we said that if they helped us, we had more shells with which to make them rich and handsome. It must have been clear to everyone that our methods amounted to nothing more or less than crudest bribery. To all of this fine but pointed talk, the assembled warrior dignitaries said in unison "Wa-wa-wa-wa-wa-wa."

—Robert Gardner. Unpublished journal, 1961, and *Gardens of War: Life and Death in the New Guinea Stone Age*, 1968.

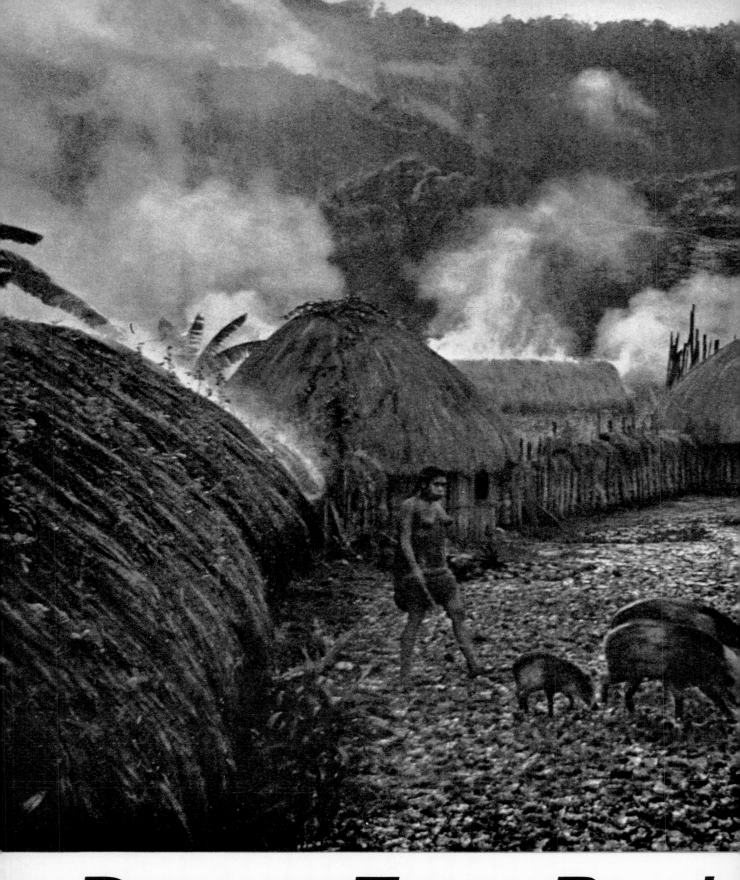

Dawn: Turn Back

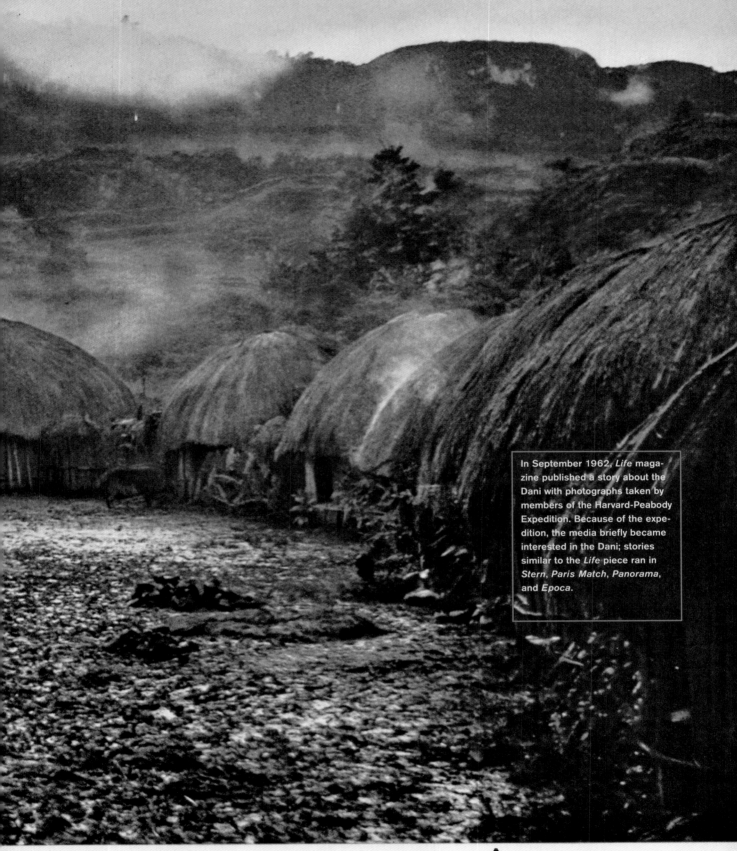

In September 1962, *Life* magazine published a story about the Dani with photographs taken by members of the Harvard-Peabody Expedition. Because of the expedition, the media briefly became interested in the Dani; stories similar to the *Life* piece ran in *Stern*, *Paris Match*, *Panorama*, and *Epoca*.

the Years

As smoke from breakfast fires hovers over the village of Wuperainma, Kolaraik, wife of a New Guinea warrior, performs the morning task of rounding up her husband's pigs.

CONTINUED

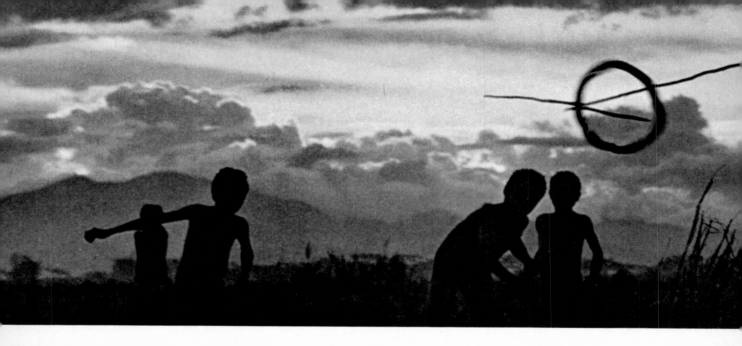

Their Way of Life: the Farm

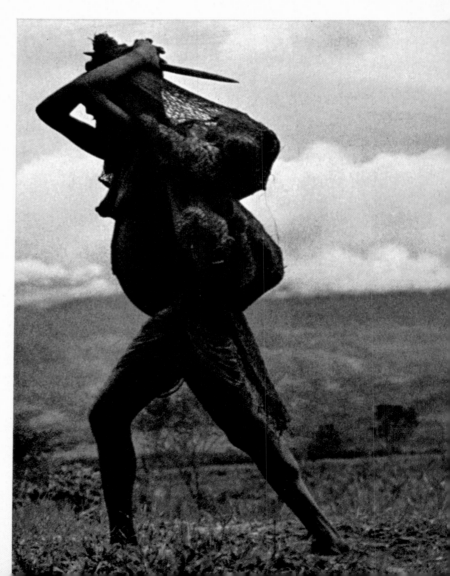

The morning peacefulness of the scene on the preceding pages belies certain harsh and inescapable facts of life for the stone-age Willigiman-Wallalua, a Dani-speaking group of clans who live against the northeast mountain wall of the great Baliem Valley, high in the central ranges of Netherlands New Guinea. The shadow of death walks with them everywhere, for they are caught in a continuous cycle of warfare with neighboring clans. Children start throwing spears soon after they have learned to walk, and men take each other's measure in terms of their skill in war and the number of people they have slain.

But the Willigiman-Wallalua are not only ardent warriors. Within their own society they are responsible citizens, affectionate parents, skilled craftsmen and industrious farmers. Their neat villages have houses soundly constructed of beech boards cut with stone adzes and lashed together with vines. They are capable, resourceful agriculturists, terracing their hillside gardens to keep them from washing away and ditching their bottom lands to drain the near-daily rain. They grow and give names to more than 60 varieties of sweet potatoes (*hiperi*), their staple crop. They also plant tobacco for cigarets, keep pigs and raise bananas, taro, sugar cane, ginger, yams, cucumbers and several kinds of spinachlike greens for food. But no one goes into the fields to work without his *tegé* (spear) or *siketok* (bow and arrows). Men jab their well-balanced, 16-foot spears in the ground close at hand. Women carry four-foot, double-ended *hiperi tegé*, useful both for digging sweet potatoes and menacing assailants.

and the Spear

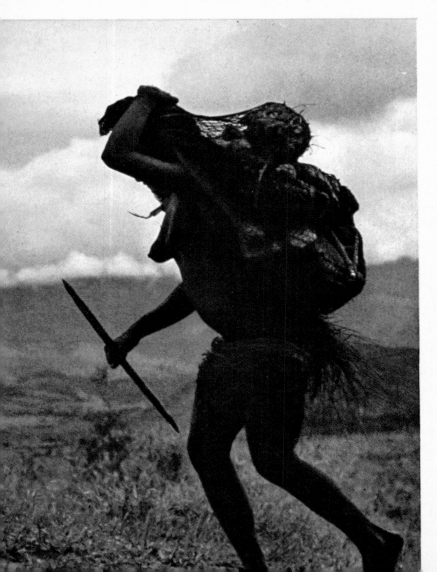

CONTINUED

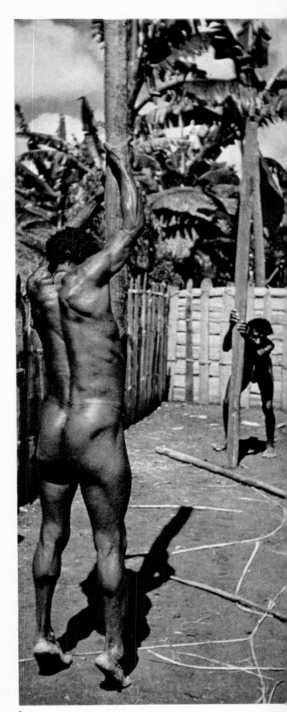

With practiced skill children "kill" a bounding hoop by flinging their three-foot wooden play spears through it in a war game called *sikoko wasin*, or "kill-the-hoop."

In the village of Abulupak two men drive the center posts for a new *hunu*, or family house, where several families will have fireplaces and gather to eat, talk and work.

Armed with short spears, two women trudge homeward past fallow fields carrying sweet potatoes and green vegetables in nets slung from their heads.

[61]

Why and How They Make War

The traditional enemies of the Willigiman-Walla-lua are the Wittaia, a people exactly like themselves in language, dress and custom, but who are nevertheless considered virtually inhuman. The no man's land between the two foes is marked on both sides by a line of 25-foot-high wooden *kaios* or watchtowers (*right*), manned during the day by vigilant warriors, alert for any sign of enemy activity.

Every week or two the Willigiman-Wallalua and their enemies arrange a formal battle (*following pages*) at one of the traditional fighting grounds. In comparison with the catastrophic conflicts of "civilized" nations, these frays seem more like a dangerous field sport than true war. Each battle lasts but a single day, always stops before nightfall (because of the danger of ghosts) or if it begins to rain (no one wants to get his hair or ornaments wet). The men are very accurate with their weapons—they have all played war games since they were small boys—but they are equally adept at dodging, and hence are rarely hit by anything.

The truly lethal part of this primitive warfare is not the formal battle but the sneak raid or stealthy ambush in which not only men but women and children are mercilessly slaughtered. Whenever the Willigiman-Wallalua succeed in killing a Wittaia, they celebrate the triumph with an *etai* or victory dance. When the Wittaia manage in turn to kill a Willigiman-Wallalua, the death must be revenged with still another death. Thus there is a relentless, unending round of death and revenge, mourning and celebration.

This perpetual bloodshed is carried on for none of the usual reasons for waging war. No territory is won or lost; no goods or prisoners seized. No better weapon or clever bit of strategy is ever devised to annihilate the enemy and put an end to war. They fight because they enthusiastically enjoy it, because it is to them a vital function of the complete man, and because they feel they must satisfy the ghosts of slain companions.

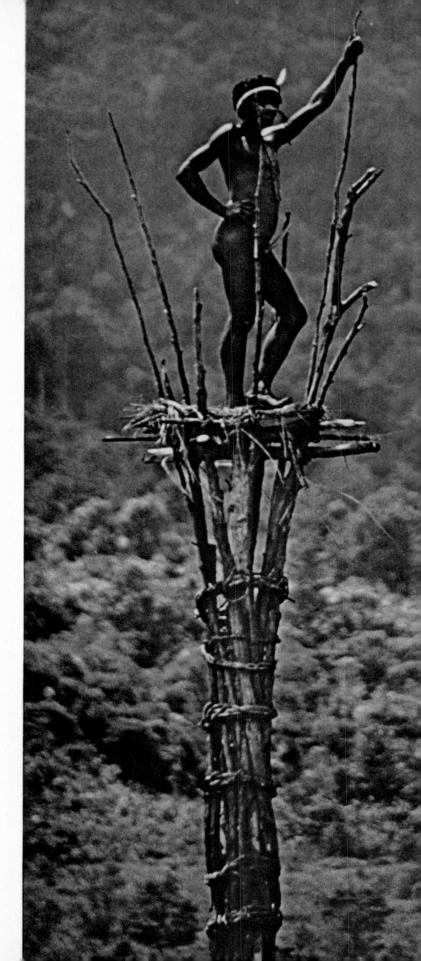

Waluem ("Cormorant"), a 20-year-old warrior, stands his turn at sentry duty. At far right Wereklowé, a renowned war leader, peers toward enemy territory. These men wear what anthropologists call penis sheaths tied to their bodies as ornaments.

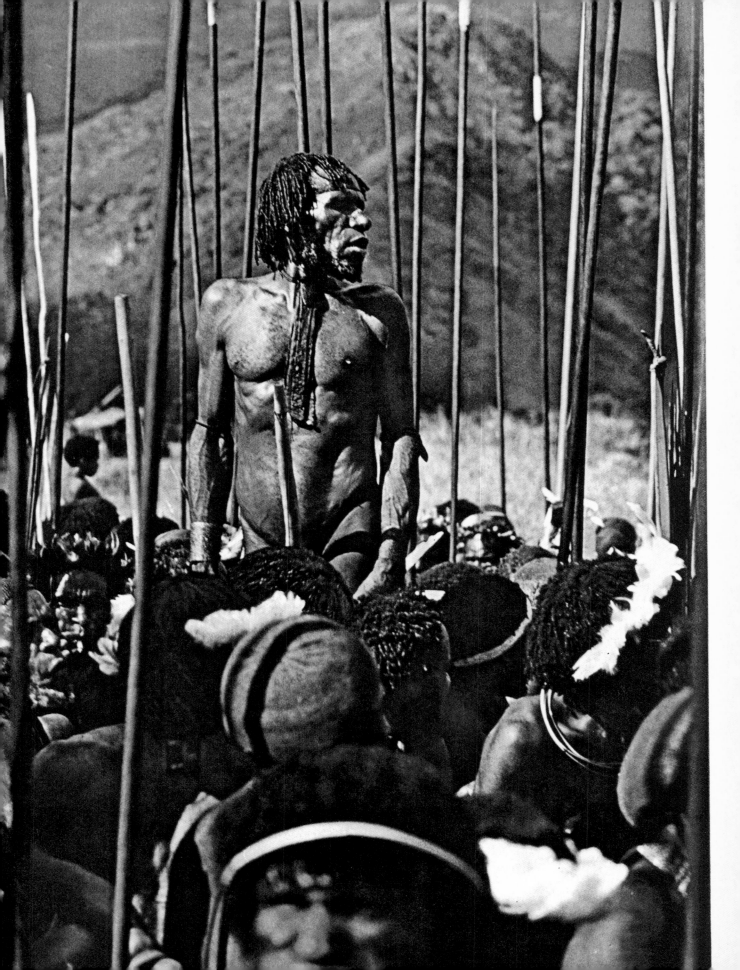

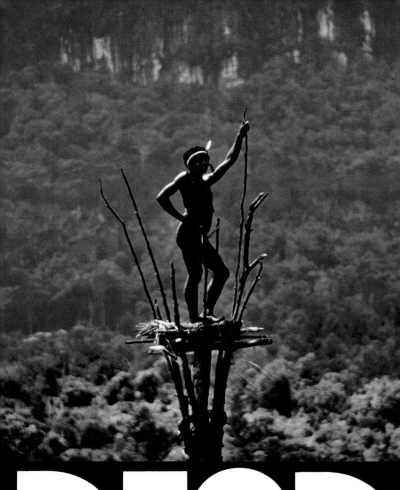

DEAD BIRDS

A Film by Robert Gardner

Phoenix Films

DEAD BIRDS

starting Jan 21 at THE MOVIE

The filming of DEAD BIRDS is a major anthropological event, comparable in its importance to such other anthropological events as the Torres Straits Expedition, the Jessup Expedition, or the publication of The Argonauts of the Western Pacific, Patterns of Culture, or The Children of Sanchez -- a genuine breakthrough in our capacity to record and communicate. The events portrayed -- the endless round of revenge, the murdered children, the terrible stubs of the women's mourning hands -- have all been reported many times by eye witnesses, without a camera, and by informants who have tried to put the intensities of their vanishing culture into words. In Dead Birds that culture is before one's eyes, vivid, inescapable, palpable.

The film carries the more readily because it is beautiful as a film; in its making, art neither has been subordinated to, nor has it been allowed to overrule science. The film has been felicitously designed in three parts, and those whose stomachs are weak -- or those for whom vulnerability others fear -- may see the first part if they are able to bear no more.

These are clearly human beings, like ourselves, entrapped in a terrible way of life in which the enemy cannot be annihilated, conquered, or absorbed, because an enemy is needed to provide the exchange of victims, whose only possible end is another victim. Men have involved themselves in many vicious circles, and kingdoms and empires have collapsed because they could find no way out but to fall before invaders who were not so trapped. Here in the highlands of New Guinea there has been no way out for thousands of years, only the careful tending of the gardens and the rearing of children to be slain. There is in Dead Birds enough of tenderness and sorrow so no man can doubt but that these people would welcome a political system which did not condemn them to an unceasing deadly engagement -- to no purpose.

Dead Birds binds together the distant past, from which the ancestors of our civilization were able to escape, and the future toward which men -- the same men, made of the same stuff, but hopefully possessed of very different cultural invention -- are moving. But while it binds together past, present, and future, it also provides a savage paradigm of the fate that always waits, just around the corner, for men, because they are men who fight and organize for fighting and organize against fighting, not like other creatures, but as men.

Margaret Mead

American Museum of
Natural History
November 18, 1963

**THE
MOVIE**
34 Kearny St.
San Francisco
SU 1-3563

At the end of the summer of 1961, Gardner began editing the footage into a documentary, Dead Birds. This film became important both as a seminal ethnographic film, standard in introductory anthropology classes, and as an artistic achievement in documentary filmmaking. The eminent anthropologist Margaret Mead was quoted on a promotional flyer for the film's first theatrical engagement in 1964, and later wrote the introduction to Gardens of War, a book on the Dani by Gardner and Heider.

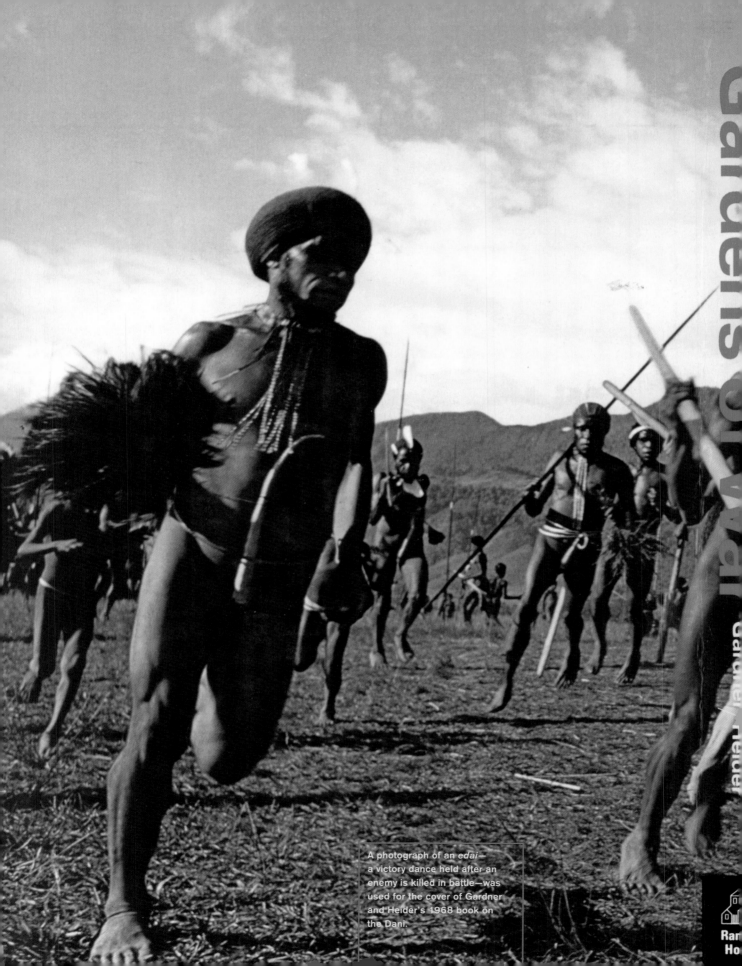

A photograph of an *edai*—a victory dance held after an enemy is killed in battle—was used for the cover of Gardner and Heider's 1968 book on the Dani.

Gardens of War

LIFE AND DEATH IN
THE NEW GUINEA STONE AGE

**Robert Gardner
and Karl G. Heider**

Introduction by Margaret Mead

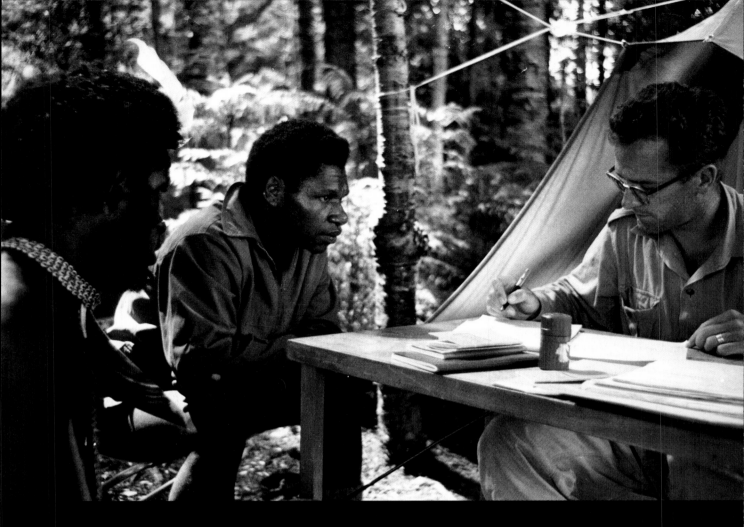

No anthropologist can permit himself to try to change a culture—

There were written records, and photographs, film, and sound recordings made, all systematically and with continual mutual exchange of information and insights.

That appears to have made it possible to provide a solid and accurate image of the authentic functioning of a "primitive" (original) culture in only a short time. What made this culture so unusual was that the conduct of warfare was such a dominant feature in it. It could not be expected that such an expedition would intervene....

Moreover, there was certainly a serious reason for the study—indeed, several serious reasons. The Harvard researchers wanted to study the Dani scientifically, and the Dutch government had a serious need to obtain insight into how Dani culture functioned, and particularly the role warfare played in it....

Broekhuijse learned to speak the Dani language while working as a district officer in the Dutch government. He and Abututi, a Dani man who also worked for the colonial government, served as translators for the expedition.

> There are very few photographs of me from the expedition, but as we were leaving, the boy who had carried my knapsack said, "Here's your photograph back. I don't need it anymore. When I had that photo, I felt your presence. I felt your protection and now that you go, your protection won't be there. So the photo is useless to me."
>
> —Jan Broekhuijse, Dutch patrol officer and ethnographer. Interview with Susan Meiselas, 2001.

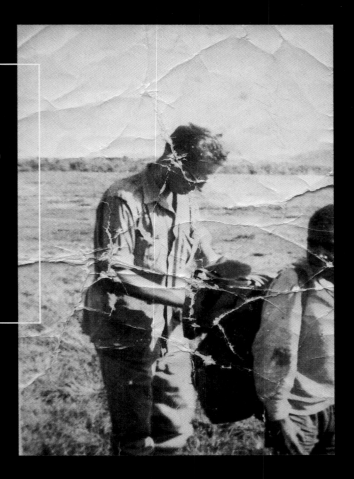

the subject of his research—during his investigation of it.

Unfortunately the denigration of the activities of the American expedition coincided with the deep disagreement between the United States and the Netherlands about the future of the Papuan people. The United States tried to broker a compromise between the Indonesian claim to sovereignty over New Guinea and the Dutch idea of self-determination for the Papuans. These American efforts were not appreciated among the Dutch in New Guinea, and anti-American feeling arose as a result. The American members of the expedition had little awareness of this. They were not interested in the Dutch, but in the Dani.

—Jan Broekhuijse. "The Harvard-Peabody Expedition into the Baliem Valley," 1996.

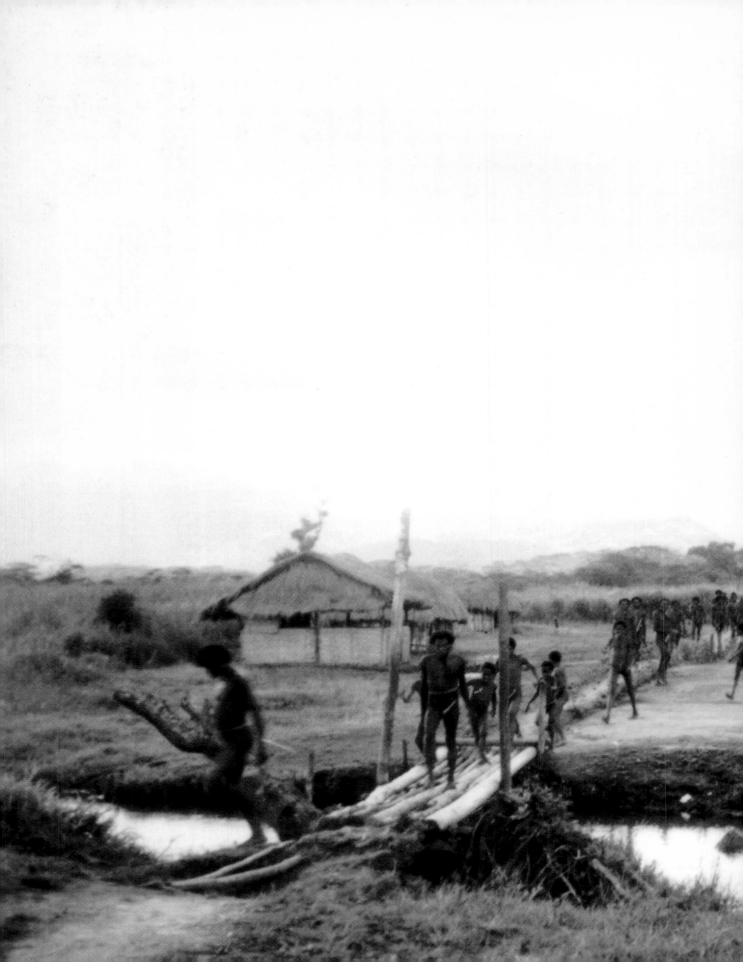

1961-69

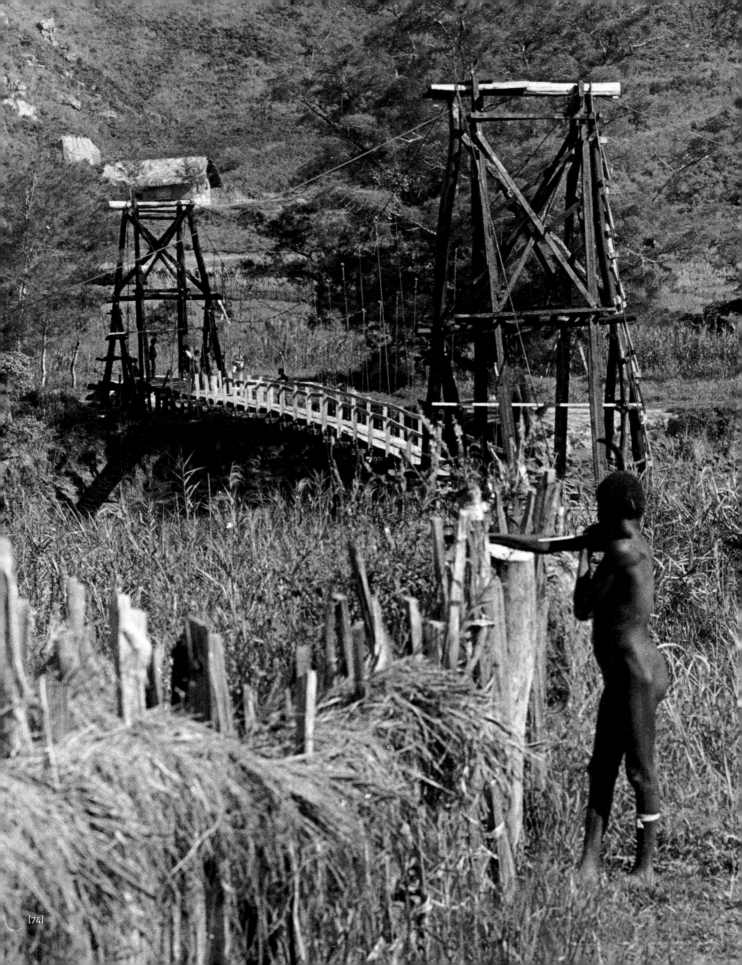

The Franciscan Project (1958–62)

The Dutch Franciscans' base was near the government post, and both the colonial government and the Franciscans made stopping the Dani wars their first priority. Nico Verheyen, one of the early Catholic missionaries in the valley, described himself as an "advisor, merchant, and doctor" to the Dani. Whereas the Protestant CAMA missionaries sought to produce mass conversions, the Catholic Franciscans focused more effort on general development projects and tolerated more integration of traditional Dani practices and Christianity than did their CAMA counterparts.

We needed a bridge over the Baliem river. For the last years, especially during rainy season, I had seen mothers crossing the river on rafts, with their babies in nets, so that they could work in the gardens on the other side of the river. I had seen them lose their own lives trying to save their babies. For the school children, the river was also a danger. I asked the engineers of the Dutch Army in Holland to advise me about how to design and build a suspension bridge over the 80-meter-wide river. This bridge became an attraction for the travelers coming from the other side, and going to the salt wells of Jiwika.

It has been suggested that war is the heart of the culture of the Baliem Valley, and if war were eliminated, their culture would collapse. Rather, it appears to us that war is a bitter necessity for the survival of residents in the Baliem. If the hunger for land could be stilled in any way, then the foremost reason for warfare would disappear. If the borders between the various clans were defined, if people were able to respect these boundaries, if agricultural methods were improved so that the ground would not have to be left fallow so often, if crop rotation and fertilization were introduced, then the men would not have to waste their energy on warfare, nor expend their efforts on the clearing of the next patch of land. There would be no time left for war, and the rich harvests would assure prosperity.

A way to minimize the dangers of war was to buy their weapons— their spears, their daggers made of the leg bones of the ostrich, their bows and arrows—and all the paraphernalia they used in the war to accentuate their manhood: their fur headdresses made into a kind of busby; their cymbium shells, the most important jewelry for warriors and their leaders; their breast plates made of rattan strips, with small shells attached to them; and the long, one-inch-wide knitted ribbons with cowry shells. Also the people become exporters of "textiles": new, freshly grown penis gourds—the longer they were, the higher the price....For two sets of bows and arrows or for two spears, the people received one spade, one ax or one bush knife.

—Nico Verheyen. Unpublished memoir, 1999.

For a long time they will go to war in this valley, but afterwards, they will be longing for peace in order that new marriages can be arranged, goods can be interchanged, and family relations renewed.

Verheyen's parish in Holland gave him a motorbike—the first one in the Baliem.

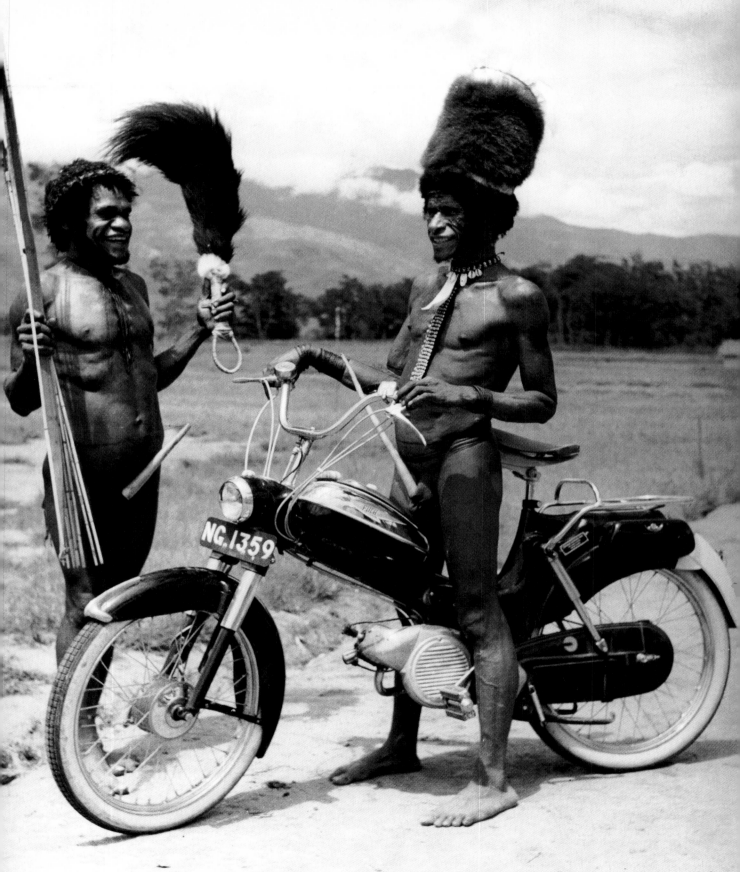

Gradually, a business plan evolved, one that would promote peace in the valley by creating more and various needs with an affinity to their own way of working and to their field of work: agriculture and husbandry. I started willy-nilly, as I was not interested at all in digging in the clay or watering plants, or feeding chickens. A few months before, I had written a letter to my parents about the climate in the valley, the texture of the soil, and the farmer-mentality of the people. Soon, I received a thin airmail envelope—my father had smuggled some small grams of cabbage seeds into the valley. Knowing my father, I was sure that after three months, he would ask me how the cabbages were doing and so I forced myself to dig into the clay behind my house in Musatfak, to make a seed bed and plant the seedlings.

The cabbages did surprisingly well, until small, orange beetles began eating the most tender parts of my cabbages. Not a couple of beetles, but a legion. The [Dani] boys, concerned with the situation, informed me, and now I could prove to them how clever we are in the West.

I took my mosquito sprayer, filled it with some kerosene and DDT powder and called all the boys around me to show them the chemical wonders of the West. At the first puff, the beetles were lifted up for a moment, but then grazed undisturbed onwards into the heads of my cabbages. Wamhelouk, however, took me aside and whispered that they handled this in a different way. He took beetles from here and there in the garden, and squeezed them with his thumb into the soil, went another meter further on and did the same and went on and on. I was so fed up with all their superstitions, I went home. After an hour or so, I went back to my garden again. Lo and behold, all the orange beetles in Wamhelouk's part were gone, while in the first half of my cabbage bed, the meal went on. I called Wamhelouk again and asked him how it was possible that what I couldn't do with my sprayer, he could do with his fingertips. He asked me: When there is a decomposing corpse in your room, do you stay, or do you go?…

Several Franciscans had been sent to the USA to be trained as Cessna pilots. The Cessnas [in the valley] needed cargo back to the coast, and at the same time, we provided the international community with the necessary vitamins not only from cabbages, but afterwards also from other vegetables such as tomatoes, beans, carrots and potatoes.…The effect of this trade was that a considerable part of the [Dani] population became green grocers, and their free time had been nicely filled with work they were used to.

—Nico Verheyen. Unpublished memoir, 1999.

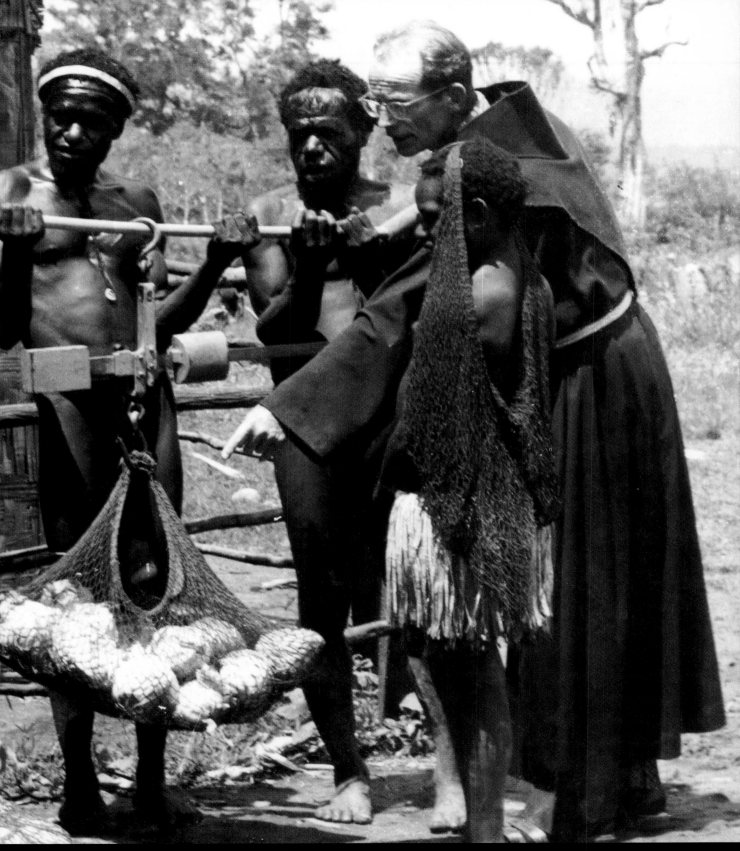

Dutch Administration (1957–62)

One afternoon I had dinner with the Fathers, enormously enjoyable, they didn't talk about religion at all. I asked them, "Just what are you doing here, are you proclaiming the Gospel of our Lord?" "Well, no," they replied. "Are you mad? What we are doing is pacification, these people are head-hunters!" They actually were helping these Papuans with cultivating the land and educating them, teaching them what was and wasn't allowed, such as "Thou shalt not kill" and "Thou shalt not steal" and so forth. There was also a stockade; they had erected a high fence and if the Dani did something which they shouldn't they were imprisoned there by the Fathers. You would have thought that they couldn't get out, but these guys just dug a hole in the ground and wiggled out through it. What amazed me is that these Fathers, so far as I knew, had nothing to do with the administration.

—J.W.A. van der Scheer, Dutch civil servant.
Interview with Rachel Corner, 2001.

The Wamena base of the Dutch colonial government, which was quite isolated from the main station in Hollandia, consisted of only a few prefabricated houses, a clinic, and an airstrip. Administrators from Wamena set up still smaller outposts to extend Dutch control of the valley and end Dani warfare, while also bringing medical care, mail service, and air service to the Baliem Valley. Meanwhile, Indonesia continued to maintain that Netherlands New Guinea was rightfully part of their newly independent republic.

With no prison structure in place, the colonial police detained Dani accused of stealing pigs or other offenses by chaining them together. The prisoners would then be forced to labor under the watch of the police, maintaining the airstrip, unloading planes, or digging ditches.

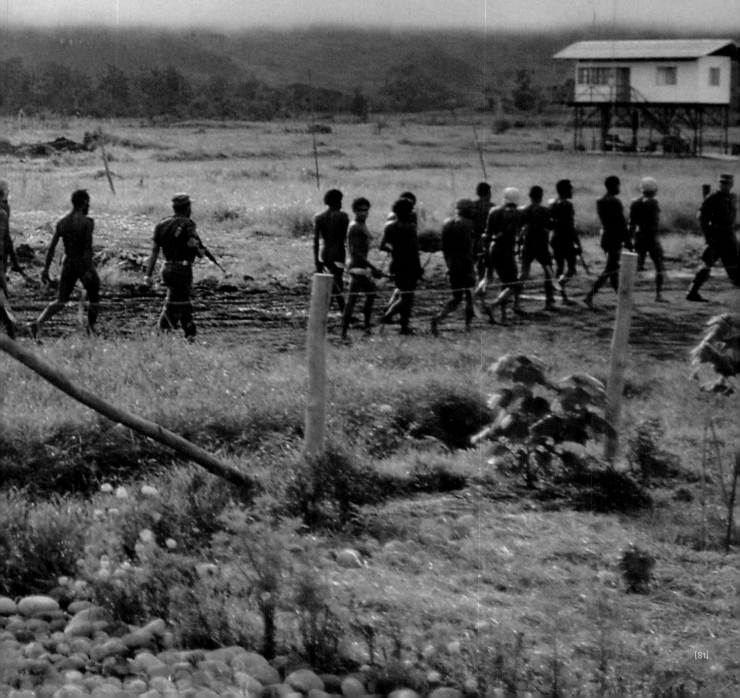

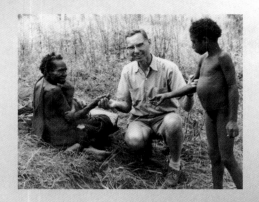

It was in the Baliem that I first came into contact with the Dani. They were terribly pleasant; the thing that has stuck with me the most is that they were absolutely not hostile, and men who could laugh like that were not shy. I wasn't afraid either—I just reached out to shake hands with the first one who came walking up to me. Of course, we couldn't talk with each other, so I didn't understand it was supposed to be with hands and feet.

—J.W.A. van der Scheer. Interview with Rachel Corner, 2001.

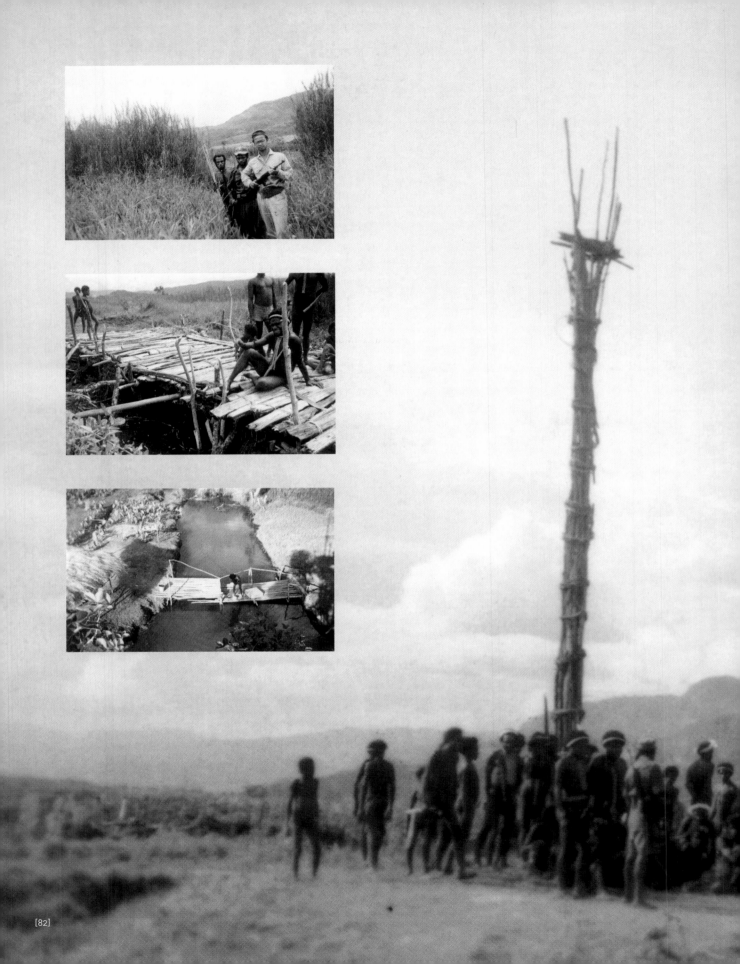

Dani men stood on top of watchtowers, built along the borders of a group's gardens, to watch for enemy raids. The Dutch dismantled them as part of the pacification process.

We had no communication, no radios. We dropped messages into the little posts from a Cessna. There were no roads, cars—everything else was done by foot.

We built hundreds of small bridges. After one rainfall they'd be gone. They used to put a tree over the swamp which was very slippery for us. The principle of these bridges was, of course, imported.

This is how we patrolled: sometimes we stayed in their round houses, but most often we put up our tents next to the village near the watch towers. If it was after some killings, we'd stay longer and investigate or possibly try to intervene. If it was peaceful, we'd pass routinely every few days, with a male nurse and agricultural services.

We were filling a vacuum of "neutral" authority that they assigned to us versus "an eye for an eye." This did not exist in their society before. We felt that it was a bit useful.

—Carel Schneider, Dutch *controleur* of the Baliem Valley between 1960 and 1962. Interview with Susan Meiselas, 2001.

Pacification represented a big part of our job as district officers in the Baliem. We were always inviting them to hold ceremonies, then waiting and waiting, until all of the parties got the courage to come. It would be held in a no-man's-land, between the tribes, of course we said that we would protect them.

There were different opinions on how to handle the situation. What does warfare mean? How do you stop it—with an iron fist?

To establish peace with the tribes you had to convince them that many other good things would develop. I was always for negotiations—to try and convince them not as "big bosses," but as arbitrators. We had to be patient. One ceremony making peace with two tribes would be broken within two weeks.

They were clever and cunning. It was hard to convince them that our way was better than theirs. No one went hungry. We couldn't teach them anything—only we had better seeds, perhaps.

It took days and days, then suddenly one party would disappear and you started all over again. They would say "you stole twenty pigs" and the other said "you stole two wives." You had to settle those disputes before you could do something about their future together.

—Carel Schneider, Interview with Susan Meiselas, 2001.

One question that constantly confronted all of the administrators working in the valley, and the missionaries, Catholic and Protestant alike, was how to fill the vacuum in the lives of the Baliem Valley people in a meaningful way, the void that was created as a result of pacification, when carrying on warfare disappeared from their traditional pattern of living. For that matter, were the tribal wars really so terrible that they had to be stamped out? Was "war" indeed an essential and deeply rooted component of Dani culture? Weren't formal battles that took place at pre-agreed times a bit carnivalesque? That was perhaps the case with these colorful encounters with bows and arrows and spears, which, on close examination, involved few deaths—but what of the constant raids on villages and attacks on defenseless people?

—Carel Schneider. "Controleur Baliem (March 1960–February 1962): Some Impressions," 1996.

The New Guinea Council was a semi-democratic body organized by the Dutch to serve as a transition from colonial administration to independence. The governor appointed Rev. Freerk Christiaansz Kamma, a Dutch Protestant missionary and ethnologist, to represent the eastern highlands peoples, including the Dani, who were considered too uneducated to choose their own representative. Kamma made his first visit to the valley in 1961, when he went to meet his "constituents."

and unavoidably, the Dani were going to be exposed to a massive cultural shock.

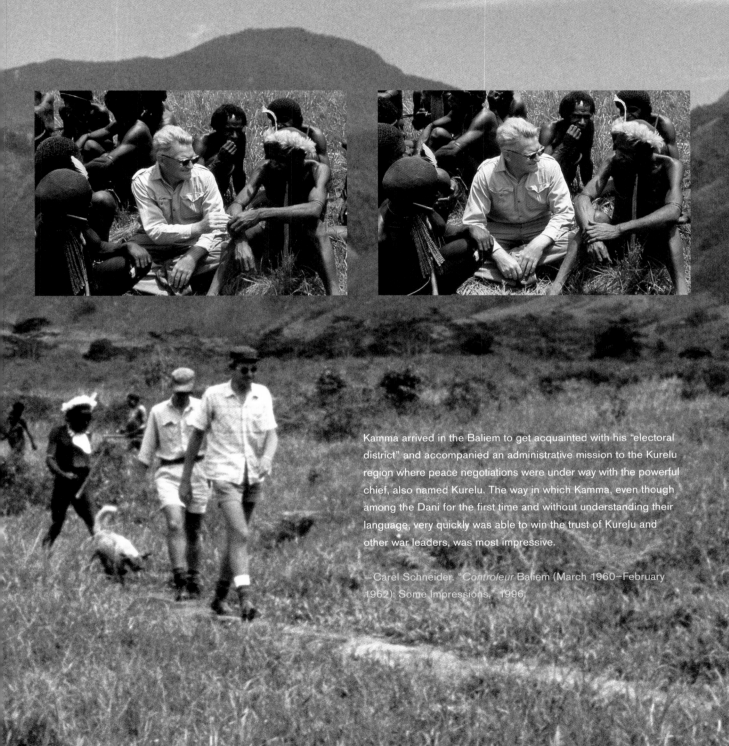

Kamma arrived in the Baliem to get acquainted with his "electoral district" and accompanied an administrative mission to the Kurelu region where peace negotiations were under way with the powerful chief, also named Kurelu. The way in which Kamma, even though among the Dani for the first time and without understanding their language, very quickly was able to win the trust of Kurelu and other war leaders, was most impressive.

—Carel Schneider. "*Controleur* Baliem (March 1960–February 1962): Some Impressions," 1996.

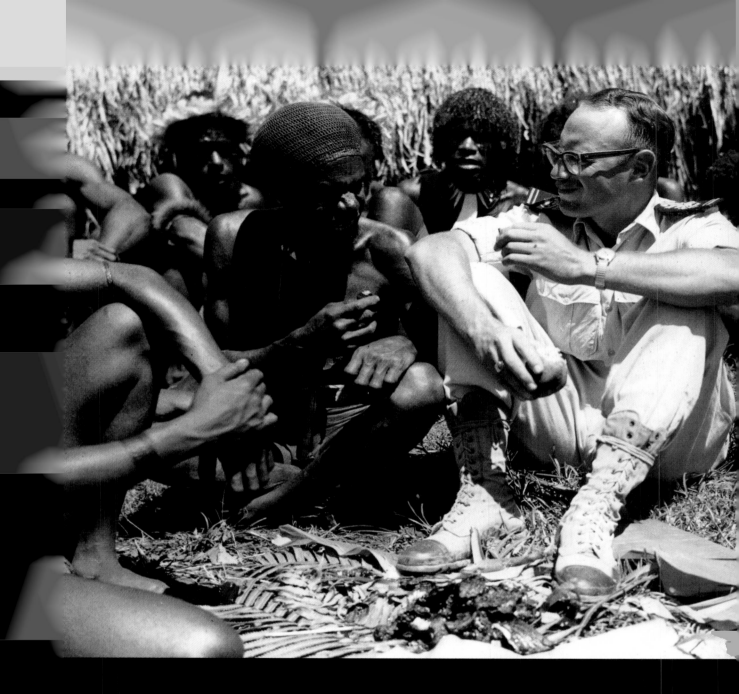

The Americans were questioning whether the Dutch were in any state to govern New Guinea and enable its development, while for our presence there the support of the United States was absolutely necessary. But is it possible to explain today why at that time I accepted that assignment, despite such a lack of manpower and resources? Did I realize sufficiently at the time what risks I was taking personally as well?

Gonsalves acquired two new nicknames in the Baliem Valley: "Gun-salvos" and "God Himself."

If I have been correctly informed by the missionary R. at Tulem, then the Dani are deathly afraid of you and they are intent on all sorts of ways of driving the administrators from the Valley. Violence sparks off violence. Fear is a bad master. You will certainly have to summon up more patience in the way you deal with these very primitive Dani, who of course simply do not understand why you want or don't want something. Crushing resistance is the easiest way, but definitely does not produce the desired result in the long run.

—Eibrink Jansen, Dutch commissioner of Hollandia between 1959 and 1961. Memorandum to R.A. Gonsalves, 1960.

Of course, one could ask if it was responsible for a handful of people with inadequate communications to try to pacify an extensive territory, where thousands of people were dying as a consequence of murder and homicide, in a short period of time. Yet that was my assignment. I was to bring peace to the situation as quickly as possible. For political reasons too, results were needed. Because of the presence of American missionaries in the Baliem, we had the United States looking over our shoulders.

—R.A. Gonsalves, Dutch *controleur* of the Baliem Valley between 1958 and 1960. *Mr. Gonsalves Memoires*, 1999.

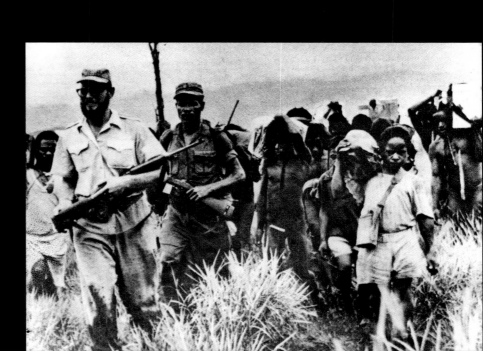

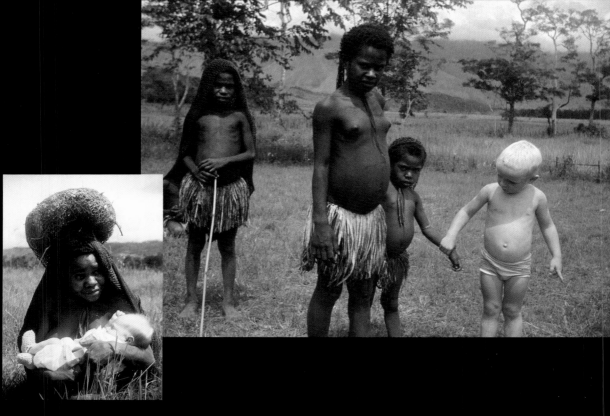

For the Dutch it was time to station the first governmental doctor officially. And I wanted that to me. My wife, our kids, and I left Genjem, where we were previously stationed and we flew to the Baliem Valley. When we got out of the plane, we were welcomed by a large group of Dani, who all wanted to touch us. They had seen quite a few white men, but white women were rare, and such blond young children as ours were even more worth seeing.

For the Dani it was quite uncommon to see a mother with three children under the age of four. In Dani tradition women have a child only once in about three years. The children have to be able to walk and take care of themselves before a mother can handle a new toddler. Because the children are breastfed that long, and stay around the mother until they are in some way self-supporting, it would be too exhausting for the women to have more than one at a time. So we were quite a curiosity with our three toddlers.

Maybe the most important role, apart from attending to tribal war wounds, caused by spears and arrows, was to get the Dani used to medical treatment. The best way to do this was to cure

the population of one of the most hideous diseases in New Guinea, which was also widespread among the Dani: yaws. A patient suffering from yaws gets ulcers on arms, legs, body, or face. These ulcers finally lead to terrible disfigurements.

For the Dutch it was an enormous advantage that yaws was so easily curable with one shot of penicillin. Once you had cured villagers of this awful disease (and everybody had of course witnessed it) the next time you were welcome again. It even became part of the Dutch strategy to introduce themselves in remote areas: first the doctor with the hypodermic needle, and afterwards (ten minutes, a day, a week later) the district officer enters the region together with some Papuan policemen to establish law and order. I myself was not fond of this practice. I did not want to carry a weapon, and I never did. I also did not like to enter a village in the company of armed policemen.

—Jan Luitzen Beiboer, Dutch doctor.
Interview with Annegriet Wietsma, 2003.

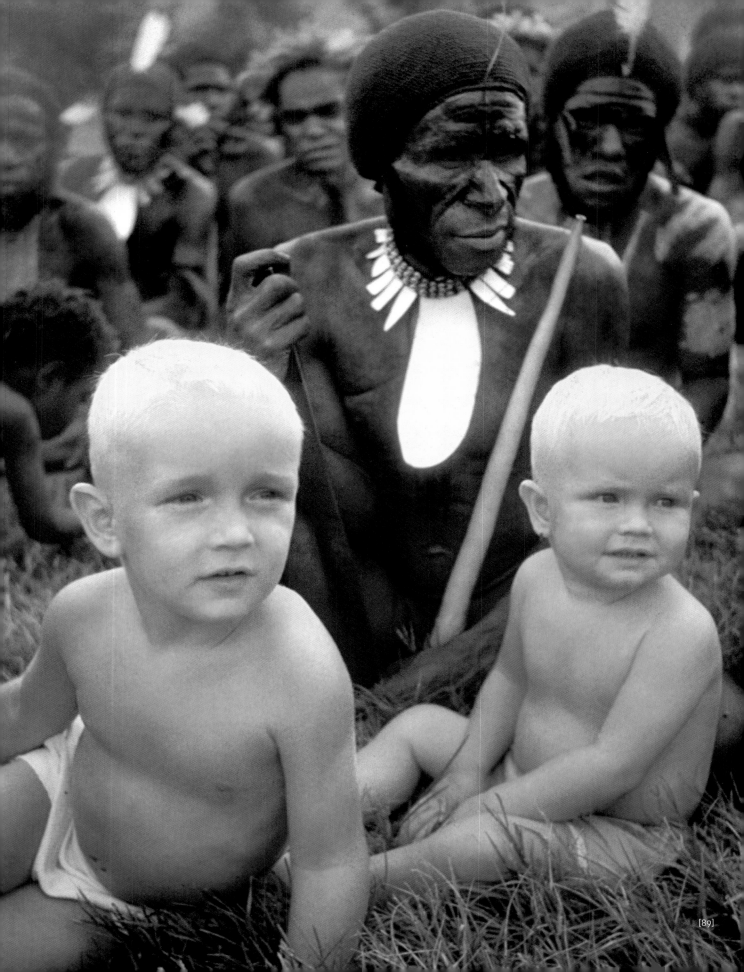

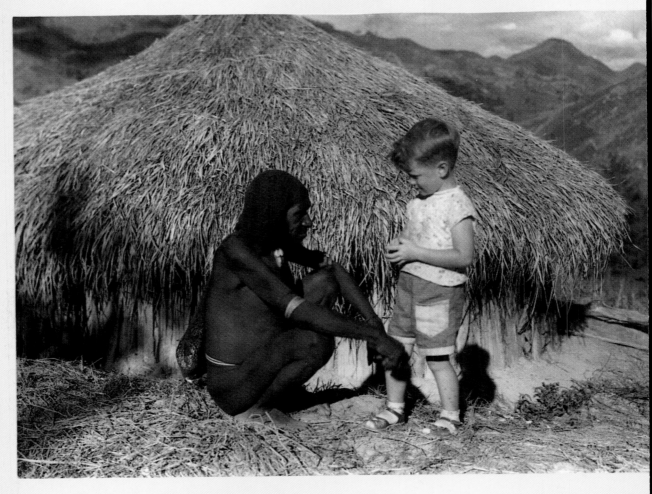

legs tucked in!

SO ODOR-FREE

A BLOODHOUND

COULDN'T FIND HE

where *Friendship* counts

The album was a farewell present from my husband's staff—
some Indonesians and half-castes [also known as "Indos" or
"Eurasians"], only a few Papuans. They found real photos and
put jokes about them. He was terribly proud of it.

—Mary Schregardus Simmers,
wife of Dutch civil servant
Machiel Schregardus. Interview
with Susan Meiselas, 2001.

I was five years old when my parents and my sister Karen and I landed on the little airstrip at Tulem. The Baliem Valley was a long way from Binghamton, New York. As we got out of the Cessna, we were surrounded by hundreds of running, screaming Dani: hundreds of men in yellow gourds, brandishing spears, bows and arrows, and chanting women clustered in little groups. It was an *etai*, a victory celebration, but to us it looked like an attack! I was terrified. Karen and I were in tears.

For weeks, everywhere we went, my sister and I were poked and pinched, admired and stalked. We were some of the first white children the Tulem Dani had seen.

About a year later, we moved to to Pugima, a new mission station about five miles down the river. White children were a rarity here, too. A great crowd met us at the river, walked with us, and then swelled in size as we made our triumphal entrance on the unfinished airstrip toward our new house.

"What is your name?" asked too many people. And finally in a bid for solitude, for being allowed to live my own life, for peace, I said my name was Kurelu.

In Tulem, Kurelu had been a name inspiring fear and tales of cannibalism. In Gardner's film *Dead Birds*, the enemies of Kurelu were the people from Tulem. If I had taken his name in Tulem, I might indeed have been given a wide berth. Now I told a Pugima crowd "my name is Kurelu," and they cheered.

Unknown to me, Kurelu was a hero of the Pugima people, his villages were allied with those near Pugima, and in taking his name I had ironically invited years of attention, of adulation.

In 1963, I met the man whose name I had stolen. My dad and Ed Maxey, and Maxey's son Buzz and I had walked to Kurelu's village, slept overnight in a tent in his woods at Homuak. All the next morning, while Buzz and I played in the cold stream in the woods, pretending we were intrepid explorers, Ed and Dad were in Kurelu's village, negotiating with him. Would he let them come regularly to tell his people about Jesus? They offered to establish a CAMA mission post there. Kurelu had let the film expedition stay in his villages and photograph his people. There in the mens' house of his village, Kurelu weighed the words of the missionaries. His power was being challenged. These outsiders wanted to live among his people, to teach in his villages, to make medical help available.

About noon, grim-faced, Ed and Dad came back to the campsite with Kurelu. Dad said quietly, "We have to go. Now."

Kurelu had said no. His word was final. The "big man" of that area had spoken.

As we began packing up, Kurelu let my dad take a picture of me meeting my namesake. I remember that he was gently bemused when Dad told him that my name was Kurelu, too. Dad didn't tell him the whole story, but enough of it to get a grin. Maybe the whole story was a little too shameful, of a small boy trading in on an aging warrior's ferocious reputation to gain fear and respect and distance.

—Larry Lake, American sociolinguist.
Unpublished memoir, 2003.

I went to the village Waiepma [near our mission station of Pugima] to treat a fellow who had an infected battle wound on his knee. You can see quite an impressive array of tools in my canvas bag and on the ground. I used the atomizer (amber glass, with a black rubber bulb) to spray sulfa powder on the wound, bound it in Johnson and Johnson gauze and gave him a 5-cc shot of oil-base penicillin. Yes, he recovered, to fight another day.

—Hi Lake, retired American missionary. Email to Susan Meiselas, 2003.

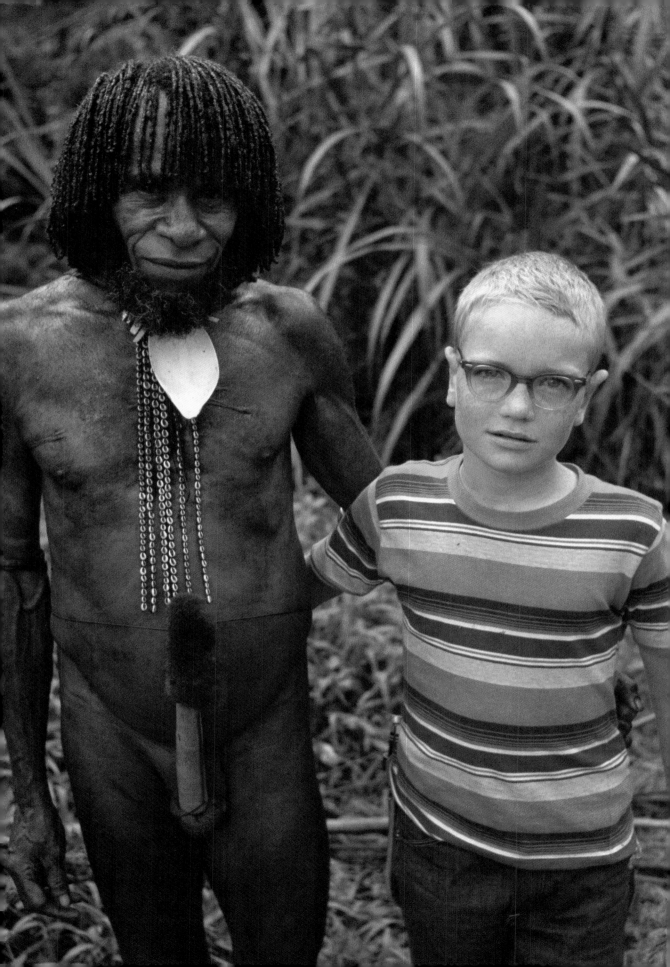

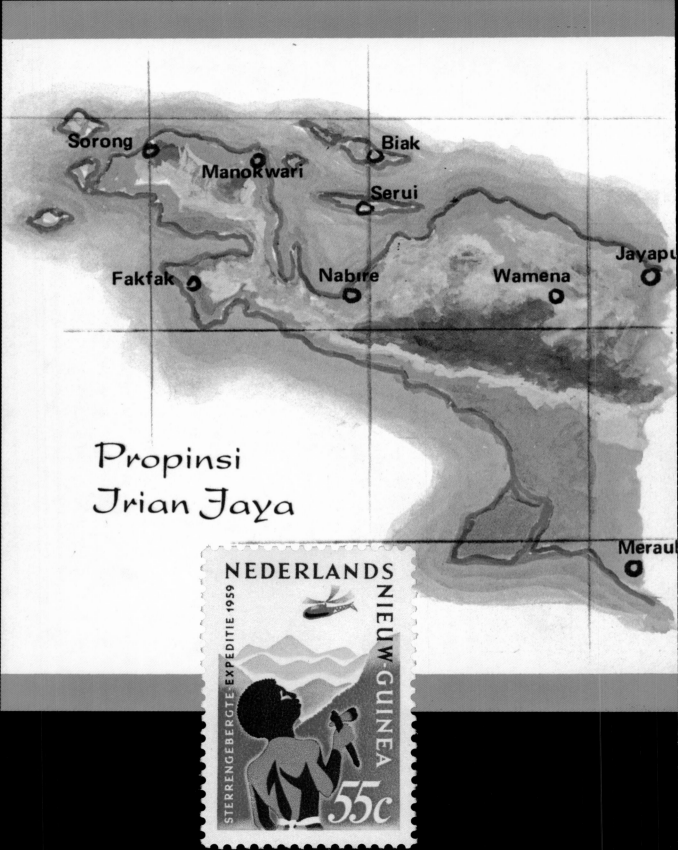

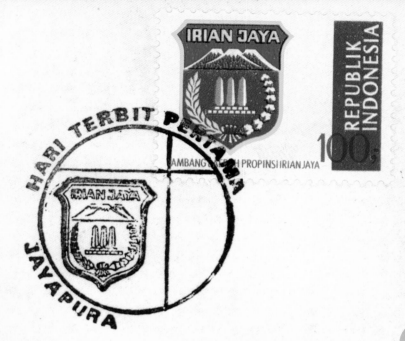

HARI TERBIT PERTAMA
IRIAN JAYA
JAYAPURA

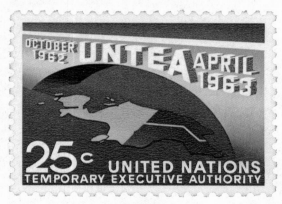

i Lambang Propinsi

SHP 1

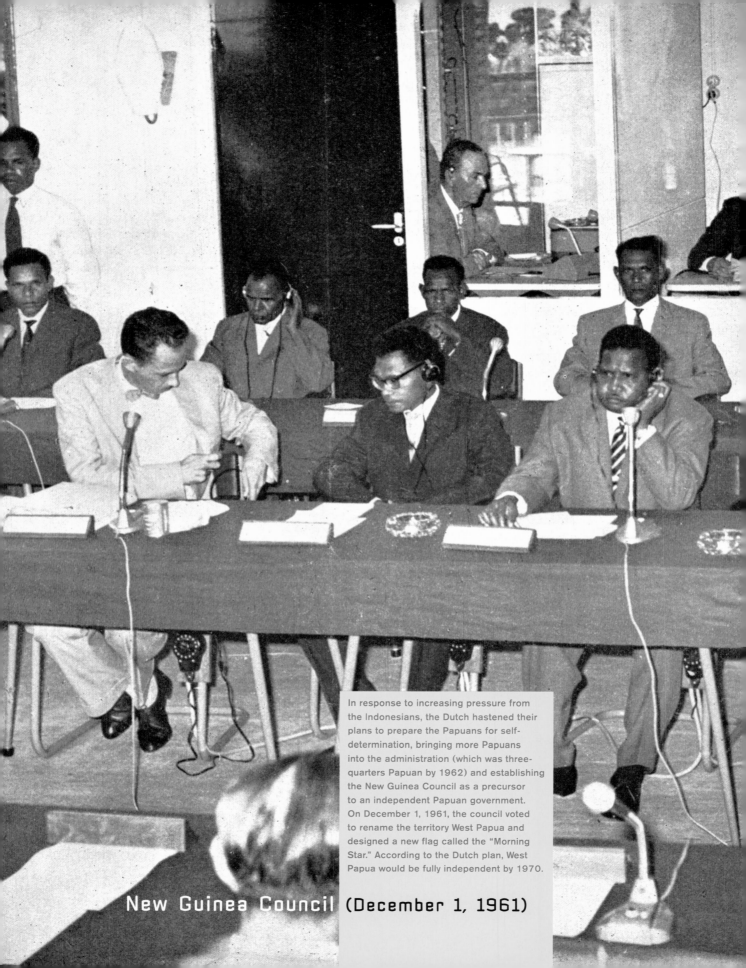

In response to increasing pressure from the Indonesians, the Dutch hastened their plans to prepare the Papuans for self-determination, bringing more Papuans into the administration (which was three-quarters Papuan by 1962) and establishing the New Guinea Council as a precursor to an independent Papuan government. On December 1, 1961, the council voted to rename the territory West Papua and designed a new flag called the "Morning Star." According to the Dutch plan, West Papua would be fully independent by 1970.

New Guinea Council (December 1, 1961)

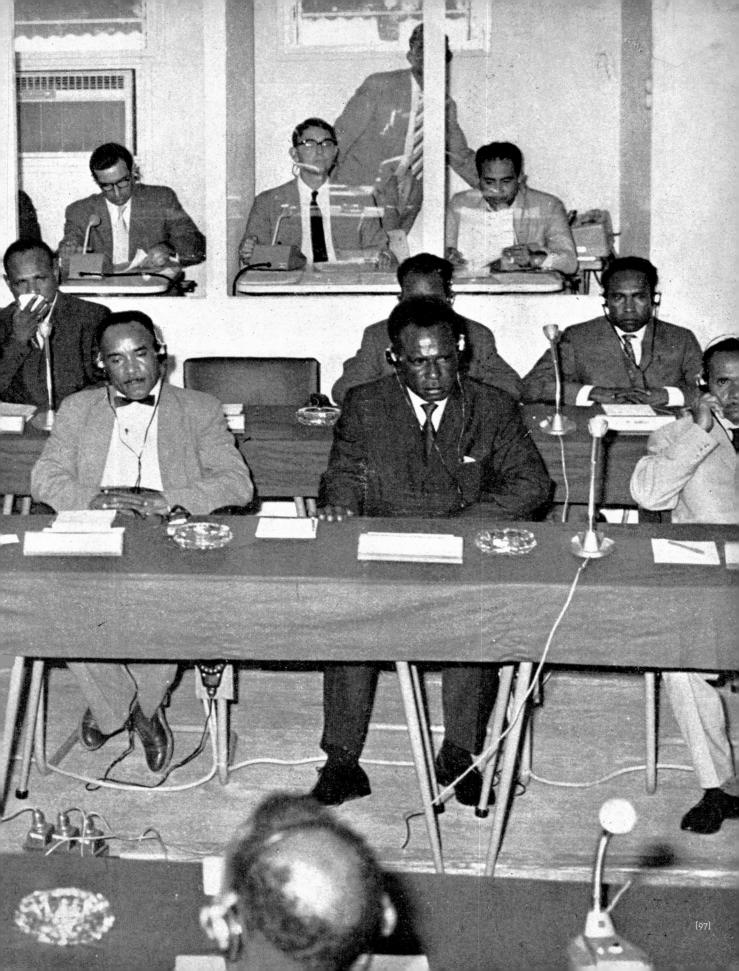

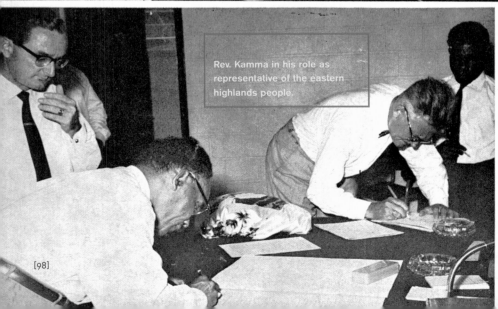

Rev. Kamma in his role as representative of the eastern highlands people.

Gambar jg diatas kiri

Sesudah Nieuw-Guinea Raad menjusun sebuah Petisi sesuai dengan Manifest Komite National, Surat permintaan itu ditulis dengan huruf-huruf bagus dan ditanda tangani oleh semua anggota NGR. Disini tuan Arian sedang tulis tanda tangannja dan pater van Berg. Sebelah kiri ketua NGR, tuan Sollewijn Gelpke dan kanan Griffier, mr. Trouw.

Gambar tengah

Njonja Tokoro memandatangani Petisi dan berikutnja tuan Torey jang tampak sebelah kiri. Jang sedang

There are many versions of the flag's history. But most importantly I think the flag is symbolic. There is an element of red meaning there is courage; the white is a sign of hope. The star is a light, which is the intervention of God. That is faith in his blessing. And it is a flag that has seven blue stripes, because the Dutch originally divided Papua into seven ethnic groups, so that it should be seven federal states. That is what we know. Whether that matches the earlier interpretation, when they made the flag, we do not have any official documents that can explain that.

—Agus Alua, Dani leader. Interview with Brigham Montrose Golden, 2003.

Our message came down to the idea that the two flags next to each other symbolized that henceforth not only the Netherlands, but also the people of New Guinea themselves were to work to create the future of the territory.

—Carel Schneider. "*Controleur* Baliem (March 1960–February 1962): Some Impressions," 1996.

bitjara dengan tuan Trouw adalah tuan Gosewisch dari Manokwari.

Gambar jg dibawah kiri

Begitu tuan-tuan Kaisiepo dan ds Kamma tjatat namanja masing-masing.

Gambar diatas

Pada pertama kali bendera negeri dipertundjukan umum dengan membukanja dihadapan sidang umum Nieuw-Guinea Raad. Jang memegangnja ada anggota-

anggota komisi jang menjerahkan bendera kepada tuan gouverneur nanti.

Gambar ▶

Tuan Kaisiepo membatjakan Petisi NGR dihadapan tuan gouverneur. Para anggota komisi berdiri dibelakangnja dengan anggota tuan Gebse memegang bendera negeri Papua Barat. Disebelah kanan belakan tampak para anggota NGR jang menjaksikan upatjara ini.

Sjukur bagimu Tuhan:
Kaubrikan tanahku,
b'ri aku radjin djuga
sampaikan maksudMu.

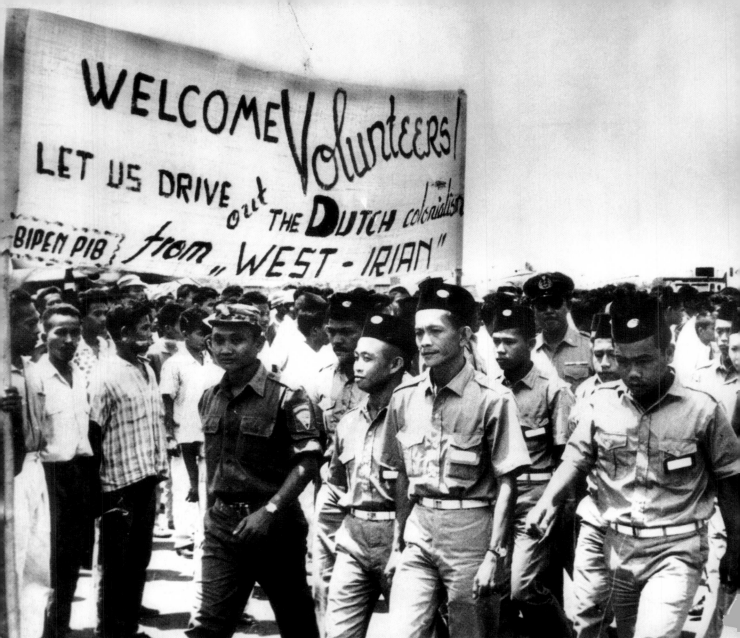

ALL FOR A CAUSE (1)
JAKARTA, INDONESIA: INDONESIAN STUDENTS AT
JAKARTA'S KEMAJORAN AIRPORT CARRY BANNERS
WELCOMING 35 VOLUNTEERS FROM SINGAPORE UPON
THEIR ARRIVAL. CLAD IN GREY UNIFORMS AND
WEARING INDONESIAN PITJIS (BLACK CAPS), THE
NEWCOMERS WORE BADGES READING: "WE ARE READY."
THE GROUP, RESPONDING TO INDONESIA'S CALL
FOR VOLUNTEERS IN ITS DISPUTE WITH THE
NETHERLANDS OVER NETHERLANDS NEW GUINEA,
CONTAINED SEVERAL CHINESE VOLUNTEERS, INCLUDING
ONE GIRL, BUT MOST OF THEM WERE OF INDONESIAN
DESCENT. "WEST IRIAN" IS THE INDONESIAN
NAME FOR DUTCH NEW GUINEA, WHICH THEY CLAIM
IS INDONESIAN TERRITORY.
NX-1-2-3-4 EUR-1- LAT-1 AUS-1
CREDIT (UPI PHOTO) 4-30-62 (JB)
(SEE TKP 1328905) 911

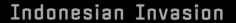

Indonesian President Sukarno viewed the New Guinea Council as a Dutch attempt to set up a puppet government. He responded by issuing the "People's Triple Command for the Liberation of West Irian" (the Indonesian name for West Papua), mobilizing the Indonesian army to invade Dutch territory under General Suharto's command. While Indonesian troops parachuted into West Papua, U.S. President Kennedy and U.N. Secretary-General U Thant pressured the Netherlands and Indonesia to negotiate behind the scenes.

Sukarno Sets Mobilization For Attack on New Guinea

Special to The New York Times.

JAKARTA, Indonesia, Tuesday, Dec. 19—President Sukarno ordered total mobilization of the Indonesian people today to take over Netherlands New Guinea. The President said: "I order the Indonesian people to wreck Dutch efforts to set up a Papuan puppet state."

He told his people to "fly the red and white [Indonesian] flag over the West Irian territory." The Indonesians call the Netherlands-ruled region West Irian.

[President Sukarno was reported to have informed President Kennedy that Indonesia will be compelled to use force to settle her dispute with the Netherlands over Netherlands New Guinea unless what he called Dutch provocation was halted immediately.]

President Sukarno announced that he had ordered his 500,000-man armed forces to be prepared to invade Netherlands New Guinea at any moment.

The Indonesian leader spoke in Jogjakarta, south central Java, at a mass rally commemorating the thirteenth anniversary of the Dutch capture of this city, which was the revolutionary capital of Indonesia.

The crowd at the rally was estimated at a total of 1,000,000 people. The speech was broadcast on a nation-wide hook-up.

We listened to the news that many guests brought with them about the rising political tensions surrounding Dutch New Guinea with a certain indifference. What happened in The Hague, Jakarta, or New York was all very far away. Of course we in the Baliem were very conscious that we were working on borrowed time, so to speak, but repairs to Wamena's electrical system, the most recent reports of a murder in the Kimbin region, the first peace negotiations with a tribal chief who until now had been unapproachable, the radio calls for aid from a missionary who had gotten himself in trouble—all these were more important than President Sukarno's speeches about the approaching liberation of "Irian Barat."

Yet we were all unconsciously caught up in an indefinable haste in our work. Whatever happened, the "National Highway" must be finished, the first coffee from the trial fields had to be harvested, the most mistrusting tribal chief brought around to cooperation. Foreign visitors were surprised by the determined enthusiasm with which we laid out our plans for the near, but also the more distant future. If someone dared to express doubts about whether we would be granted time to carry out our plans, we simply shrugged our shoulders.

—Carel Schneider. "*Controleur* Baliem (March 1960–February 1962): Some Impressions," 1996.

IT'S SQUAD DRILL TIME FOR THESE
SPEAR-CARRYING MEMBERS OF A SECRET PRO-
INDONESIAN GUERRILLA BAND IN THE INTERIOR.
MANY OF THE PRO-INDONESIAN RESIDENTS FLED
HOLLANDIA SHORTLY BEFORE THE U.N. TAKE-OVER
BECAUSE THEY FEARED REPRISALS BY PAPUAN
SEPARATISTS AND PRO-DUTCH ELEMENTS OF THE
POPULATION. SOME OF THE VILLAGES OF WEST
NEW GUINEA ARE OPENLY PRO-INDONESIAN AND HAVE
SHELTERED PARATROOPERS DROPPED INTO THE
JUNGLE REGIONS OUTSIDE OF HOLLANDIA. THEY
ARE ORGANIZED FOR SELF-DEFENSE WITH CRUDE
WEAPONS.

CREDIT LINE (UPI PHOTO) 10-20-62 (JB)
UNITED PRESS INTERNATIONAL ROTO SERVICE

OCT 1962

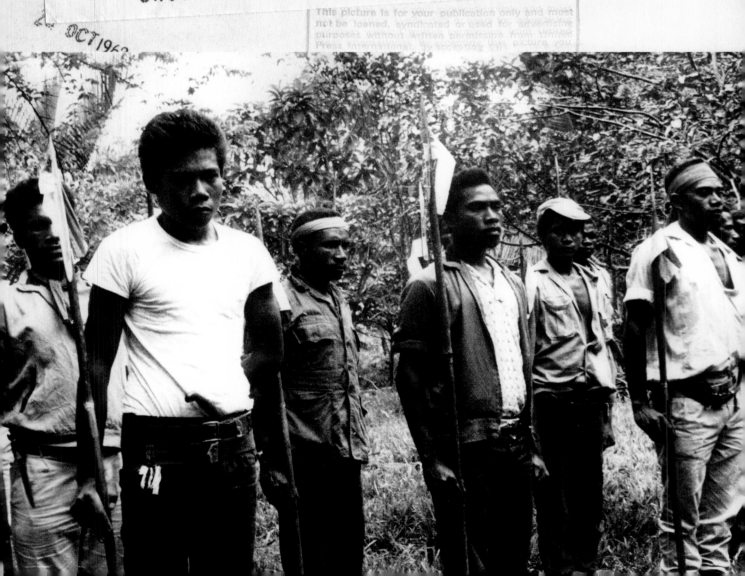

TKP1334990 UNIPIX

FAMILIAR TERRITORY
HOLLANDIA, NEW GUINEA: Capt. Djalaludin,
COMMANDER OF AN INDONESIAN C-47 AIR TRANSPORT
WHICH WAS SHOT DOWN BY A DUTCH NEPTUNE
BOMBER DURING AN INDONESIAN PARADROP
OPERATION, POINTS TO A MAP OF WEST GUINEA
WHILE IN A HOLLANDIA PRISONER OF WAR
COMPOUND.
CREDIT (UPI PHOTO) 6/12/62 BAK
NX-1-2 EUR-1-2-3-4 L -1 ASI-1 PSS BECH

VOOR DE VR|

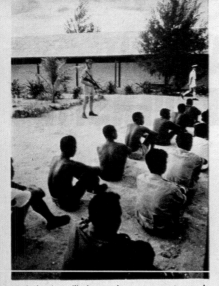

Nederlandse militairen waken nauwgezet over de gevangengenomen ,,illegale grensoverschrijders''.
Dutch soldiers guard Indonesian POWs

vechten en vallen, strijden en sneuvelen Hollandse jongens. En hun ouders zijn bang en bedroefd.
,,Ik heb geluk, als hij levend terugkomt,'' zegt de moec van Leo. ,,Hij is dood, maar ik wil hem zo graag hier hebben,'' zegt de moeder van Klaas. Met hun tranen betalen ze de dure strijd op het grootste eiland ter wer

Dutch boys fight and fall, battle and die. And their parents are afraid and sad. "I'll be lucky if he comes home alive," says the mother of Leo. "He is dead, but I just want to have him here with me," says the mother of Klaas. With their tears they pay for the expensive fight on the largest island in the world.

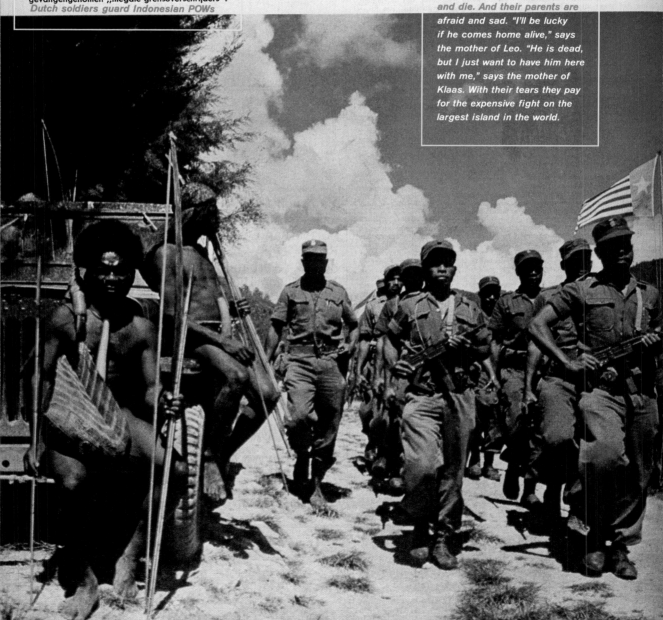

EID VAN VRIENDEN

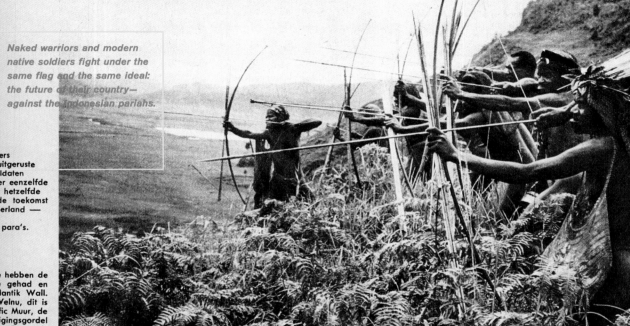

*Naked warriors and modern
native soldiers fight under the
same flag and the same ideal:
the future of their country—
against the Indonesian pariahs.*

Irijgers
rn uitgeruste
e soldaten
onder eenzelfde
voor hetzelfde
— de toekomst
vaderland
e
sche para's.

We hebben de
dlinie gehad en
e Atlantik Wall.
Welnu, dit is
Pacific Muur, de
rdedigingsgordel
der Papoea's
met hun pijlen.

dat vechten op Nieuw-Guinea heeft
niet de minste zin. En als ze toch met
ten de hoge heren uit Den Haag en Djakar-
het dan maar opknappen. Mijn oudste
on Klaas is bij Kaimana gesneuveld. Ik zal
nooit meer terugzien. Het was een
e jongen, net twintig geworden, en nu is
dood. Wat schieten we daarmee op? Waar-
or is hij gestorven? Voor een paar Papoea's?
ken die mensen niet." Dat zegt mevrouw
ber in Amsterdam.

,,Als wij Nieuw-Guinea aan Indonesië ver-
vanselen, durf ik geen Papoea meer recht
de ogen te zien. Als het niet anders kan,
t de wereld dan maar tekenen voor de
erdracht. Laat Amerika zo flink zijn. Breng
zaak voor de Veiligheidsraad. Geef de
N. de kans een heilige belofte te breken.
ar wij mogen de Papoea's niet overleveren
het rijstgebrek en de algemene schaarste
Indonesië. In de geschiedenis van Nieuw-
inea zijn we nu beland bij het punt, waar
t aankomt op beginselvastheid. Het gaat
or de Papoea's of zijn of niet zijn. Het gaat
mensen." Dat zegt dr. Vic de Bruyn in
kranteïnterview.

Twee meningen. Het woord van een be-
oefde, niet-begrijpende moeder en de uit-
raak van de ,,jungle Pimpernel", de voor-
lige bestuursambtenaar, die zijn vrienden
t verraden wil. In deze tegenstellingen
t de tragiek van de strijd bij Sorong, Kai-

mana, Gag en Waigeo. De verdeeldheid
het thuisfront over de noodzaak van
flict maakt de inzet van de mariniers
risten, artilleristen, marine- en lu
mannen bitterder dan welke kogel

Ook in het Nederlandse leger is
een bevel. De generaals, de sche
nacht en de commodores bevelen.
daten kruipen met de kapiteins, de
of de sergant-majoors aan het hoofd op hun
buik door de taaie modder van het
bied of door de hoge, harde varen
rimboe. Zij voeren hun opdracht u
gezind, want een order is heilig.

There was an ongoing debate
in the Netherlands, covered in
mass-circulation magazines like
Panorama, as to whether New
Guinea should remain a Dutch
colony. Some were sympathetic
to Indonesia's anti-colonialist
rhetoric and believed that the
Netherlands should pull out
completely. Others wanted to stay,
for a wide variety of reasons: to
keep a foothold in the Pacific, to
maintain a place for Eurasians to
live, or to protect the "primitive"
Papuans.

"All the fighting in New Guinea doesn't make sense at all. And
if they want to shoot each other, let the high-rolling politicians
from The Hague and Jakarta handle it. My eldest son was
killed at Kaimana. I'll never see him again. He was a fine boy.
Just turned twenty, now he's dead. What good does it do us?
For what did he die? For a few Papuans? I don't know those
people." That's how Mrs. Faber in Amsterdam sees it.

"If we barter away New Guinea to Indonesia, then I won't be
able to look any Papuan straight in the eyes. If it can't be
helped, let the whole world sign for the transfer. Let America
be tough. Bring the matter to the Security Council. Give the
U.N. a chance to break a sacred vow. But we cannot turn the
Papuans over to a shortage of rice and the general poverty
of Indonesia. In the history of New Guinea we've now reached
the point where we're faced with principle. For the Papuans it
means to be or not to be. It's about people." As expressed by
Dr. Vic de Bruijn in a newspaper interview.

...And in these contradictory opinions lies the tragedy of the
battle in Sorong, Kaimana, Gag and Waigeo....

"Give that worthless island to Sukarno," [say some]....
Perhaps their voices are heard on a small portable radio
when a marine prepares for a days-long patrol mission
through treacherous swamp brush where Indonesian
infiltrators have been sighted.

Nr. 28 - 23

INDICATE: ☐ COLLECT
☐ CHARGE TO

~~SECRET~~

EYES ONLY

M

Origin
SS
Info:

ACTION: Amembassy, THE HAGUE PRIORITY 857
RPT INFO: Amembassy, Djakarta NIACT 1102
USUN NEW YORK 2543

001

EYES ONLY AMBASSADORS

REF DEPTEL 856

Following Presidential letter de Quay mentioned reftel for delivery after 5:00 P.M. your time April 2.

VERBATIM TEXT

Dear Mr. Prime Minister: I have been intimately concerned i recent weeks with the problems facing your government in arrang-ing an honorable solution to your dispute with Indonesia over th disposition of Netherlands New Guinea. I was disturbed by the cessation of the secret talks between your representatives and those of Indonesia. However, I am convinced that a peaceful solution is still possible, provided the two parties are pre-pared to resume negotiations in good faith.

The Netherlands government has made a statesmanlike effort to meet this problem first through the United Nations and, when that failed, through direct secret negotiations with the

Drafted by:	Telegraphic transmission and	
EUR/WE R. M. Beaudry	classification approved by:	The Secretary
Clearances:		
FE - Gov. Harriman		White House - Mr. Bundy
EUR - Mr. Tyler		S/S Mr. Grant
IO - Mr. Wallner		

REPRODUCTION FROM T
COPY IS PROHIBITED
UNLESS "UNCLASSIFIED"

~~SECRET~~

EYES ONLY

FORM
DS-322

The New York Agreement (August 15, 1962)

In the midst of the Cold War, the U.S. felt pressure to support Indonesian claims to New Guinea, fearing that to do otherwise might lead to an alliance between Indonesia and the Soviet Union. Rather than lose a crucial Southeast Asian "domino" country to Communism, the U.S. introduced a compromise to the conflict that both sides could grudgingly agree to: after a brief period of U.N. administration, West Papua would be handed over to Indonesia. Papuans would be granted the opportunity at some point before the end of 1969 to exercise their "right of self-determination" and determine whether they wanted to be part of Indonesia or an independent nation.

(continued from telegram on facing page:)

Indonesians. I am appreciative of the heavy responsibilities which the Dutch Government supports in protecting its citizens in New Guinea and understand why you felt it necessary to reinforce your defense establishment in that area. However, we face a danger that increasing concentrations of military forces will result in a clash which will be a prelude to active warfare in the area. Such a conflict would have adverse consequences out of all proportion to the issue at stake.

This would be a war in which neither the Netherlands nor the West could win in any real sense. Whatever the outcome of particular military encounters, the entire free world position in Asia would be seriously damaged. Only the communists would benefit from such a conflict. If the Indonesian army were committed to all-out war against the Netherlands, the moderate elements within the Army and the country would be quickly eliminated, leaving a clear field for communist intervention. If Indonesia were to succumb to communism in these circumstances, the whole non-communist position in Viet-Nam, Thailand, and Malaya would be in grave peril, and as you know these are areas in which we in the United States have heavy commitments and burdens.

The Netherlands position, as we understand it, is that you wish to withdraw from the territory of West New Guinea and that you have no objection to this territory eventually passing to the control of Indonesia. However, the Netherlands government has committed itself to the Papuan leadership to assure those Papuans of the right to determine their future political status. The Indonesians, on the other hand, have informed us that they desire direct transfer of administration to them but they are willing to arrange for the Papuan people to express

their political desires at some future time. Clearly the positions are not so far apart that reasonable men cannot find a solution. Mr. Ellsworth Bunker, who has undertaken the task of moderator in the secret talks between the Netherlands and Indonesia, has prepared a formula which would permit the Netherlands to turn over administrative control of the territory to a U.N. administrator. The U.N., in turn, would relinquish control to the Indonesians within a specified period. These arrangements would include provisions whereby the Papuan people would, within a certain period, be granted the right of self-determination. The U.N. would be involved in the preparations for and the exercise of self-determination.

My government has interested itself greatly in the matter and you can be assured that the United States is prepared to render all appropriate assistance to the United Nations when the Papuan people exercise their right of self-determination. In these circumstances, and in light of our responsibilities to the free world, I strongly urge that the Netherlands government agree to meet on the basis of the formula presented to your representatives by Mr. Bunker.

We are of course pressing the Indonesian government as strongly as we can for its agreement to further negotiations on the basis of this same formula.

I have written to you in the spirit of frankness and trust which hope is appropriate to the relation of our countries as friends and allies. What moves me is my conviction that in our commo interest the present opportunities for peaceful settlement in this painful matter must not be lost.

Sincerely, John F. Kennedy.

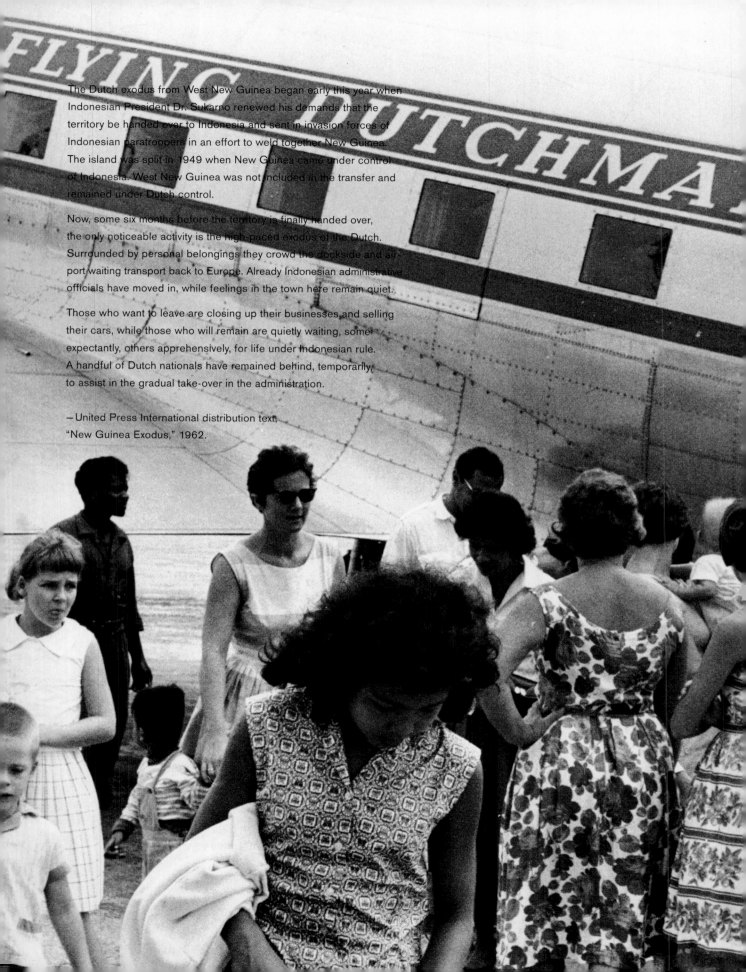

The Dutch exodus from West New Guinea began early this year when Indonesian President Dr. Sukarno renewed his demands that the territory be handed over to Indonesia and sent in invasion forces of Indonesian paratroopers in an effort to weld together New Guinea. The island was split in 1949 when New Guinea came under control of Indonesia. West New Guinea was not included in the transfer and remained under Dutch control.

Now, some six months before the territory is finally handed over, the only noticeable activity is the high-paced exodus of the Dutch. Surrounded by personal belongings they crowd the dockside and airport waiting transport back to Europe. Already Indonesian administrative officials have moved in, while feelings in the town here remain quiet.

Those who want to leave are closing up their businesses and selling their cars, while those who will remain are quietly waiting, some expectantly, others apprehensively, for life under Indonesian rule. A handful of Dutch nationals have remained behind, temporarily, to assist in the gradual take-over in the administration.

—United Press International distribution text, "New Guinea Exodus," 1962.

Dutch Departure (August–October 1962)

Although the New York Agreement was endorsed by a minority of the New Guinea Council, it was signed by the Dutch and Indonesian governments and ratified by the U.N. The United Nations Temporary Executive Authority (UNTEA) moved in and the Dutch moved out by air and sea, in preparation for the handover to Jakarta. Some Papuans who had worked in the colonial administration left with the Dutch and resettled as exiles in the Netherlands.

The event marked the beginning of the final chapter in the long tug-of-war struggle for the possession of the 151,000-square mile territory between Holland and Indonesia.

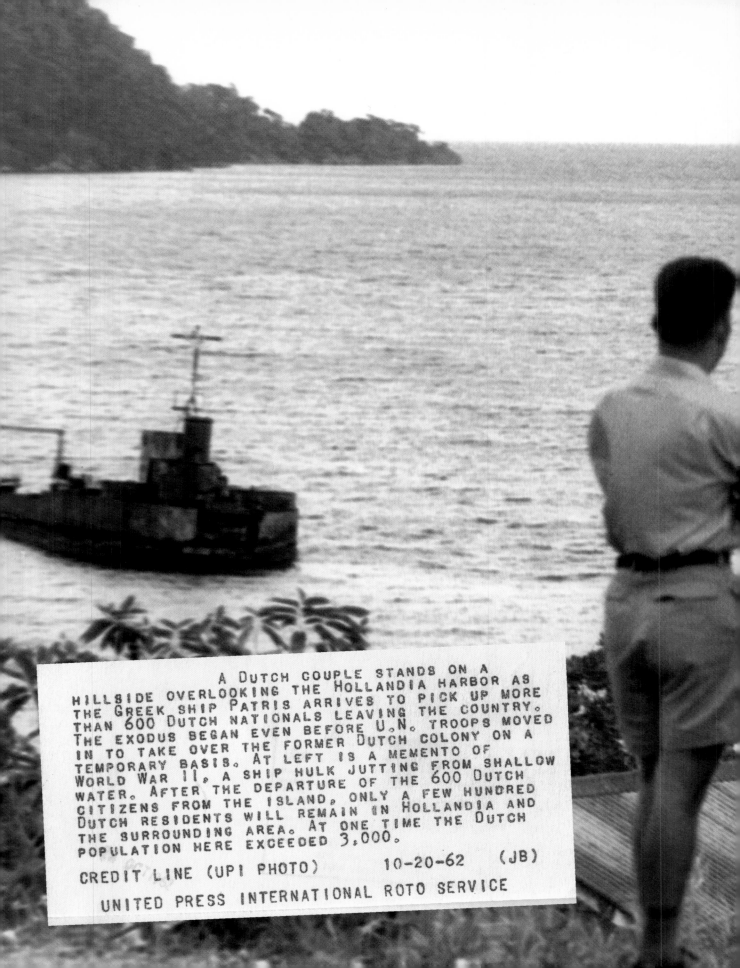

A DUTCH COUPLE STANDS ON A HILLSIDE OVERLOOKING THE HOLLANDIA HARBOR AS THE GREEK SHIP PATRIS ARRIVES TO PICK UP MORE THAN 600 DUTCH NATIONALS LEAVING THE COUNTRY. THE EXODUS BEGAN EVEN BEFORE U.N. TROOPS MOVED IN TO TAKE OVER THE FORMER DUTCH COLONY ON A TEMPORARY BASIS. AT LEFT IS A MEMENTO OF WORLD WAR II, A SHIP HULK JUTTING FROM SHALLOW WATER. AFTER THE DEPARTURE OF THE 600 DUTCH CITIZENS FROM THE ISLAND, ONLY A FEW HUNDRED DUTCH RESIDENTS WILL REMAIN IN HOLLANDIA AND THE SURROUNDING AREA. AT ONE TIME THE DUTCH POPULATION HERE EXCEEDED 3,000.

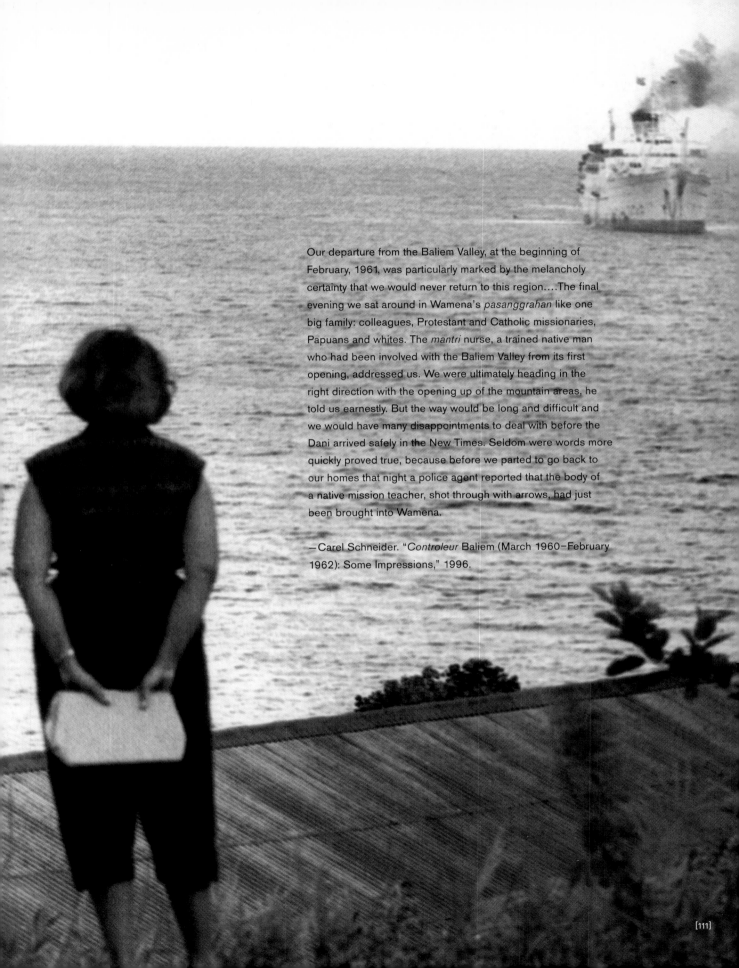

Our departure from the Baliem Valley, at the beginning of
February, 1961, was particularly marked by the melancholy
certainty that we would never return to this region....The final
evening we sat around in Wamena's *pasanggrahan* like one
big family: colleagues, Protestant and Catholic missionaries,
Papuans and whites. The *mantri* nurse, a trained native man
who had been involved with the Baliem Valley from its first
opening, addressed us. We were ultimately heading in the
right direction with the opening up of the mountain areas, he
told us earnestly. But the way would be long and difficult and
we would have many disappointments to deal with before the
Dani arrived safely in the New Times. Seldom were words more
quickly proved true, because before we parted to go back to
our homes that night a police agent reported that the body of
a native mission teacher, shot through with arrows, had just
been brought into Wamena.

—Carel Schneider. "*Controleur* Baliem (March 1960–February
1962): Some Impressions," 1996.

It's not clear what will happen to these people when the Indonesians take New Guinea and the missions have left. It might be as bad if the missions stay because they are making it difficult for the young to acquire their own culture and they are certainly not giving them a promising alternative way of life. There is an evil time ahead for all natives of New Guinea but that story will never be known to anyone but themselves. New Guinea is too unblessed to warrant the world's attention. For a long time it will be just mud, rain, green with plants and red with someone's blood....

The signs of cultural failure are everywhere: the defeated missionaries, the abject Eurasian specialists who have begun to leave already for the U.S. and Holland, the bewildered natives who cannot conceive the cost of progress. Whites are the most pitiable and Papuans the most fortunate. If no-one can find a natural resource worth removing, New Guinea will be itself for a long time.

—Robert Gardner. Unpublished journal, 1961.

August 8, 1962

Mr. MacGeorge Bundy
The White House
Washington, D.C.

Dear Mac:

I returned two nights ago from my third visit to Netherlands New Guinea, where I've spent the last nine of 15 months. If I had not been dining last night with Bobbie Wolff, this letter would probably not have been written.

I write it on his urging and from a conviction within myself that our country has acted with dismally shortsightedness in regard to the continuing Dutch-Indonesian contest.

The U.S. should support the Dutch because the Dutch, from everything I have beheld in all parts of West New Guinea, are discharging a promise to the Papuans to prepare them for self determination.

The Indonesians, it should be apparent, are in no position to taken on this obligation. They are, regrettably, in a very good position to lay claim to anyour all southwest Pacific land masses with which any Western power is or has been associated. Their aims are, to me, transparently territorial. For this they should be dredited with extraordinary good sense for I would judge that the most formidable social problem in a very few decades will be the very basic one of simply finding the ground for our exploding human population to live upon. The populations with land reserves are clearly the ones whibh will absorb the greatest increases.

Quite aside from any such still remote eventualities, the apparent surrender by the U.S. to the shrill and largely spurious claims of Indonesia must certainly be condemned on grounds of principle, i.e. the right of all people to determine their own destiny. The Dutch could, in ten years, bring the people of West New Guinea to a level of self sufficienty economically and politically from which, with close ties to the west, they would be able to negotiate a thoroughly dignified

future. In ten years the Indonesians will acomplish a very different
sort of indoctrination, one which will unquestionably, someday, confront
the U.S. with another New Guinea question - will it support the Papuans
of the Australian side against the claims of Indonesia for the rest
of the Island. Whatever the political or strategic consequences may
turn out to be as a result of our sanctioning Indonesia's claims,
the consequences for the million Papuans of West New Guinea are,
at best, social stagnation and, at worst, some form or other of
neo-colonial oppression. We have won no friends in the Pacific,
unless we think that Sockarno really needs or wants to feel grate-
ful to a country he must also realize is faint hearted, insecure or
both. We cannot but have failed to win admiration from our European
allies who must interpret our eagerness to compromise as a lack not
only of principle but of understanding as to the diffdrence between
colonialism and humanitarianism.

Perhaps the war in New Guinea, between the Dutch and Indonesians, has
been ended, but the trouble that will come to the people for whom
it was being fought has only just begun.

Please accept these views as coming less from an expert than an
associate who is grateful for the chance to have them heard.

I will be in New York for the next week c/o Marion STeinmann,
Science Department, Life Magazine in the event you or anyone else
might want to hear more. I could come for one of those days to
Washington, I'm quite sure. From New York I go, at the end of the
week, to join my family in Europe.

My best to Mary -

 Yours,

 Robert G. Gardner

RGG:cft

McGeorge Bundy was Kennedy's
national security adviser, one
of the administration's team of
"the best and the brightest." He
was formerly dean of the Faculty
of Arts and Sciences at Harvard,
where he met Robert Gardner.

August 18, 1962

Dear Bob:

Having recently seen the wonderful photos by Tony Saulnier in
Les Papous Coupeurs de Têtes--167 Jours dans la Prehistoire,
I wonder how soon these New Guineans of yours will be ready for
self-determination, or how meaningful an exercise it will be.
Indeed I gather we don't even know quite how many there are;
you talk of a million and Van Roijen of 700,000 in his UN statement
the other day.

Nonetheless, the one thing upon which the Dutch insisted, and on
which they won, is explicit guarantees of a valid self-determination
exercise by 1969, with the UN there to see that it is carried out.
Admittedly one cannot foresee what sort of indoctrination the
Indonesians will go in for during the intervening period. But we
are more sanguine than you that they will be wise enough to try for
more than social stagnation. Nor can I quite agree that the settle-
ment has won no friends in the Pacific. The Philippines, Malays,
and Australians have applauded it as well as we.

Your point about land reserves for exploding populations suggests
to me that the Indonesians are quite farsighted. Hopefully they'll
be sufficiently so to avoid the neo-colonial oppression of which you
speak. I'm sorry, but I think the UN and Ellsworth Bunker did a fine
job of anticipatory diplomacy in forestalling a useless war with
inevitable anti-colonial overtones -- and one from which the Dutch,
Indonesians, and Papuans would all be the losers, with only the Bloc
promoters standing to gain.

Have a good time in Europe, and tell your Dutch friends not to think
too badly of their allies. A historian might say that we helped them
to get out of one of those painful situations from which their own
domestic politics would not permit them to disengage.

Sincerely,

McGeorge Bundy

Mr. Robert G. Gardner
Peabody Museum of Archaeology
 and Ethnology
Harvard University
Cambridge 38, Massachusetts

Flags Are First Issue for U. N. in New Guinea

By A. M. ROSENTHAL
Special to The New York Times

HOLLANDIA, Netherlands New Guinea, Sept 29—The United Nations, facing its first political test here, decided today that diplomacy was more important than a flag.

As a result, the United Nations will take jurisdiction over the western part of the island from the Dutch Monday without raising its blue and white flag in public ceremonies.

For days United Nations officials have been caught in the middle of a politically based controversy as to how many flags should fly here.

No one had any objection to the United Nations flag. No one had any objection to flying the flag of the Netherlands, which is giving up administration over western New Guinea. Indonesia is to take over as soon as possible after May 1, but to satisfy President Sukarno's pledge that the Indonesian flag would fly over New Guinea by the New Year, the Dutch flag will be struck by the United Nations Dec. 31 and the Indonesian banner raised.

The dispute was over a flag only a year old and almost unknown outside the island—the red, white and blue single-starred emblem of western New Guinea. The Dutch had adopted it as their territory's special flag and it had come to symbolize hopes for an independent republic, hopes that have now disappeared.

To those Papuans who had believed the pledges of eventual independence, the flag is still important. It flies from cars, bicyles and houses.

Demand by the Papuans

"They have seen how much importance foreigners put in flag-raising and lowering, and their own flag became almost a fetish," a Dutch official said.

In the last few days Papuan leaders have told United Nations officials repeatedly that the New Guinea flag must be raised Monday as well as those of the United Nations and the Dutch.

This posed a delicate dilemma for the United Nations officials.

If they agreed to raise the New Guinea flag, the Indonesians would have been furious. The Indonesians regard the idea of an independent New Guinea as a totally discredited, Dutch-sponsored device to arouse the Papuans against them.

If the United Nations officials refused to raise the New Guinea flag, there would have been the possibility that the Papuan nationalists would turn the ceremonies into a political demonstration.

The decision was that a proclamation announcing the turnover would be read but that no flags would be raised. But the United Nations will quietly raise its own flag.

While foreign powers have been deciding what to do with New Guinea, the Papuans have been trying to figure out, in puzzlement or despair, the meaning of what has been happening.

body came to our country. We lived here. We will have food and we will live."

Temporary U.N. Chief Named
Special to The New York Times

UNITED NATIONS, N. Y., Sept. 29—The Acting Secretary General, U Thant, announced today that he had appointed José Rolz-Bennett to be temporary administrator of Western New Guinea. The United Nations takes over its administration at midnight tomorrow from the Netherlands.

Mr. Rolz-Bennett, a Guatemalan, is already on the scene helping to arrange the transfer of authority as special representative of the Secretary General.

The brief announcement said that under Article IV of the Dutch - Indonesian agreement signed Aug. 15 and ratified here Sept. 20, a United Nations administrator acceptable to Indonesia and the Netherlands was to be appointed by the Secretary General to act in the area during the interim period until Indonesian administration is installed.

The United Nations assumes full responsibility for the territory as of midnight tomorrow, under a body to be known as the United Nations Temporary Executive Authority (U. N. T. E. A.).

Mr. Rolz-Bennett has been in Hollandia since Sept. 21 discussing the transfer with Gov.

P. J. Platteer and other Dutch officials. He announced Wednesday that some Dutch officials would stay at their posts temporarily to keep essential services running.

When the United Nations Agency is fully organized, it will include Indonesian personnel. Mr. Rolz-Bennett said that as many Papuans as possible would be included in administrative and technical posts.

Law and order will be in the hands of a United Nations Security Force of 1,400 officers and men provided by Pakistan. It was reported here that the commander, Gen. Said-Uddin Khan, was already on hand with 327 officers and men, and that the rest were en route.

The dispute was over a flag only a year old and almost unknown outside the island.

[115]

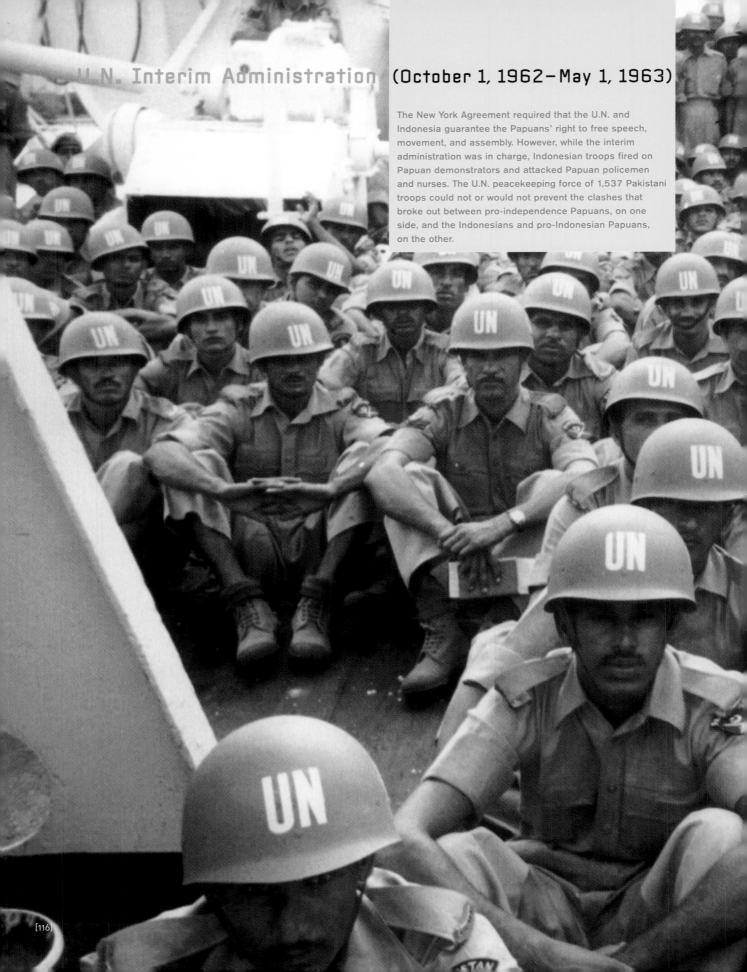

U.N. Interim Administration (October 1, 1962–May 1, 1963)

The New York Agreement required that the U.N. and Indonesia guarantee the Papuans' right to free speech, movement, and assembly. However, while the interim administration was in charge, Indonesian troops fired on Papuan demonstrators and attacked Papuan policemen and nurses. The U.N. peacekeeping force of 1,537 Pakistani troops could not or would not prevent the clashes that broke out between pro-independence Papuans, on one side, and the Indonesians and pro-Indonesian Papuans, on the other.

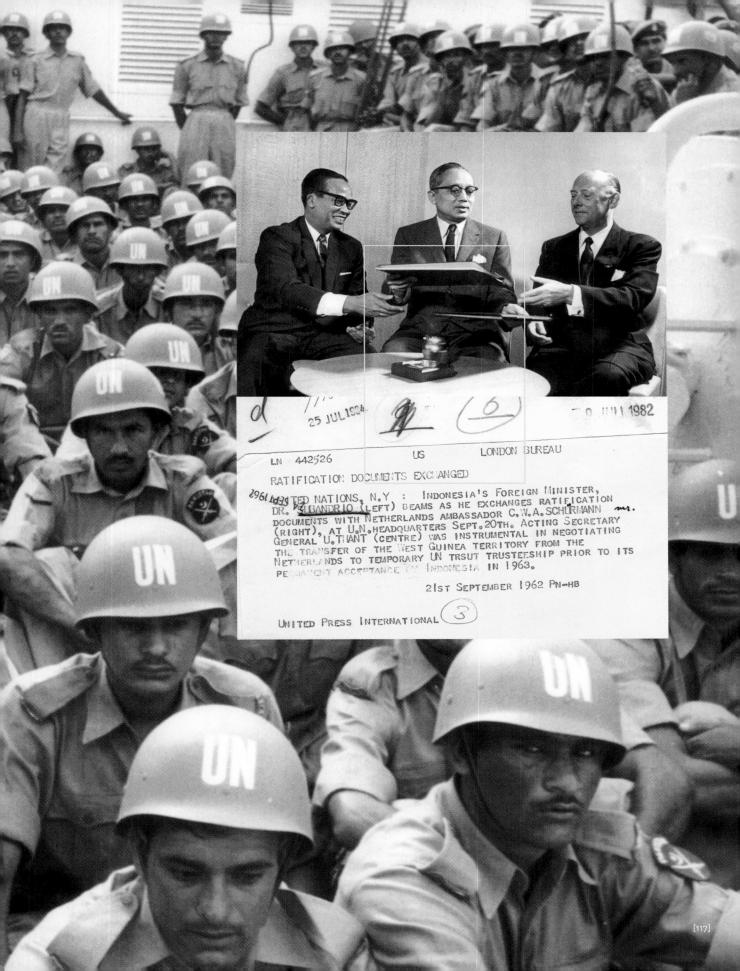

LN 442526 US LONDON BUREAU

RATIFICATION DOCUMENTS EXCHANGED

UNITED NATIONS, N.Y : INDONESIA'S FOREIGN MINISTER,
DR. SUBANDRIO (LEFT) BEAMS AS HE EXCHANGES RATIFICATION
DOCUMENTS WITH NETHERLANDS AMBASSADOR C.W.A. SCHURMANN mr.
(RIGHT), AT U.N. HEADQUARTERS SEPT. 20TH. ACTING SECRETARY
GENERAL U. THANT (CENTRE) WAS INSTRUMENTAL IN NEGOTIATING
THE TRANSFER OF THE WEST GUINEA TERRITORY FROM THE
NETHERLANDS TO TEMPORARY UN TRSUT TRUSTEESHIP PRIOR TO ITS
PERMANENT ACCEPTANCE BY INDONESIA IN 1963.

21ST SEPTEMBER 1962 PN-HB

UNITED PRESS INTERNATIONAL ③

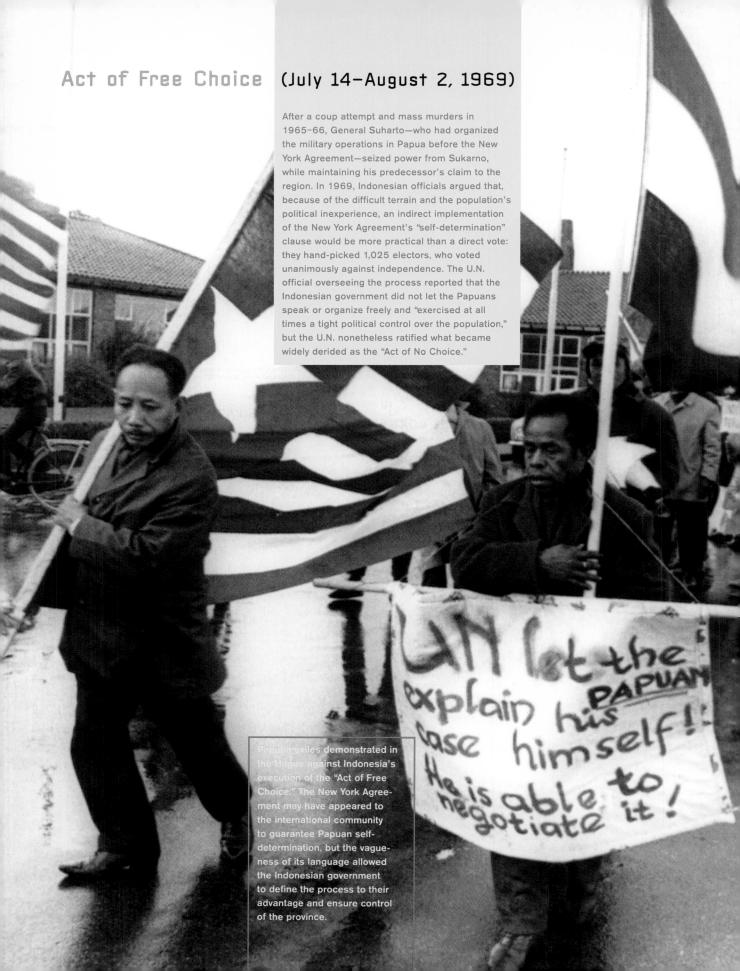

Act of Free Choice (July 14–August 2, 1969)

After a coup attempt and mass murders in 1965–66, General Suharto—who had organized the military operations in Papua before the New York Agreement—seized power from Sukarno, while maintaining his predecessor's claim to the region. In 1969, Indonesian officials argued that, because of the difficult terrain and the population's political inexperience, an indirect implementation of the New York Agreement's "self-determination" clause would be more practical than a direct vote: they hand-picked 1,025 electors, who voted unanimously against independence. The U.N. official overseeing the process reported that the Indonesian government did not let the Papuans speak or organize freely and "exercised at all times a tight political control over the population," but the U.N. nonetheless ratified what became widely derided as the "Act of No Choice."

Papuan exiles demonstrated in the Hague against Indonesia's execution of the "Act of Free Choice." The New York Agreement may have appeared to the international community to guarantee Papuan self-determination, but the vagueness of its language allowed the Indonesian government to define the process to their advantage and ensure control of the province.

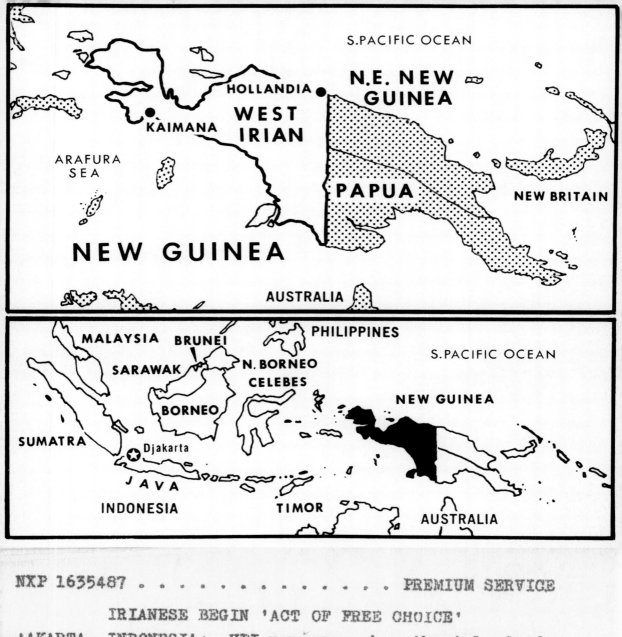

NXP 1635487 PREMIUM SERVICE

IRIANESE BEGIN 'ACT OF FREE CHOICE'

JAKARTA, INDONESIA:- UPI newsmaps show the island of
New Guinea (top), with West Irian under control of
Indonesia, and it's eastern territories under the
administration of Australia. Lower shows the islands
comprising Indonesia and surrounding countries. The
people of West Irian are now exercising what is described
as their "act of free choice" to decide whether they
wish to be part of Indonesia. The complex process will
continue until August 4.

A shoddy script for the Act of No Choice'

From GEOFFREY HUTTON in Djakarta

WHAT IS DESCRIBED in private as the Act of No Choice is now being grimly played out to the finish in West Irian in an atmosphere of frenzied patriotism backed by the best-known techniques of persuasion.

With half the "consultations" complete the only possible danger to the stage managers is that some "negative elements" have slipped through the careful screening and may attempt to register a lone No vote at Biak (August 1) or Djayapura (August 4), but if the security squads have done their work, potential dissidents have already been put in a safe place.

In a country which has held only one general election (with unhappy results) in the 25 years since its Declaration of Independence, it is not surprising that readers of the loyal Press should believe without question that the well-tried method of Musjawarah is working out to the common benefit.

It was clear from the start that the Suharto Government had made its maximum concession to world opinion by reversing Sukarno's offhand decision to scrap the embarrassing articles in the New York agreement of 1962. But while it agreed to go through the motions of formally confirming the takeover of West Irian, it firmly maintained that the territory had been an integral part of Indonesia since the Declaration of Independence of August 17, 1945.

Affirmation

Pepera, or the Act of Free Choice, was to be an affirmation, a massive display of loyalty, not an attempt to discover the wishes of the Irians. In a republic with more than 6,000 inhabited islands and the shakiest communications, tendencies towards fragmentation are not tolerated. Troubles in West Irian might have started a chain reaction. From what I have seen in a limited visit to West Irian and

West Irian tribesmen sitting among newsmen at Wamena at the Act of Free Choice there last week.

heard from others who have visited the region earlier, I have no doubt that seven years of rule from Djakarta have set up strong cross-currents of opinion among the Papuans— both favourable and hostile. This has been confirmed by evidence of the consultations at Merauke, Wanemo, and Nabire.

There are angry people, independent people, resentful people, but there is also a strong body of Indonesian loyalists who see their only future as equal members in a great multiracial State stretching more than 3,000 miles from Sabang in the Indian Ocean to Merauke at the entrance to Torres Strait.

The extremes are represented by the officially backed Merah Putih (Red and White) organisation which carries the colours of the Indonesian flag, and the illegal, ill-defined Free Papua Organisation (O.P.M.), which might in time develop into a scratchy kind of resistance movement.

Motives range between simple cargo-hunger and wild stirrings for independence among the more sophisticated coastal people. There seems no clear pattern in the love-hate attitudes of the West Irians.

At Biak one is instantly aware of the attitude of resentment which expresses itself through familiar political channels. The island has long been in contact with the outside world, both as a port and —until Sukarno's heady days —an international airline.

This was where three men were arrested at the preliminary consultation carrying banners with slogans like "One, one vote" and "Sendire" ("self"). On my first walk down the main road I was passed by an open-tray truck, carrying Papuans home from the wharf. They waved and shouted, then all crossed their wrists and held them up in the attitude of a man wearing manacles.

Several correspondents have been handed letters, slipped to

them by someone who beckons at a window. The one I received was addressed to the foreign correspondents, and handed over with three others addressed to the United Nations representative, Dr Ortiz Sanz, the foreign Ambassadors, and "Free Papuans" living abroad (in Holland).

It contained detailed accusations of bribery of delegates, arrests of three local council members and four Public servants and wholesale murder of villagers in the interior. Although marked very secret it was signed with five names, giving each man's occupation.

Such letters have been common in the more sophisticated coastal areas, but it is impossible to separate the facts from the rumours. At Merauke, where there was a noisy display of patriotic enthusiasm for Indonesia, and a procession with bands and many flags, correspondents report that they were followed by security men who moved in when Papuans spoke to them and quickly put a stop to their efforts to communicate. This never happened to me.

In the Highlands the contrast was even sharper. Those who dodged the cloud to get into Wamena for the Act found a genuine surge of tribal feeling. Whatever they may have thought of the Dutch, they did not want to lose their contact with the outside world. They had tasted cargo and they passionately desired the Indonesians to stay and bring in more aeroplanes.

But in the Western Highlands, at Enarotali and Waghete, the Indonesians are engaged in active fighting against tribesmen aided by rebellious Papuan policemen. Officially it will soon be ended, but reports filtering out through missions described it as a war of ambush and flight which the Indonesian Army, well trained and well equipped as it is, finds baffling and unfamiliar.

Efforts at pacification have so far failed. My information, which comes from missionary sources, puts the root of the trouble down to the corruption of an Indonesian official who smuggled supplies back to Djakarta to sell on the black market.

Troops sent to clean up the rising aggravated it by undisciplined action, and looted an American mission. The tribes-

men then joined forces and ordered out even peaceful Indonesian teachers in an act of total rejection.

In this context there is significance in the announcement by the Information Minister, Air Marshal Budiarjdo, that all officials who had been in West Irian more than six years would be recalled and replaced by a fresh team.

In the overstaffed and underpaid Indonesian bureaucracy corruption in some form is tacitly accepted as a way of keeping alive, and in the remote wilderness of West Irian there is a strong inducement to feather the nest against the happy recall to Java. With the exception of the tough up-and-go Brigadier - General Sarwo Edhie (Sarwo means "ubiquitous" and well describes him), most of the officials in Irian are old-time Sukarnoists, and they have urgently needed replacing for a long time.

The appearance of senior Ministers and their assistants for the Pepera celebrations may have been as important as the presence of outside observers. In Djakarta, where there is no credibility gap and there are more than enough urgent, national problems, the outlying region has been largely sealed off and overlooked.

The picture must now be clearer to the highly intelligent Foreign Minister Adam Malik and the Interior Minister Major-General Machmud, and the reaction has been swift. The new team of officials will probably be carefully briefed to do some house-cleaning.

Well staged

Mr Malik has told me that the form of autonomy promised has not yet been decided in detail, but it seems likely to extend the functions of local councils and increase Papuan representation in the Public Service.

Pepera has been a highly expensive piece of play-acting, efficiently staged by the Army and Air Force, but with a shoddy script and some highly dubious work behind the scenes. But its outcome may be to open the eyes of the Government in Djakarta to the problems which have been building up unnoticed.

Indonesia's attitude has been the direct opposite of Australia's. It cannot do much eco-

Before the ceremonial day we were trained by Indonesian officials and military officers. We lived together in Wamena for more than one month.

There was a sign that had been made from Magi that said "Indonesia Merdeka." There was one tribal leader who spoke out strongly in favor of Papua Merdeka, but then the military removed him from the group.

After we were indoctrinated they selected certain people to speak. Of the 175 people who were participants in the ceremony only seven were pre-selected and allowed to speak. I was given a place to speak as the seventh and Matias Wenda was supposed to be the eighth. The seven of us were given clothes of a specific color.

We were all given presents after they "won" the Act of Free Choice. I was given a flashlight that held six batteries, a radio that held four batteries, an umbrella, a metal saw, and money—100 IB (the currency of Irian Barat). 100 IB wasn't worth anything. We all returned to our villages feeling like we had been cheated. There were some tribal leaders who proudly proclaimed "Indonesia Merdeka." But Matias Wenda and I gathered the people to make a party and tell the people about the news. The young people were angry after they heard the news. They invited two military members to go out walking in the villages. They killed these two military men and threw them into the Baliem River.

At that point Obeth Komba became the mediator. All of the people ran into the forest and mountains. After that Indonesia conducted a military operation. The Act of Free Choice took place on July 14, 1969, and the killing took place one week later.

—Kulok Wenda, tribal leader. Interview with Eben Kirksey, 2003.

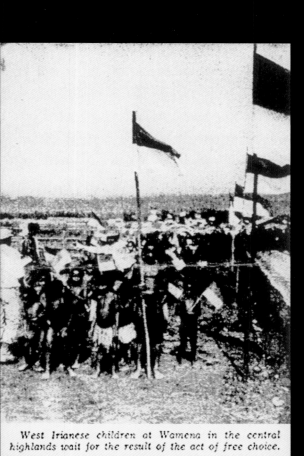

West Irianese children at Wamena in the central highlands wait for the result of the act of free choice.

Pepera, or the Act of Free Choice, was to be an affirmation, a massive display of loyalty, not an attempt to discover the wishes of the Irians,

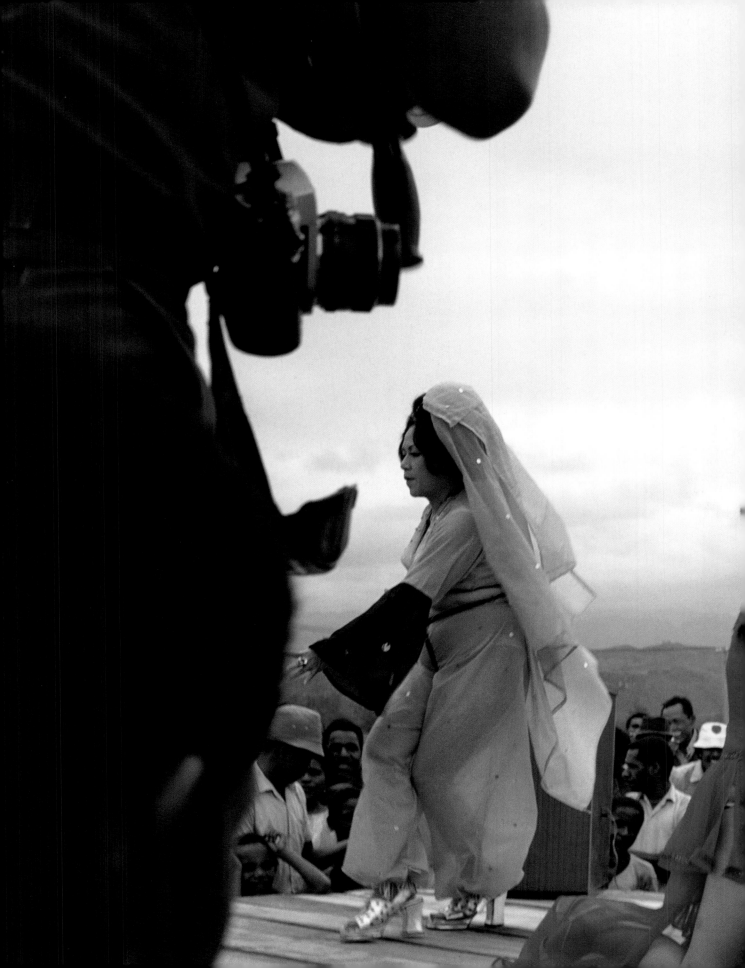

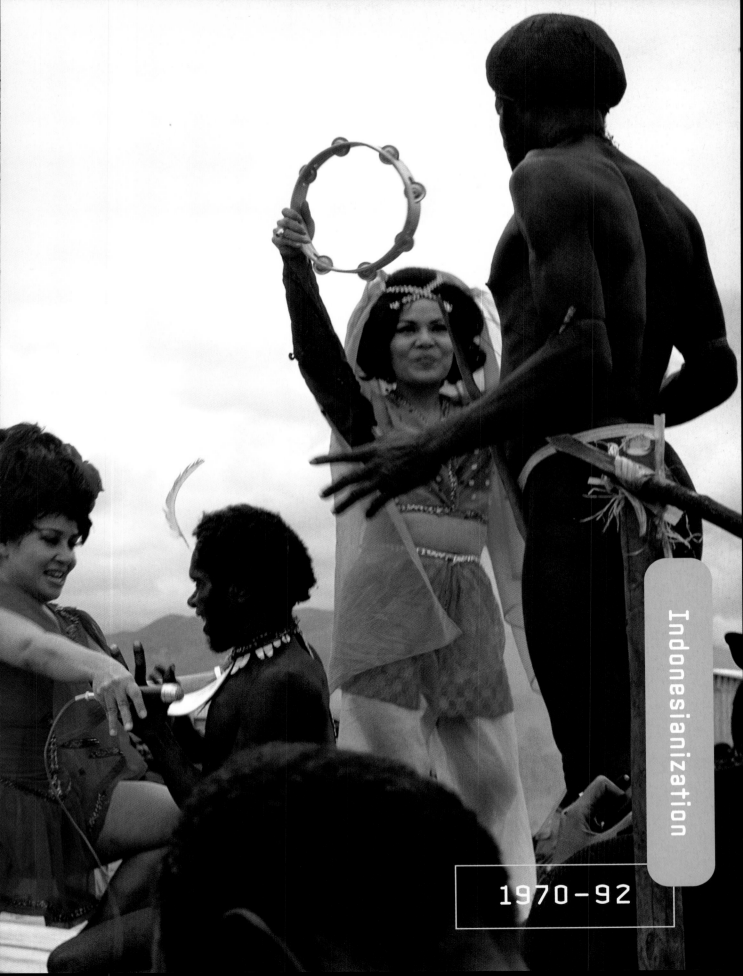

1970-92

Operation "Koteka" (1971–73)

Operation "Koteka" was an Indonesian military campaign aimed at inducing highland Papuans to abandon aspects of their indigenous culture, attend school, modernize economically, and adopt a more mainstream Indonesian identity. Officials tried to force the Dani to exchange their *koteka* (the Indonesian name for penis gourds) for Indonesian-style clothes. As part of the campaign, administrators gave Dani schoolchildren shorts, skirts, and photographs of President Suharto.

**Distribution of Responsibilities and Work Rules
for the Koteka Operations Command**

I. Basic principles
The Command of Operation "Koteka" is a special body combining the role of coordinating join activities with the command function.

II. Main objectives
1. The Command of Operation "Koteka" consists of elements of the Armed Forces and of the Civil Government engaged in activities designed to civilize the inland communities of West Irian and to develop and create social, cultural, economic, and political conditions, which will serve as a basis for the further development of West Irian, with the ultimate aim of realizing the national ideals of Indonesia, a just and prosperous society based on the *Pantjasila* and the Constitution of 1945.

Pancasila **is the official Indonesian state ideology, consisting of five principles:**
Ketuhanan **(monotheism);**
Kemanusiaan **(humanism);**
Kebangsaan **(nationalism);**
Kerakyatan **(representative government or democracy); and**
Keadilan Sosial **(social justice)**

2. These main objectives include:
 (1) To educate and give practical training to the people in normal social ethics so as to improve their living standards and their way of life.
 (2) To instill national consciousness and awareness of nationhood and of possessing a Government.
 (3) To encourage the people to abandon their habit of nakedness and to begin wearing clothes.
 (4) To encourage activities designed to create a better social, economic, and cultural order.
 (5) To encourage and induce the people to abandon their unsettled and dispersed way of life and tribal fanaticism and to create a well-ordered, permanently settled society, offering mutual help among its members.

—Acub Zainal, Indonesian general. "Distribution of Responsibilities and Work Rules for the 'Koteka' Operation Command," 1971.

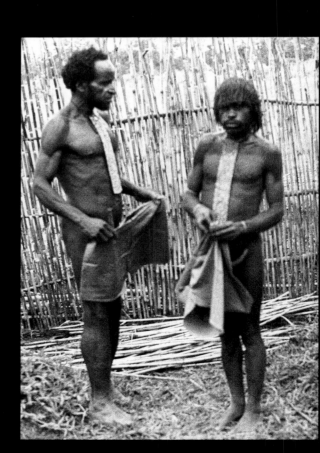

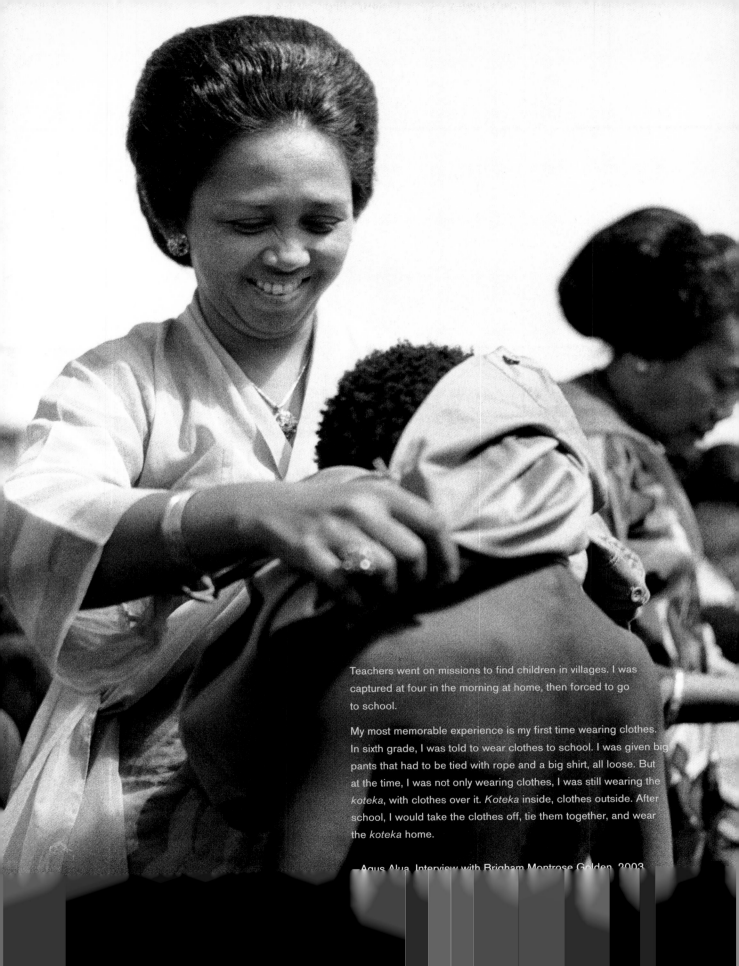

Teachers went on missions to find children in villages. I was
captured at four in the morning at home, then forced to go
to school.

My most memorable experience is my first time wearing clothes.
In sixth grade, I was told to wear clothes to school. I was given big
pants that had to be tied with rope and a big shirt, all loose. But
at the time, I was not only wearing clothes, I was still wearing the
koteka, with clothes over it. *Koteka* inside, clothes outside. After
school, I would take the clothes off, tie them together, and wear
the *koteka* home.

—Agus Alua, Interview with Brigham Montrose Golden, 2003

6. Methods: usually only lectures are utilized -- also writes on the
 board which the students are expected to copy in their note-
 books -- are also teaching aids such as counters which come
 from the mission

7. Dutch time: maybe 100,000 students only were educated -- Baliem
 had twelve schools - started in 1961 -- mission at that
 time was subsidized by the government

8. Facilities:
 a. Jiwika: run by the mission and supplied by the mission
 entirely -- three school building, one that doubles for
 the church
 One building has grades 1,2,5
 Church/school - has only the sixth
 One has grades 3 & 4
 Size: 7 meters by 16 meters
 Other structures: 10 houses used for teachers and stude
 1 dormatory for grade 4,5 & 6 boys
 b. Wenabubaga: has one school building (size same) and two
 teacher's houses
 c. Waga-Waga: has two buildings used for school and two teachers
 houses
 d. Mulima: has one school building and two teacher's houses

9. Village Response to the Schools:
 a. most of the older people in the villages can't see any
 benefit from the schools
 b. only touches the young children
 c. beginning to see the advantage in part for they see the boys
 who now speak the language of the government, know how to
 use money,(a real problem for most although they all now
 insist on being paid in money), can see the profits of this
 knowledge
 d. for girls, the traditional roles are steadfastly maintained -
 girls must garden and marry
 e. Leaders: Kurelu goes along with it for the boys (this was
 confirmed in an interview with him on the 2nd of March - he
 said it was the way of the future, especially for the boys
 who would in the future lead, the only way that leaders will
 come -- for him, he is too old to change) -- despite this, he
 is always seeking ways to get the small girls out of school -
 Mabel -- completely negative
 Other anti-school: Fakilik, Elagabik (whose son works for the
 Bupati) and Mikmo -- also Polik who just doesn't
 bother himslef with the subject.

10. EDUCATION PROBLEMS:
 a. freedom of the children in traditional culture causes problems
 in the school - they attempt to come and go as they please -
 this is wooven into traditional culture (ref: Phua story
 in "Under the Mountain Wall") same kind of thing -- roughly,
 if the parents are rough, the children are free to leave
 home, which is frequent, and live elsewhere with another
 relative -- in school if they are scolded by the teacher,
 they still feel they can get up and walk out of school

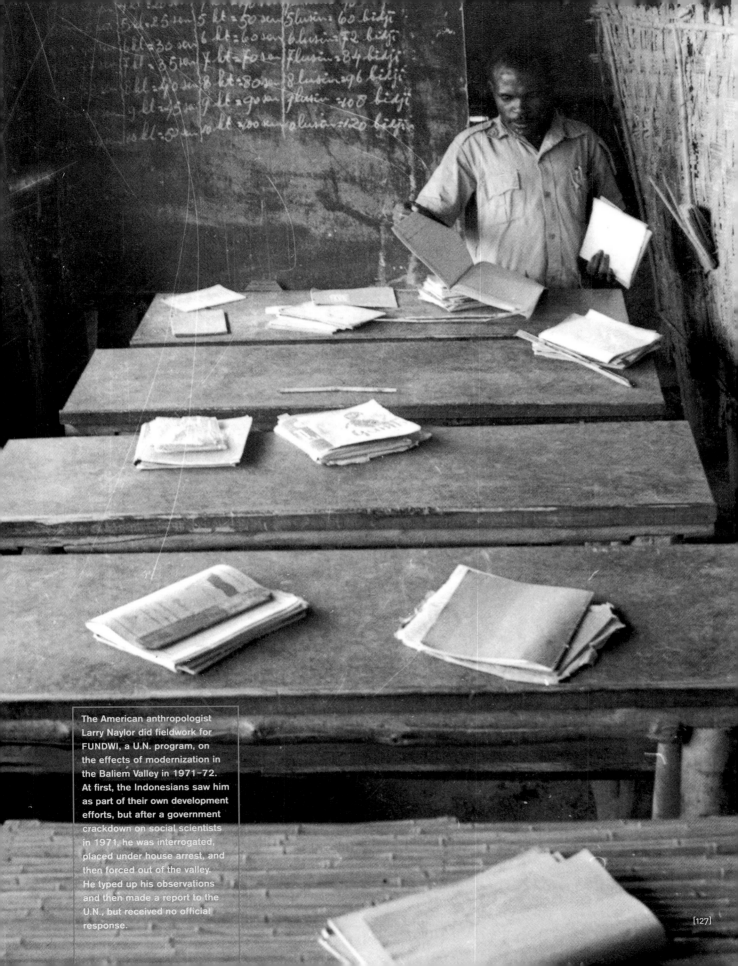

The American anthropologist Larry Naylor did fieldwork for FUNDWI, a U.N. program, on the effects of modernization in the Baliem Valley in 1971–72. At first, the Indonesians saw him as part of their own development efforts, but after a government crackdown on social scientists in 1971, he was interrogated, placed under house arrest, and then forced out of the valley. He typed up his observations and then made a report to the U.N., but received no official response.

Interview: Camps / Jiwika / 1/9/72 - Money Problems
1. 7 years ago the people began to ask for clothes to trade with the CAMA people for pigs.
2. Know the value of money -- in the sense they know they can trade this thing for other things, more variety of things -- didn't have a shell money (not in the sense of purchasing power) only had a barter system -- it might be called a transitory barter system
3. People buying pans, etc. but they don't use them -- they take them instead to Parimid where they are traded for pigs, nets, skirts of traditional variety
4. Now there is a problem with the military personnel taking advantage of the people with money -- a gun can't be argued with and all the police have guns which the people fear.

Interview: 1/2
1. At first.

2. This woul it --
 they als

3. Second, t

4. Then:
 /j

5. Presently
 (eka is
 produce

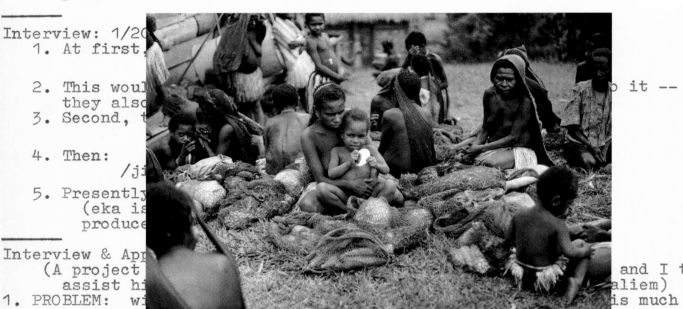

Interview & Ap
 (A project and I to
 assist hi aliem)
1. PROBLEM: wi is much
 deceit y
 a. People are now afraid to sell to the police and military -- especial
 if payment is to be in money
 b. Up to recent times, the Irian Barat rupiah was used here in the Vall
 a money especially printed for use here -- this has been designate
 to be phased out of use in March 1972 -- already great quantities
 have been colleted and burned
 c. RP or Indonesian rupiah is now replaced the old IB -- it involves ne
 or different colors from the old and has many more varieties
 d. 1 IB = 20 RP which looks like more money
 e. First money used in WI was Dutch money
 f. the special IB money has been used here for four years
2. SITUATION WITH MONEY:
 a. Selling: example of a boy selling honey in Wamena for which the usua
 price paid is about 150 IB rupiah -- the Indonesians gave him
 40 new bank notes but which amounted to only 5 IB rupiahs --
 b. Money Exchange and Change: for a 1,000 rupiah new note, the toko
 owners will give little or no change despite the article purchase
 amounted to only 200 of the new rupiahs -- numerous instances
 c. Handling: money is usually carried by the people xxx wrapped in
 leaves - both men and women carry money in this way
 d. Payments: now boys draw wages from teachers or other Indonesian for
 whom they work -- also for wood -- some hiring of interpreters
 by the natives themselves when they have to deal with the Indones
 it amounts to a go-between fees and usually means the interpreter
 takes a percentage from the final amount settled on.

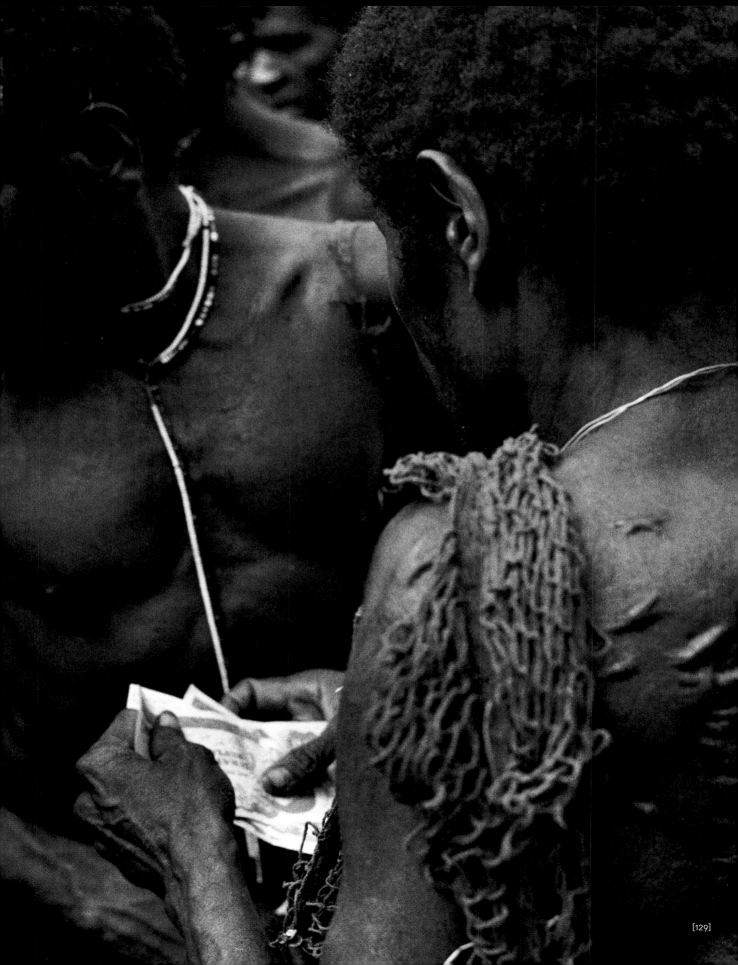

In pre-contact time, the Dani of the Dugum area...danced cere-
moniously following the killing of an enemy....The ceremony was
held concurrently with the mourning of the dead and concern for
his ghost.

In 1972, these dances are still held, although the circumstances
have been altered somewhat to fit the patterns now acceptable
to the government. With the end of traditional warfare in the valley,
at least as practiced in earlier times, dances are not held on the
death of an enemy in battle, at least in the strict sense....The new
pattern is to call for such a dance when it is learned that an old
enemy has died. This is manipulated, usually as a death caused
by old wounds inflicted in an old battle, when warfare was still the
central theme of this culture....In addition, it now requires govern-
ment permission to hold such dances, as well as the presence of
a policeman during the ceremony. The thinking of the police is that
these dances may still result in the remembering of old grudges
or fighting may occur. Although the idea of an enemy is fading,
this does not mean that old resentments are not remembered.
The high tension and occasional flareups over the smallest things
attest to this fact.

The purpose of such dancing today is highly questionable....The
people continually express the need for such dances and singing.
The shift may be toward recreation as well as for placating the
ghosts....The dances are now used to show off old battle trophies
and dress. As both sides still have these ideas and items embedded
in their culture, the dances will probably continue for some time
to come.

—Larry Naylor, Unpublished notes, 1972.

1967 Incident: Lt. Noordim of Indonesian military shot a man for
demonstration purposes.

Incident occurred during a patrol to Waga-Waga. Soldiers first
fired into a rock to demonstrate the power of the rifle. People
nearby were still unconvinced about the gun's effectiveness. One
man was particularly vocal about this, saying that it only produced
a puff of smoke. The officer told him to walk to the rock and as
he did so, he was shot three times in the back and head.

Total people killed by this man is eleven Balient people with his
own sidearm.

—Father Camps, Dutch missionary. Interview with Larry Naylor, 1970.

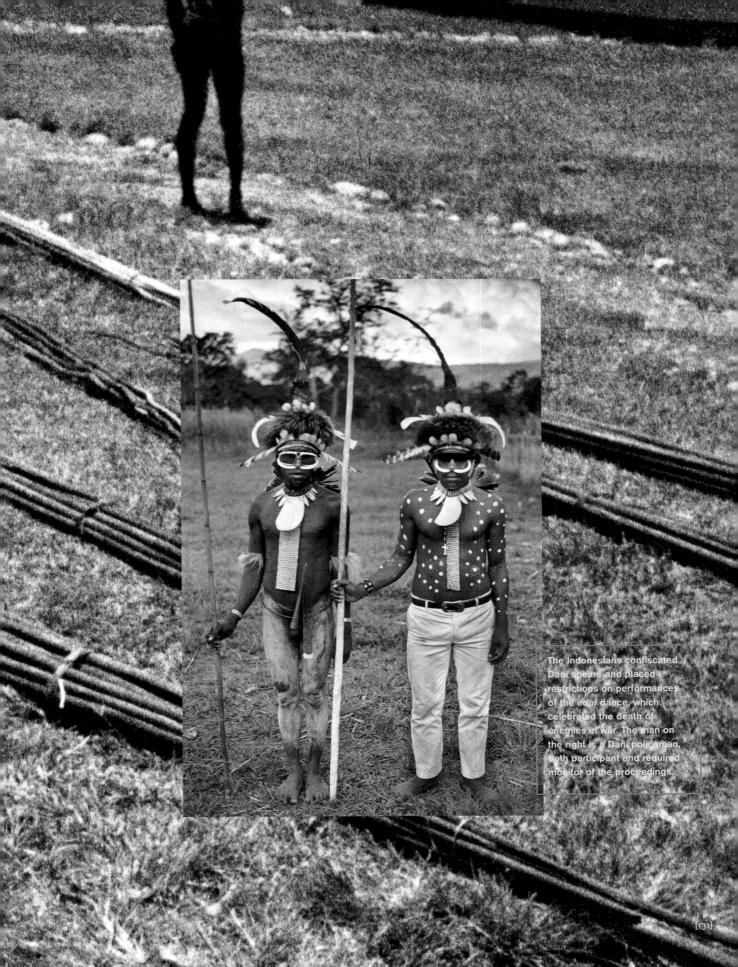

The Indonesians confiscated Dani spears and placed restrictions on performances of the *edai* dance, which celebrated the death of enemies in war. The man on the right is a Dani policeman, both participant and required monitor of the proceedings.

The forced pacification with guns and ammunitions, the government's interference in internal Dani affairs, and the discontentment within the Kurulu Alliance itself channeled violence in the Great War of 1966....

The Mabels and Kurulu's warriors attacked the villages south of the Lagora River. It was the bloodiest massacre in the history of the Baliem Valley. They burned the compounds and killed the men, women and even the children....When they were finished, over one hundred and fifty people lay dead on the battlefield.

...Within hours he'd [Obaharok] gathered his forces together and mapped out his strategy. He meant not only to revenge, but to defeat the whole Kurulu Alliance. At dawn the following day Obaharok and his warriors attacked....Kurulu, his empire crumbling, blew the whistle on Obaharok. When he called for help from the Indonesian military, the fighting stopped.... Kurulu's powerful alliance collapsed, and he ceased to be the great overlord of the Baliem Valley.

The new boundary line between the alliances of Kurulu and Obaharok was set. A short era of peace entered the Valley. It lasted until February or March 1972, a few months prior to my arrival in Wamena. A handful of...men staged a revenge attack on the village of Feratsilimo....Obaharok and his warriors pushed in to counterattack. When the battle was over, the Indonesian police entered again. They captured Obaharok and seven of his chiefs.

The police marched the chiefs off to the police post in Jiwika. There they tied their hands behind their backs, strapped their ankles to wooden bars and tortured them by beating and burning their bodies for five days and five nights....On the sixth day Obaharok managed to loosen his ties and he freed the others....

In July 1972 the senseless robbing and beating of the Dani people by the Indonesian government officials incited Obaharok to attempt to overthrow the whole Indonesian government. Armed with bows and arrows and spears, Obaharok and his warriors marched to Wamena. But when he saw Indonesian guns and ammunition and the men who knew how to use them, realism moved into Obaharok's heart. He laid down his primitive weapons at the government's feet. For the first time in his life he had no way to fight back. It must have been awful for him.

—Wyn Sargent, American writer. *People of the Valley*, 1974.

Wyn Sargent, a self-styled writer-explorer, left for the Baliem Valley with a tourist visa in 1972. Her intention was to live with the Dani and write a book about them; she found herself an unintended witness to the brutality with which the Indonesian police and military treated them. She sent photographs she took of Dani who had been beaten and tortured, along with a report, to *Tempo*, a major Jakarta-based news-magazine. The magazine published them and chose a picture of Sargent nursing the wounds of Obaharok, a Dani leader, for the cover. She later married Obaharok, after arriving at the quixotic idea that this would make peace among warring Dani groups.

While we are not in the position to investigate the truth of the allegation, we also don't see reason to doubt it.

—Niall McDermot, Secretary-General of the International Commission of Jurists. Letter to U.N. Secretary-General Kurt Waldheim, 1973.

2 JUNI 1973

TEMPO

Obaharak Berbicara

Mengapa Wyn Sargent Diusir

Tempo June 2, 1973
Obaharak Speaks
Why Wyn Sargent Was Expelled

Harga Rp 125

She Tells Why She Married a Tribal Chief

By JUDY KLEMESRUD

Wyn Sargent, one of the better known brides of 1973, came to town the other day. One reason, she said, was to tell her side about her much publicized marriage to the chief of a cannibal tribe in West Irian, formerly Netherlands New Guinea.

The 47-year-old California photojournalist had resisted talking about her marriage in the past, she said, "because it just didn't seem worth the denials I'd have to make." Now, with a book completed about her experiences, she has different ideas.

"The marriage was performed solely for one reason —to bring three savage warring tribes together in peace and harmony," Miss Sargent said, as she sat on the bed in her Americana Hotel suite.

Her marriage to Obaharok, one of the most powerful of the Dani chiefs in West Irian, was short-lived: A few days after the ceremony, in which 25 pigs were slaughtered and 5,000 near-naked warriors got together to celebrate, Miss Sargent was forced to leave the country by Indonesian Government officials who said she had married the chief—who already had six wives—to get material for a book on "primitive sexual practices."

Gives Her Side

She was also accused, she said, trying to stifle a smile, of mining uranium in West Irian, of being a spy for the United Nations and of trying to promote tribal warfare ("which is ridiculous because I'm a Quaker").

"The real reason I was forced to leave," the 6-foot-tall Miss Sargent insisted in her throaty, well-modulated voice, "was because I had taken photographs and had been outspoken about how Dani tribesmen were being beaten and tortured by Government officials.

"It's purely a racial thing," she added. "The Dani are Negroid people, and the Indonesians don't like them for that reason; they treat them just like American whites treated the American Indians."

Miss Sargent, who writes of her four and a half months among the Dani in her new book, "People of the Valley" (Random House. $10) denied comments attributed to Chief Obaharok in an interview in a recent issue of Paris-Match. The chief was quoted as saying, among other things, that at first he wouldn't have

Wyn Sargent with photos taken in West Irian

The New York Times/Edward A. Hausner

dreamed of honoring with his virility "that woman with false eyelashes who smoked long cigarettes." What changed his mind, he said, was a promised dowry of rifles, hatchets, knives and clothing.

Miss Sargent said that while she did occasionally wear her false eyelashes in the jungle, along with lipstick and toenail polish, she did not offer to give Obaharok a dowry.

She was especially incensed at the chief's reported comment that he was impotent on their wedding night, despite the prayers of his villagers ("Make our beloved chief, so valiant by habit, draw his bow for his new wife.")

"There was no sex between us at all," she said sharply. "The marriage was not created for the purpose of sleeping with anyone. As I said, it was solely for the purpose of

peace between three warring tribes."

People who buy Miss Sargent's book thinking it will be filled with intimate details of Dani sexual practices are in for a disappointment; sex is virtually nonexistent in the book.

Miss Sargent, who stressed that she was not an "anthropologist" as often reported, said the Dani are not terribly interested in sex—"it's very low on their list of priorities."

The men and women sleep in separate buildings, she said, and the women generally refuse to have more than two children because they are more interested in working in the sweet potato fields than they are in being mothers. After the first child is born, the woman generally abstains from sex with her husband for about five years, Miss Sargent said.

"This is the only culture I've ever come across where the men and women do not live together," said Miss Sargent, who once spent three years in Borneo and described her adventures there in the 1971 book, "My Life With the Headhunters."

"There are no feelings at all between the Dani men and women," she explained. "You never see flirting among the teen-agers. Romantic love simply does not exist."

Marriage ceremonies are held every four to six years, at which time about 200 to 300 young women are married, she said. Men buy wives with pigs, she said, and the number of wives a Dani man has indicates his importance, along with the number of pigs and sweet potato fields he owns.

Her own marriage helped make "peace," Miss Sargent said, because it brought together three rival chiefs in whose villages she had lived while studying and photographing the Dani people. It is a Dani custom, she said, that one's friends get together and celebrate on such a big occasion.

Miss Sargent said she had originally gone to West Irian at the suggestion of the then Indonesian President Suharto, who she said had been impressed with her work in Borneo, where she helped to establish a hospital and a school. She said Mr. Suharto told her at a meeting in Disneyland in 1970 that the Dani were very primitive and needed help "badly."

Once she got there, the auburn-haired Miss Sargent said that most of the Dani people thought that, because of the shirts, Levis and heavy boots she constantly wore, she was a man, "or at least something other than a woman."

Did she witness any cannibalism during her stay? "No, but I talked with two men who were in a Government jail for doing it. The Dani do not eat people because they have a love for flesh; they do it mostly to humiliate an enemy."

Miss Sargent said that after her marriage to Obaharok, wire service accounts of "the Indonesian Government's version" of the wedding were sent around the world, and that she had not been asked for her side of the story.

"It was very painful, just awful," she said sadly. "I'm quite an old fogey morally, and I suppose that's why I felt pain when they accused me of doing primitive sexual research. The only thing that got me through my blackest hour was the words of my son, Jmy, who was quoted in a news story as saying, "My mom knows what she's doing."

Today Miss Sargent and her 19-year-old son live in her native Huntington Beach, Calif., where she said she is independently wealthy with money from her family's citrus fruit business. She has been married twice in this country; her first husband died, she said, and she divorced her second husband.

At present, she said she is taking medical courses at Golden West College, a junior college in Huntington Beach, with the hopes of going back to West Irian someday and opening a medical clinic for the Dani people. She added that she was also realistic enough to know that this will probably be impossible as long as West Irian remains under Indonesian rule.

Has she heard from the Dani since her return to the United States? She smiled. "A message was smuggled out of New Guinea to me," she said. "It said that peace prevails, and that they're waiting for me to come back. It also said that Obaharok (who ordinarily wears nothing but a penis sheath) wants a bright red shirt and a pair of long trousers. I guess there really is hope for these people."

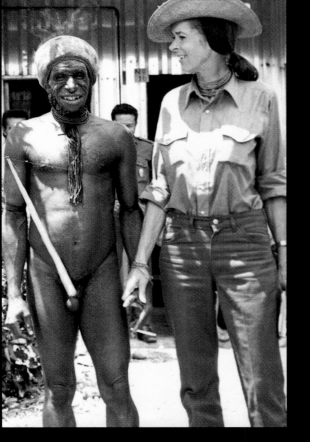

We were blinded by our pride that a white woman would want to become a Dani.

There was a woman from over there who didn't know things about us and who wanted to learn *adat* (customs) of our Dani weddings. She was the same as you but she was mostly interested in knowing about weddings. She met a big tribal chief, Obaharok Doga from Akima. He already had maybe ten wives, but she said she wanted to marry him, and to become one of his wives. He was amazed and at first disbelieving, but then quickly he became very happy. He was very happy, in fact delighted that a white woman wanted to enter into the Dani culture. His wives were all happy too; they gave up the pigs they had been raising for the festival, and they all participated in preparing a great big wedding feast.

We didn't know if this white woman loved him for real or not, but we know she married him for real. She did the whole ceremony. She put on the traditional woman's *yokal* (skirt), they made it big for her because she was a very big woman, they had to make it extra long to fit her. She took off her top, her skin was white all over, and everyone went half crazy with happiness. Everyone got all dressed up and danced and danced for days; a lot of people brought pigs, special pigs, maybe 50 pigs or more. Everyone brought pigs and everyone danced. This Mama Wyn, she ate a lot of pig and danced for 10 days, and after that she sat down with her husband and they made the sign of marriage together: the man and the woman cut up the pig together and then they went to sleep together.

They slept together three or four times and then she ran away, she just disappeared. She changed her clothes from the *yokal* into clothes like you have, she had them hidden in a backpack like you have, hidden in Wamena somewhere. She threw away the *yokal*, combed her hair, put her things into her backpack, got into the plane and disappeared.

—Paskalis Matuan, Dani farmer. Quoted in Leslie Butt,
The Social and Political Life of Infants Among the Baliem Valley Dani, Irian Jaya, 1998.

Indonesian authorities forced Sargent to leave the country, and salacious articles about her marriage to Obaharok circulated in the Indonesian and international press. Her report in *Tempo* magazine, however, attracted the attention of Papuans living in exile in the Netherlands, who asked her to testify before the U.N. Committee for the Gross Violation of Human Rights. She was the sole witness to Indonesian brutality in the highlands to come forward to speak about it.

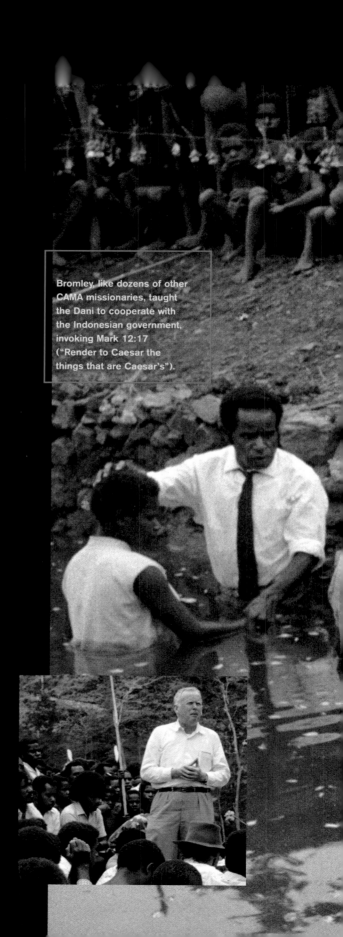

here was a sacred place quite near the area where we wanted
to build an airstrip. Some people didn't want to help do this work,
they thought that everyone would die if they violated the place.
So we waited until the gardens had been harvested of the sweet
potatoes and then the local pastor from our church said a prayer
and we started to work.

By the end, no one was sick or had died. So Chief Muliason told
the people that the Christian god was more powerful than the spirits
of the ancestors. The very day that they opened the airport in
Pulimo, he became a Christian and then, with two other chiefs,
they decided to burn their fetishes. They brought some sacred
axes, many bows and arrows, net bags with things inside that were
wrapped in leaves, maybe bones and feathers for different spirits.
There was a lot of tension because other people and chiefs were
against the fetish burning and said they would kill the people who
did it. Some of those chiefs even went to the police in Wamena
to forbid the burning.

It wasn't until a few months later in July 1974 that the people
asked us to do a baptism. In the morning we had a little prayer and
then we made a dam in the river. Not everyone who was there was
baptized: thousands came only to look. There were 112 baptisms
in Polimo and another 39 in Ibiroma. We then had a big pig feast
to celebrate, and while waiting for the pig to steam for two hours,
Bromley, our neighbor, preached. It was a good beginning. We
began to go to all the villages and hoped more people would
become Christian.

Hanna Kessler, German missionary.
Interview with Susan Meiselas, 2003.

Bromley, like dozens of other
CAMA missionaries, taught
the Dani to cooperate with
the Indonesian government,
invoking Mark 12:17
("Render to Caesar the
things that are Caesar's").

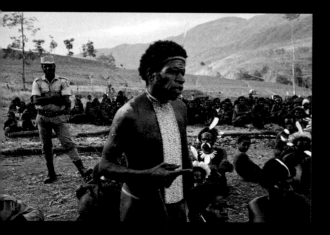

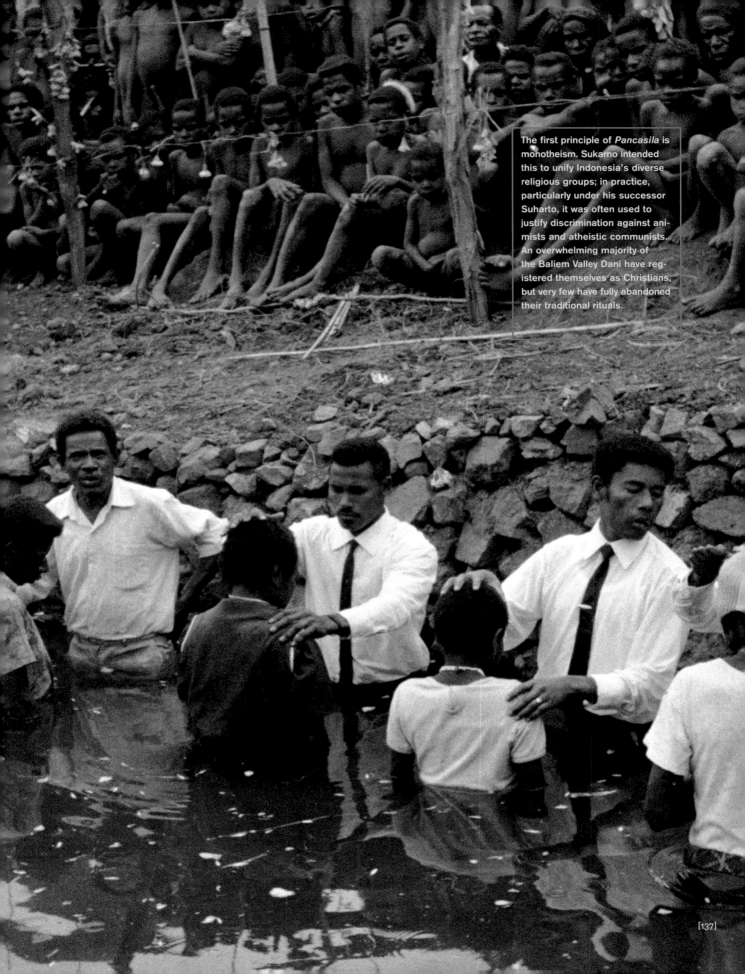

The first principle of *Pancasila* is monotheism. Sukarno intended this to unify Indonesia's diverse religious groups; in practice, particularly under his successor Suharto, it was often used to justify discrimination against animists and atheistic communists. An overwhelming majority of the Baliem Valley Dani have registered themselves as Christians, but very few have fully abandoned their traditional rituals.

This evangelistic tract, produced by American Christian publisher Chick Publications in the early 1970s, depicts stories from the Bible. The tracts were offered to missionaries with the suggestion that they be dropped out of airplanes over areas of New Guinea not yet reached by missions. It is not known if they were ever used for this purpose.

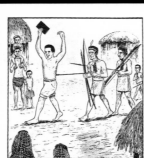
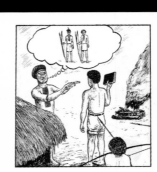
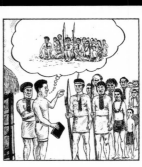

 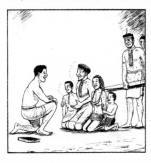 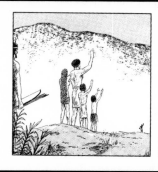

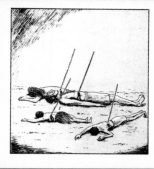 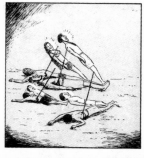 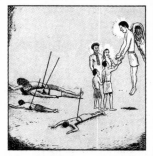 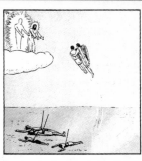

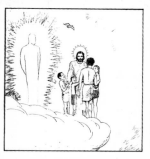

We puzzled over whether a Dani who had never seen a book would know how to open or hold or sequentially read such a thing, and how one might interpret the drawings. These images are easy enough for us missionary kids to read—who have encountered the concepts and seen drawings similar to this in Sunday school work-books—but it is highly doubtful whether any of this would have meaning to a New Guinea person without some background knowledge.

—Larry Lake. Email to Susan Meiselas, 2003.

The main storyline is about an attack on the visiting native missionary by the village he comes to preach in.

7 May 1971 I was given a false impression by the Indonesians in Ok Sibil. I thought that they were poor but sincere and struggling. I am now convinced that it was an incredible travesty of justice on the part of the United Nations to allow Indonesia to have West Irian…. [T]he Indonesians are extraordinarily insensitive to the physical beauty of Irian Jaya, to the wildlife—there is a thriving Bird of Paradise trade—and to the native cultures…. They are more culturally destructive than the Protestant missionaries. Irian Jaya is being turned into an Indonesian slum [by transmigration].

19 July 1972 The army is currently on maneuvers, and apparently, the OPM is quite active. A surveyor was shot. He was surveying a pipeline and put up a survey flag which attracted the attention of an army patrol, who turned a machine gun on the poor character. He is now in hospital in a serious condition.

3 January 1973 Recently, a Dani was shot while working on a bridge. The Dani had refused to carry out an order and was walking away in contempt. An Indonesian army lieutenant shot him in the leg with a sub-machine gun…[T]he missionary doctor is hoping to save his leg. The shooting has heightened tension between the Indonesians and the local people. The people made a special point of not allowing the army to pay for the fellow's medical expenses. They did not want to feel indebted to the Indonesians in any way.

27 January 1974 My arrival in Sagapo results in everyone dressing up in their best and only pair of filthy shorts. After my second day there, I was accepted to the point where the necessity for impressing me, or politeness had gone and everyone had ditched their clothing and looked far better for it. It is strange how the Indonesians cannot see that it is far more degrading to have a person in dirty rags than in nothing at all.

22 November 1974 I am becoming too narrowly involved with this place, and will soon have to leave it. It has got to the point where I resent intrusion by strangers, and the momentum of change is accelerating. Irian Jaya is being "discovered" and brutally dragged into the sphere of influence of the technocrats—strange people everywhere; self-seeking people, who have no feeling for this ountry apart from what they can get from it.

July 1976 The almost total lack of critical economic and social studies is deplorable but is a reflection of Indonesian government policy. The Indonesian administration is hypersensitive to any form of criticism of its development policies. The area has been virtually closed to bona fide research, and those researchers who have obtained permits do so with the knowledge that any overt criticism will jeopardize future research prospects for themselves or their peers.

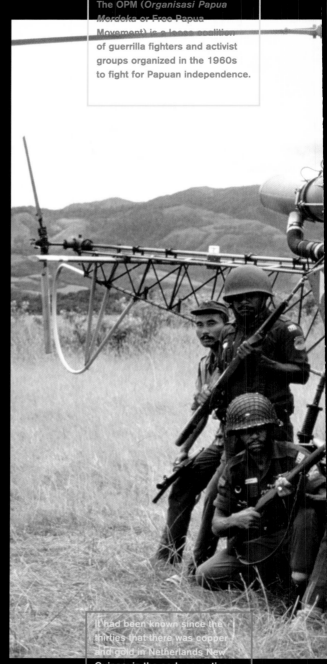

The OPM (*Organisasi Papua Merdeka* or Free Papua Movement) is a loose coalition of guerrilla fighters and activist groups organized in the 1960s to fight for Papuan independence.

It had been known since the thirties that there was copper and gold in Netherlands New Guinea; in the early seventies, multinational mining corporations, particularly the U.S.-based company Freeport, which runs an enormous gold-and-copper-mining operation west of the Baliem, began to exploit these resources on a large scale. Robert Mitton, an Australian who worked as a camp manager for various mining companies, was in a unique position to recount events in the valley after it was closed to anthropologists, journalists, and tourists in

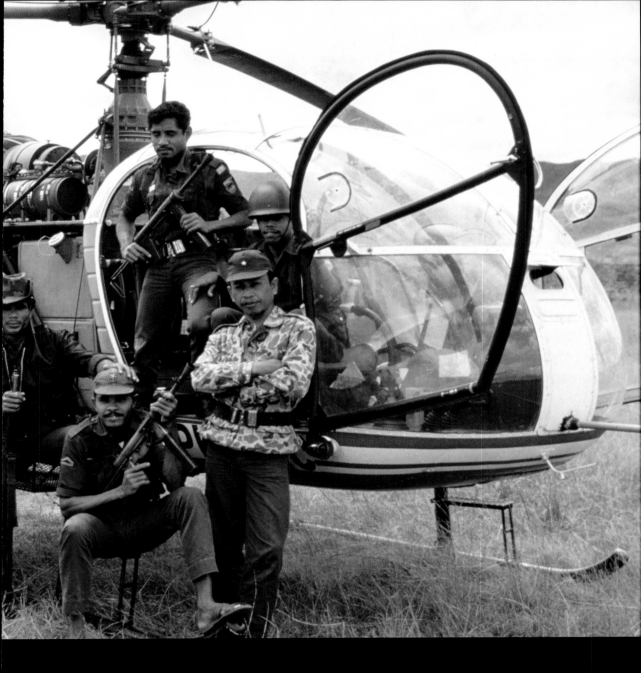

A second potential source of information are missionaries
many of whom have had a close association with the region
the post-war opening of the region. The missionaries are a

Jayapura—A Piper Navajo takes off from Sentani airfield. On board, the pilot and three hundred kilos of rice for an isolated station in the Baliem Valley, in the middle of the territory. Day begins to dawn…

A tiny landing strip on a ridge becomes visible. The ground is sloped towards the mountains, and the takeoff towards the abyss. The runway is very short and permits no mistakes. Last August, all five on board a plane died on a similar airfield.

The pilot gently lands his plane on the grass. Suddenly a line of stakes appears before him, obstructing the middle of the airstrip. Impossible to take off again. If he cuts the engine, his plane will be impaled on the stakes. Miraculously, the pilot escapes the adventure unharmed. Still completely stunned by the shock, he finds himself surrounded by small men who contemplate him silently. Almost naked, they are armed only with bows and arrows. These are the Dani, one of the most important tribes of the Baliem. Their trap wasn't meant for a civil aircraft, but for the Indonesian military planes.

In most Baliem villages the authorities have set up military surveillance posts. In one of them, three soldiers watch night fall apprehensively. One is on watch, submachine gun in hand, while his comrades sleep. All is calm. His attention relaxes. Invisible shadows approach and swoop down on the small group. Clubs smash skulls and the assailants disappear with the unfortunate soldiers' weapons. These are just two incidents, among many others, that have taken place in the valley since April 1977.

A forbidden territory

Every rebel raid is followed immediately by reprisals. The region is off-limits and it is impossible to know the number of victims on either side. Rumors circulate, impossible to check: for a soldier killed, a hundred Danis are shot; villages are bombed. In Sentani, a town populated by Indonesians, fear reigns: rumor has it that a patrol intercepted Papuans getting ready to poison the city's drinking water reservoir. In the south, people have left their villages since the army arrived. In Mimika, to the southwest, the pipe bringing copper ore from the gigantic American-run Cartstaenz Mountain mine to the coast was cut in several places, letting a million dollars worth of ore escape. The guerrillas have settled into the Baliem Valley and reach into other areas.

The Indonesian authorities display great discretion on the topic of these events, and, so that nothing filters through, deny access to Irian Jaya to foreign visitors, with the aim, they say, of preserving their security. They recognize that there are problems in Irian Jaya, but attribute them to small tribal wars; they send troops to keep the peace. Jakarta denies any news to the contrary. Actually, there are still tribal battles in the region. But the Danis have united to struggle against the Indonesians, and other groups might well imitate them.…

Jayapura—The electoral campaign that took place in the spring of 1977 throughout Indonesia allowed the Papuan liberation movement, the OPM, to exploit the population's unhappiness with the central government and to launch a broad offensive. This unhappiness is as intense among the educated Irianese as among those who have stayed in the tribal state. The former note with bitterness that the profits drawn from the exploitation of the territory's mineral riches benefit above all the Indonesians, that their country lacks roads, hospitals, and schools, that it is hard for them to find work and that they are paid insufficiently. For the latter, which make up the immense majority of the population, the situation is still more dramatic because their culture itself is threatened.…

The Jakarta authorities have made the same mistakes as the colonists and missionaries of the last century, ignoring the value of a civilization neither better nor worse than others, but simply different. It is poetic justice that now it's the missionaries who—having made their mea culpa—invite the Papuans to preserve their traditions, their own originality. Certain of them have become suspect to the Indonesians, who keep vigilant watch over their activities.

The Indonesians in charge have begun to see the error of their ways and to understand that it is high time to let the Irianese benefit from the profits taken from their country. But it's a bit late. For fourteen years, the despoilment, the constraints, the insults have offended the Papuans, now ready to listen to the leaders of the separatist movement. The Papuans don't know the entire meaning of the words used by the OPM—"politics," "liberty," "independence" —but they do not want any more of Indonesia's tutelage.

—Toni Mellive, "Indonesia: The Papuans' Revolt," *Le Monde*, 1978.

1977 Operations (1977)

In the spring of 1977, the Baliem Valley was the site of a major battle between the Baliem Valley Dani and the Western Dani. The military and the police were called in and turned what was a tribal war into a ruthless "war of pacification." Many have suggested that the tribal warfare was fomented by increased military pressure and by OPM guerrilla groups attacking Indonesian military and police posts in the valley and in Western Dani territory. The military responded by sending in hundreds of troops by ground and by air. Some say as many as 3,000 were killed.

We divide our history between before and after 1977, because in 1977 we realized we had to learn how to be "developed."

—Agus Kossay. Quoted in Leslie Butt, *The Social and Political Life of Infants Among the Baliem Valley Dani, Irian Jaya*, 1998.

The report was the result of communication and discussion with a people who never had the chance to openly express the voice of their hearts. And when they did, no one listened to them and many became victims of the process of unification of the Nation.

—"For Justice and Peace: A Historical Responsibility", Indonesia Christian Church (GKI) report to the Communion of Churches in Indonesia (PGI), 1992.

After most of the fighting was over, the army forced everyone to surrender, surrender, surrender. Once this was almost completed, Unit 752 from Sorong, all soldiers, entered the village of Wogi. They just pillaged the place. They went where they wanted, and grabbed all the wealth of the village people there. Then they marched from Wogi to Wamena. Very belligerent they were; they walked along the path in formation. Walking this way, that way…they grabbed all the pigs from the fields, they just took them. Women also were raped, and they sold the pigs in town, all the vendors were soldiers that day.

I wrote a report of what happened. I was encouraged to do this by the head of the Jayawijaya Catholic Church. My report got a lot of attention because it told the truth, and Unit 752 was forced to leave the region.

—Agus Kossay. Interview with Leslie Butt, 2003.

You ask how it looks now in the West Dani Region. It is like "scorched earth." Almost all the villages have been burnt to the ground. Last week the government official from Kurima was with us. He said that the number of dead Dani was estimated to be over 70,000. At Kurima, one can often see the corpses down in the Baliem. What should we do in the face of this situation? Should we protest and get thrown out? That is what we feel like doing. But what would we accomplish by doing that? Hasn't the senseless killing been made public abroad? In the meantime the Dani fight wars among themselves. The non-Christians attack the Christians, steal their pigs, plunder their gardens, violate their women. Some evangelists have already been killed. This conflict has in the meantime spread from the West Dani Region all the way to Hetigima and Tangma.

—Anonymous missionary. Quoted in GKI report on events of 1977.

GKI authored a report in 1992 that critiqued 30 years of Indonesian policy in West Papua. Of special concern to the authors was the Baliem Valley, in the wake of the events of 1977 and other human rights violations. The larger community council of churches in Indonesia felt that it took too strong a stance, so local churches were instructed not to release it publicly. However, it was circulated internally and portions were used by Amnesty International.

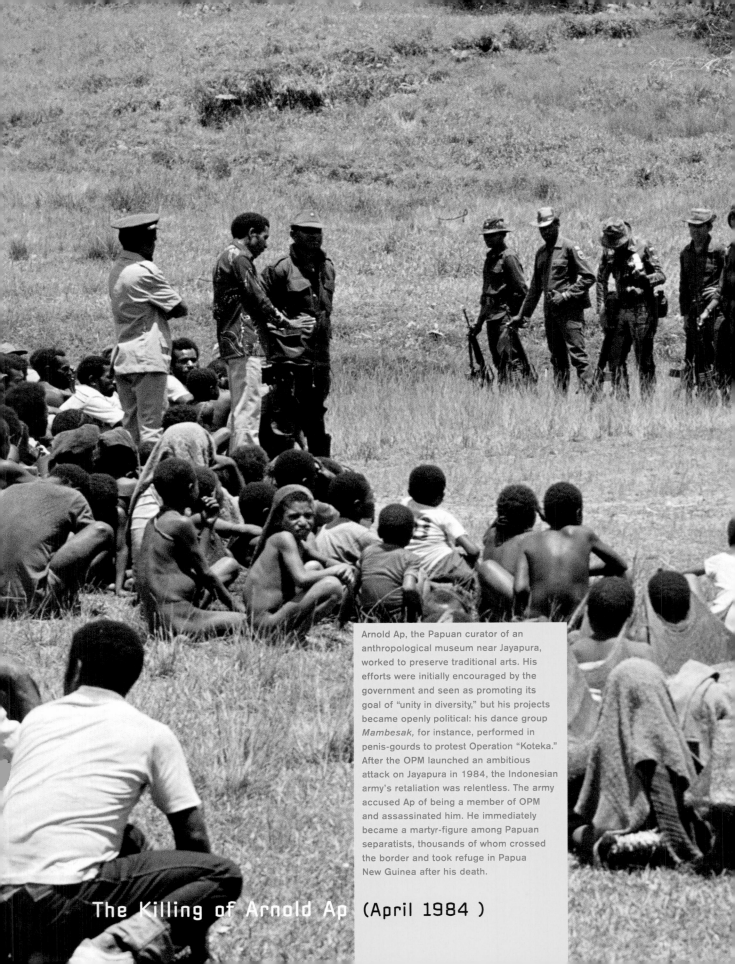

Arnold Ap, the Papuan curator of an anthropological museum near Jayapura, worked to preserve traditional arts. His efforts were initially encouraged by the government and seen as promoting its goal of "unity in diversity," but his projects became openly political: his dance group *Mambesak,* for instance, performed in penis-gourds to protest Operation "Koteka." After the OPM launched an ambitious attack on Jayapura in 1984, the Indonesian army's retaliation was relentless. The army accused Ap of being a member of OPM and assassinated him. He immediately became a martyr-figure among Papuan separatists, thousands of whom crossed the border and took refuge in Papua New Guinea after his death.

The Killing of Arnold Ap (April 1984)

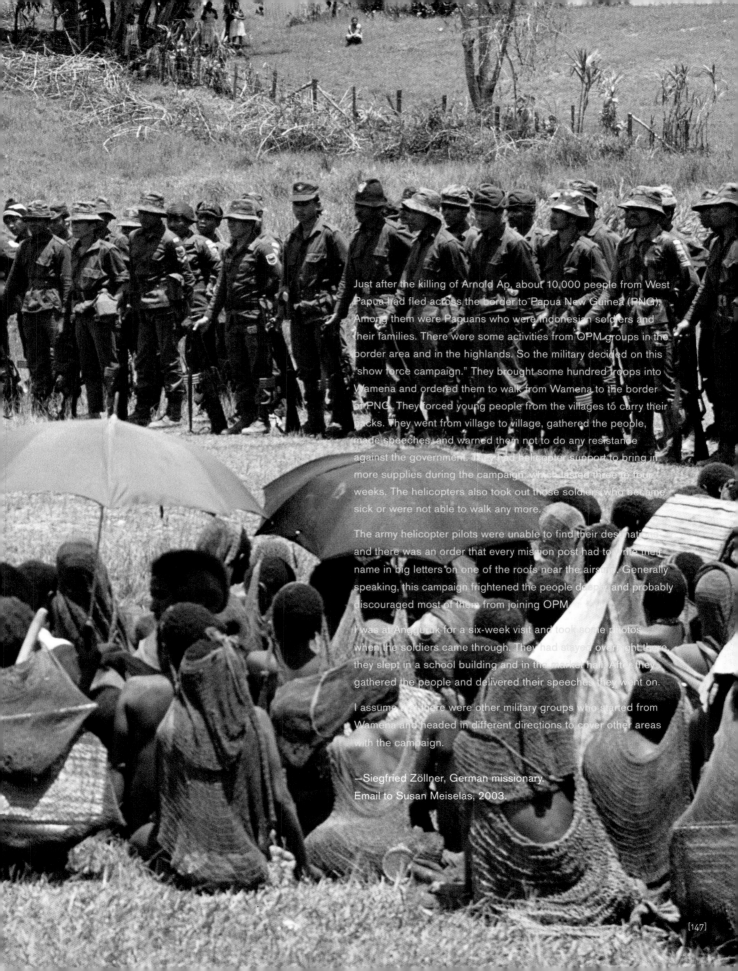

Just after the killing of Arnold Ap, about 10,000 people from West Papua had fled across the border to Papua New Guinea (PNG). Among them were Papuans who were Indonesian soldiers and their families. There were some activities from OPM groups in the border area and in the highlands. So the military decided on this "show force campaign." They brought some hundred troops into Wamena and ordered them to walk from Wamena to the border of PNG. They forced young people from the villages to carry their packs. They went from village to village, gathered the people, made speeches, and warned them not to do any resistance against the government. They had helicopter support to bring in more supplies during the campaign, which lasted three to four weeks. The helicopters also took out those soldiers who became sick or were not able to walk any more.

The army helicopter pilots were unable to find their destination and there was an order that every mission post had to write their name in big letters on one of the roofs near the airstrip. Generally speaking, this campaign frightened the people deeply and probably discouraged most of them from joining OPM.

I was at Angguruk for a six-week visit and took some photos when the soldiers came through. They had stayed overnight there, they slept in a school building and in the market hall. After they gathered the people and delivered their speeches they went on.

I assume that there were other military groups who started from Wamena and headed in different directions to cover other areas with the campaign.

—Siegfried Zöllner, German missionary.
Email to Susan Meiselas, 2003.

[147]

The "Smiling Policy" (1984)

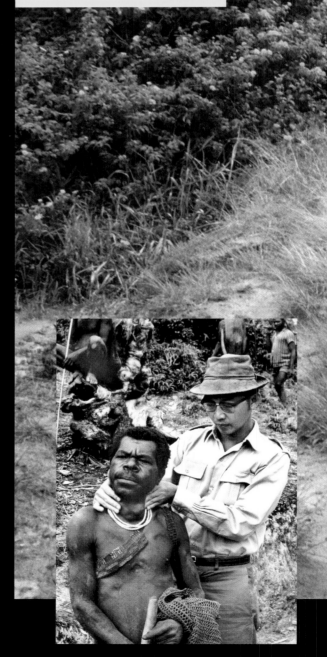

In 1984, the Indonesian military tried a new strategy to deal with native resistance. Irian Jaya military commander General Sembiring advocated what he termed a "smiling policy," a more conciliatory combination of "socio-anthropological, socio-religious, and socio-psychological approaches" to detach the general population from the OPM and its separatist vision. Despite this new approach, the cycle of violence, with OPM actions and Indonesian reprisals, continued.

The people in the interior have no sense of being inferior to people from the towns. They regard themselves as human beings, even as the real human beings. They therefore have no sense of inferiority. Their self-respect is strong, and they do not feel dependent on anyone, not like town people who feel dependent on local officials, for example. They live their lives by their own efforts, gather their own food, hunt animals for themselves. People from the towns may think they are richer or better educated, but when they make contact with people in the interior of Irian, they should discard such ethnocentrist feelings.

It isn't easy. Treatment provided by doctors or medical staff is very different from their concept of traditional medicine. How is this gap to be bridged? The first thing is to convince them that medical personnel have the power to cure them. They are not at all bothered about our way of thinking, but the important thing for them is whether medics can cure them. It's a pragmatic way of thinking, and they will come back for more treatment, and bring their children, if they feel confident we can cure them. Then, it's a matter of whether doctors can change their way of seeing things, and that isn't easy....Doctors need to understand their way of thinking while at the same time being less condescending themselves....It may take a whole generation before they can accept the scientific approach behind modern medicine. But this is not only found in Irian. There are still many people living in Jakarta who prefer magic to treat illnesses.

...They have been able to adapt to their environment over a long period of time. I am not suggesting that they should be left to live without clothes, but I think that with time, as their economic conditions improve, they will come to this themselves. It's not enough to have a single item of clothing. They would need to have many items of clothing as well as soap, and they would need to know something about simple, practical hygiene. Sometimes, they are forced to wear clothes to go into town to report to the office of the local *camat*. Because they don't have enough clothes of their own, they have to borrow things from their friends. This spreads disease because the clothes are not clean and have probably been worn by many other people.

—Suriadi Gunawan, Indonesian doctor.
Interviewed in *Higine*, 1984.

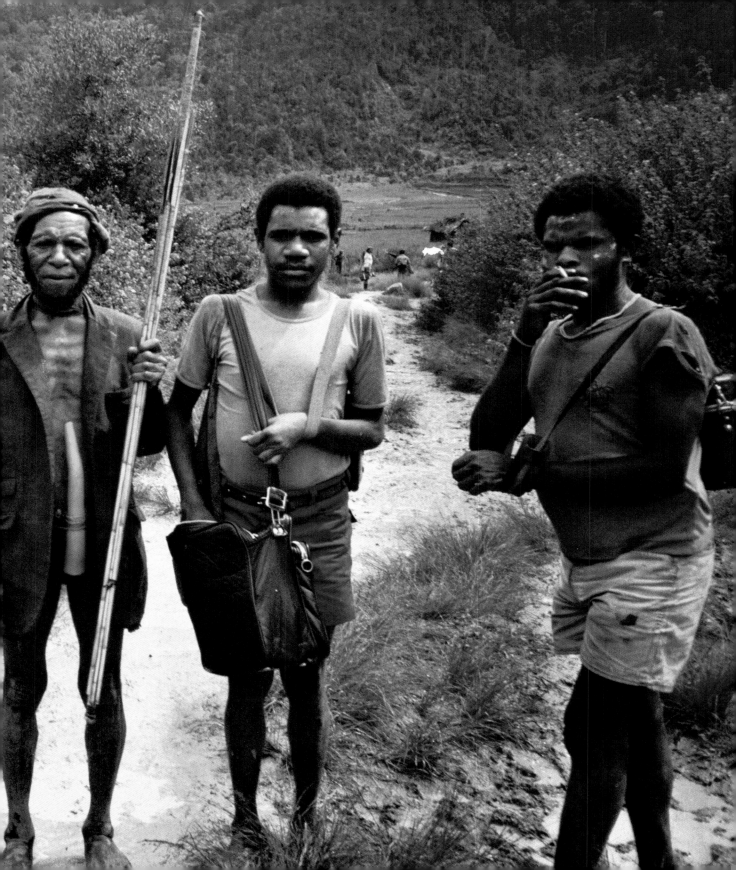

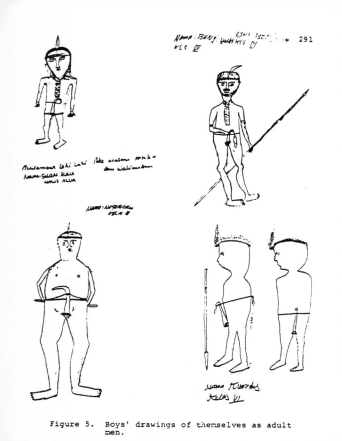

Figure 5. Boys' drawings of themselves as adult men.

Figure 6. A boy's drawing of himself as an adult man.

As my knowledge of Irian Jaya was quite limited, it was necessary for me to do background reading….All the information located emphasized the undeveloped state of the area. The people were portrayed as highly passive, non-thinking creatures; the inference was that only by assistance from the modernized thinking segment of the Indonesians in Jakarta would the Irianese become a "better" people.

I sought impressions, comments, and assessments from friends, colleagues, and average Indonesians in the city…. They were not sure precisely where it is located. Their knowledge of the place was captured in their phrase describing it as "wild and scary"…Sensing my determination to go to Irian Jaya in spite of their warnings, my relatives and family began to collect the amenities I would need to survive there. They produced a heavy duty flashlight, an extra heavy duty siren box with an alarm that could be heard for 20 kilometers; a set of army "walkie-talkies"; medical supplies in all forms,

I was told that it is a policy of the government that anyone who plans to go to Irian Jaya and East Timor is required to obtain clearance from the Ministry of Defense, and the Bureau of Intelligence. The sessions were unfriendly and very intimidating; but I was finally granted permission….

Education for the Baliem Valley people, like that for any other Indonesian citizen, is aimed at the development of citizens who can function effectively and productively in a *gotong royong* (state of mutual cooperation)….This study dealt with the cultural aspects of schooling in the Indonesian societal context. I was able to have several meetings with the pupils between their subject classes….They had no thoughts that schooling would make them modern, functioning Indonesian citizens as schooling is promoted to do by the Government…. I asked them to draw pictures of how they would look when they become adult men and women, or to draw what they would be when they became adults in the *kampung*,

Figure 7. Boys' drawings of themselves as adult men.

Figure 8. A boy's drawing of himself as an adult man.

Figures 5 and 6, which show samples of the boys' drawings of how they see themselves as adult men, suggest no change in their primitive appearance. Fundamentally, the *koteka* is seen as still the basic clothing, paired with a feather that is attached to the forehead by a headband. The spears are still part of their personality and the pig is also a part of their identity....As clearly shown, they expect to become adults just like the present adults in their compound.

On the other hand, the drawings in Figures 7 and 8 illustrate the changed identities of the three boys who indicated in our conversations that their lives would be different from what they had known....Obviously, these changed images of themselves represent or are modeled after the most visible modern men in their experience; the government soldier, the teachers, and the first modern man they had come into contact with—the preachers (missionaries).

What do these images suggest as far as schooling is concerned? To the majority of the boys who see themselves as primitive adult men, school has no influence. While this majority admits changes in themselves as a result of schooling—being able to read, write, and compute—these changes are not seen by them to affect their adulthood.

Within this overall context, one could similarly surmise that given the schooling experience the children undergo, whatever shift there might have been (as in the case of some pupils) toward modern attitudes, it would not be sustained through practice as there are no immediate places or opportunities where such modern attitudes can be applied.... For the minority who have been partially re-socialized, the lack of local application would leave them marginalized.

—Soeharini Soepangat, Indonesian sociologist. *Indonesian School as Modernizer: a case study of the Orang Lembah Baliem Enculturation (Indonesia)*, 1986.

Soepangat studied the elemen-

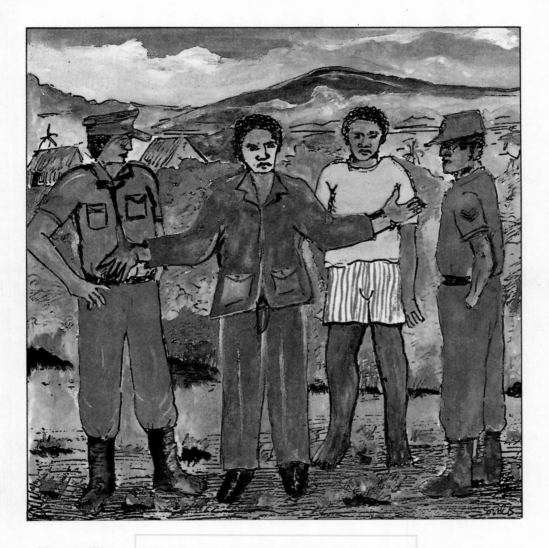

Kepala Desa aktif tukar pendapat dengan semua aparat yang ada di desa. Persoalan yang timbul di desa dibahas bersama. Laporan masyarakat segera diteliti dan bila perlu dimusyawarahkan untuk menentukan langkah-langkah mengatasinya. Kesemuanya demi kesejahteraan dan keamanan masyarakat desa.

The village head actively shapes opinions through the structures available in the village system. Problems that arise in the village are discussed together. Reports from the people immediately are recorded and discussed in order to make steps forward together. All this is for the sake of togetherness and peace among the residents of the village.

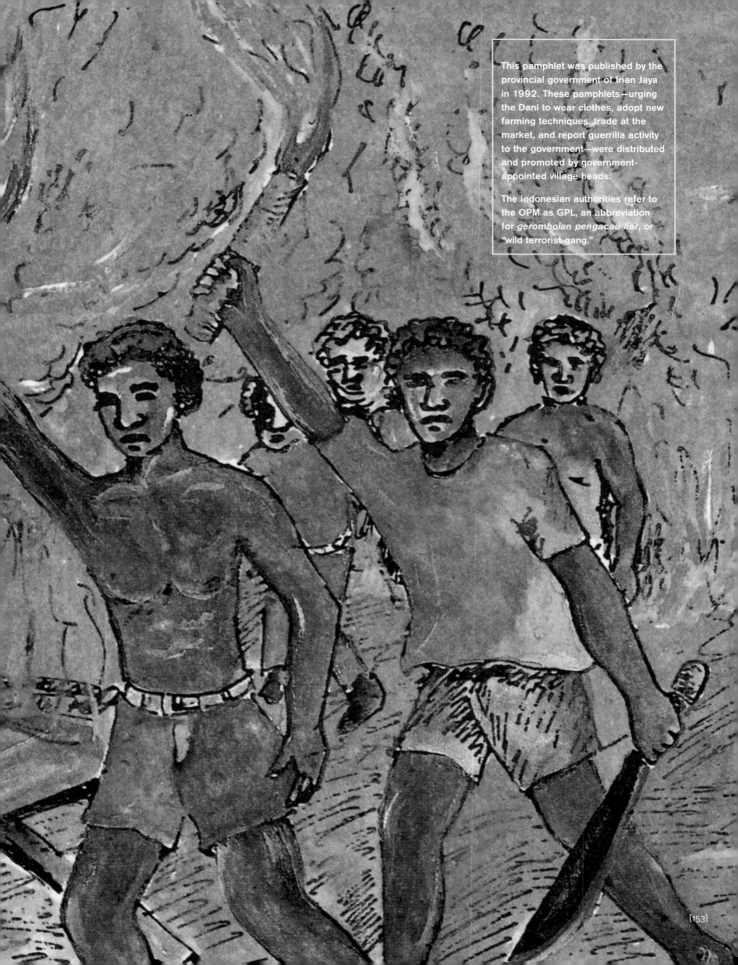

This pamphlet was published by the provincial government of Irian Jaya in 1992. These pamphlets—urging the Dani to wear clothes, adopt new farming techniques, trade at the market, and report guerrilla activity to the government—were distributed and promoted by government-appointed village heads.

The Indonesian authorities refer to the OPM as GPL, an abbreviation for *gerombolan pengacau liar*, or "wild terrorist gang."

[153]

Cultural Survival

1988-96

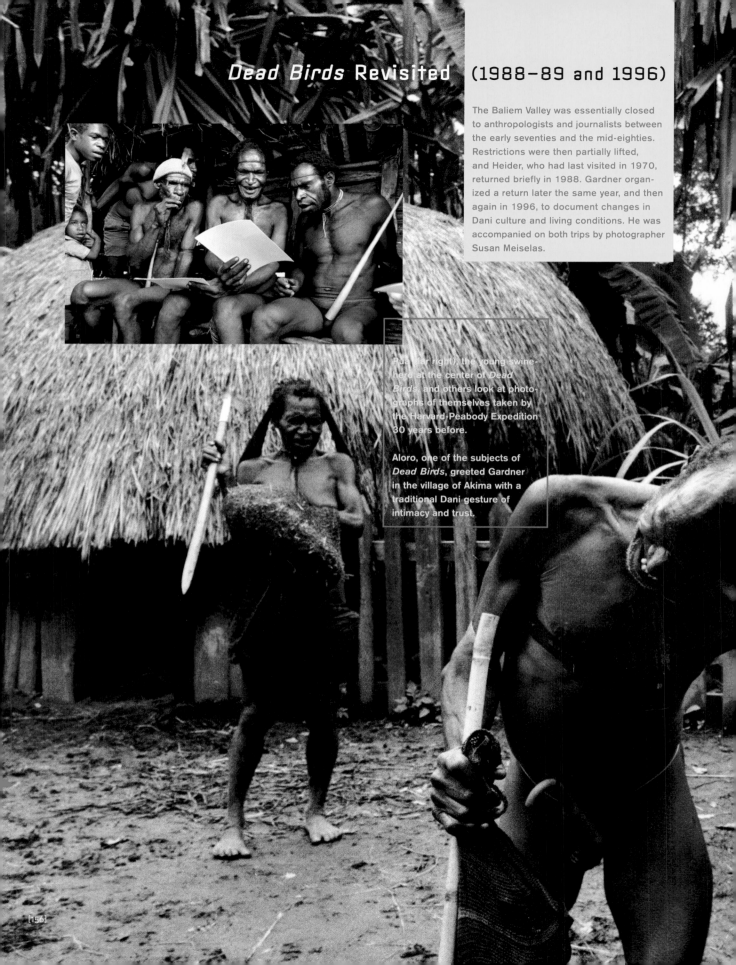

Dead Birds Revisited (1988–89 and 1996)

The Baliem Valley was essentially closed to anthropologists and journalists between the early seventies and the mid-eighties. Restrictions were then partially lifted, and Heider, who had last visited in 1970, returned briefly in 1988. Gardner organized a return later the same year, and then again in 1996, to document changes in Dani culture and living conditions. He was accompanied on both trips by photographer Susan Meiselas.

Pua (far right), the young swine-herd at the center of *Dead Birds*, and others look at photographs of themselves taken by the Harvard-Peabody Expedition 30 years before.

Aloro, one of the subjects of *Dead Birds*, greeted Gardner in the village of Akima with a traditional Dani gesture of intimacy and trust.

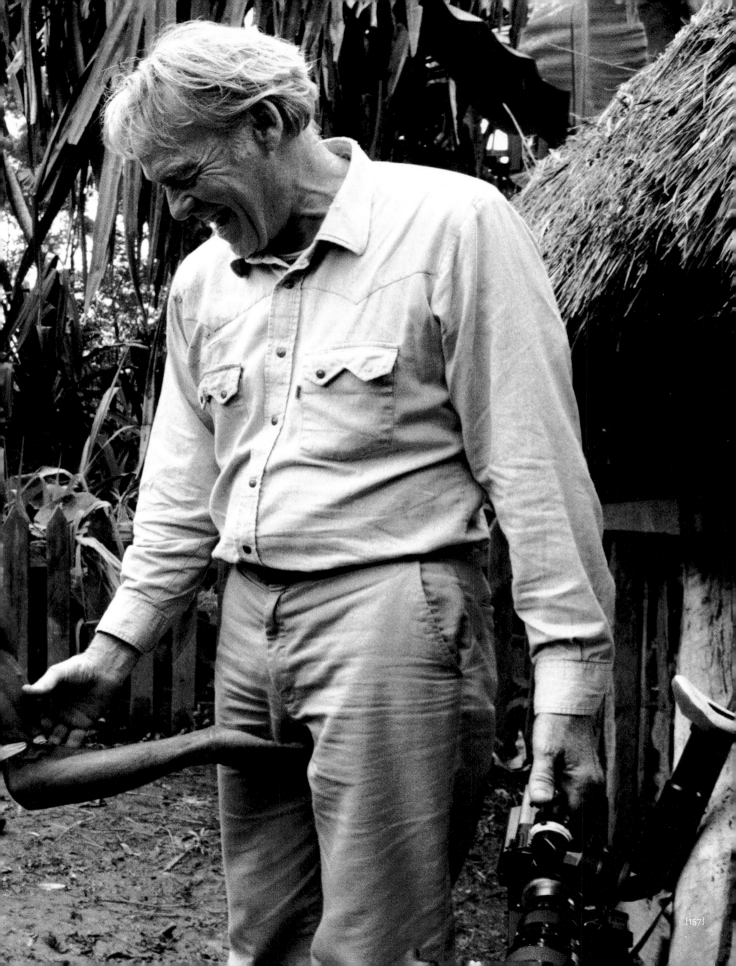

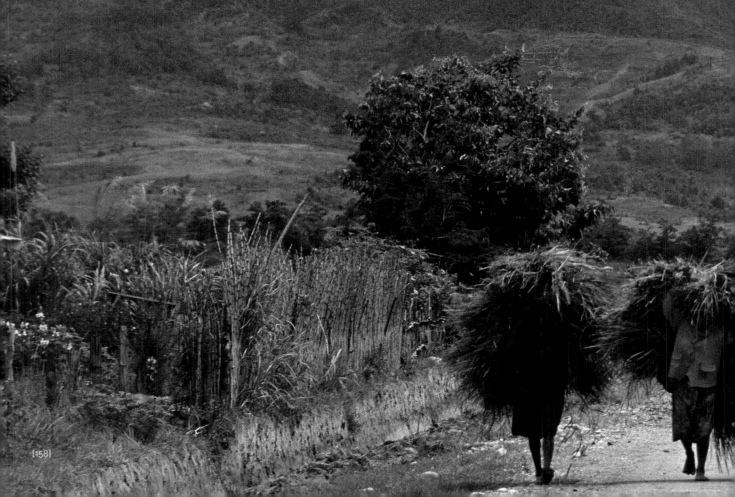

January 6, 1989

We left Wamena to come back up the road to Yibika. This road has begun to acquire an importance I had not at first glimpsed. It was something I greatly resented. I wanted the valley as I had remembered it. But it is too late and the road too inescapably present to not have a place in my view of this changing world. So now it stands not only for what has happened, but for everything it will cause to happen. It is the way to a dismal and inevitable future full of impoverishment and hopelessness. The prospect of any sane or rewarding progress is completely illusory and the memory of what was is rapidly entering myth....

—Robert Gardner. Unpublished journal, 1988–89.

The road is an enormous grave

being dug by its future inhabitants.

In 1979, work began on the Trans-Irian Highway. According to the original plans, the highway was supposed to connect Wamena to Jayapura (formerly Hollandia) on the north coast and Merauke on the south coast. It has not yet been completed, but the road does extend several hours drive outside Wamena, facilitating transport, trade, and political control.

Perhaps the strangest transformation in Wamena is the statue of Gutelu [also known as Kurelu], standing in a landscaped park near the Bupati's office. In the early 1960s, Gutelu was the most important leader of the Alliance where we stayed. During the last battles, in 1961, he was in charge of the rituals, and in a sense "owned" or had responsibility for, those battles....In 1988, Gutelu was an old man, irrelevant to what remained of the old life as well as the new. As he was dying in 1991, there was some discussion as to whether he should be cremated or turned into a mummy as an additional tourist attraction. He himself insisted on cremation, and that won out, but the life-sized statue standing proudly in war dress was erected in Wamena (and not in Jibiga, his home). The statue was modeled on an early photograph and is finished in glossy black, very like The Mummy.

In 1969, the Suharto regime began a major relocation program, resettling "transmigrants" from the more crowded parts of Indonesia—namely Java and Bali—to the less dense regions such as Irian Jaya. Besides relieving overcrowding, this was supposed to intersperse the less politically reliable parts of Indonesia with a new population whose loyalty to the government was ensured through subsidies. The *pendatang* (newcomers) in the Baliem Valley, however, are not sponsored by the government: they come on their own, looking for work and the opportunity to buy land, and often find jobs as merchants, in the government, or in the tourist industry.

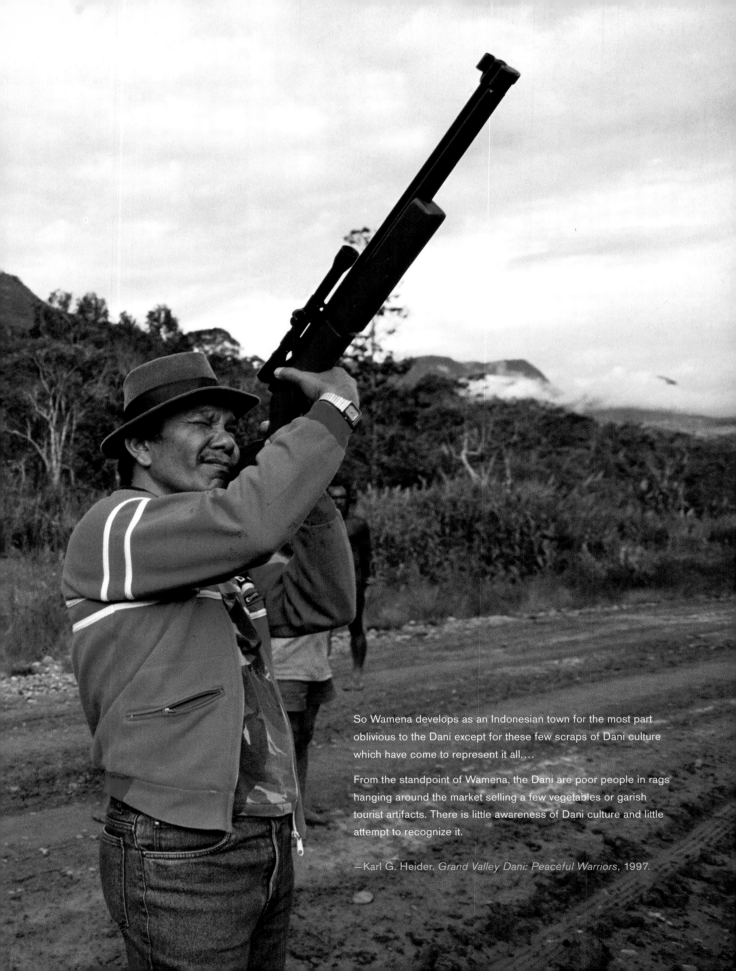

So Wamena develops as an Indonesian town for the most part oblivious to the Dani except for these few scraps of Dani culture which have come to represent it all....

From the standpoint of Wamena, the Dani are poor people in rags hanging around the market selling a few vegetables or garish tourist artifacts. There is little awareness of Dani culture and little attempt to recognize it.

—Karl G. Heider. *Grand Valley Dani: Peaceful Warriors*, 1997.

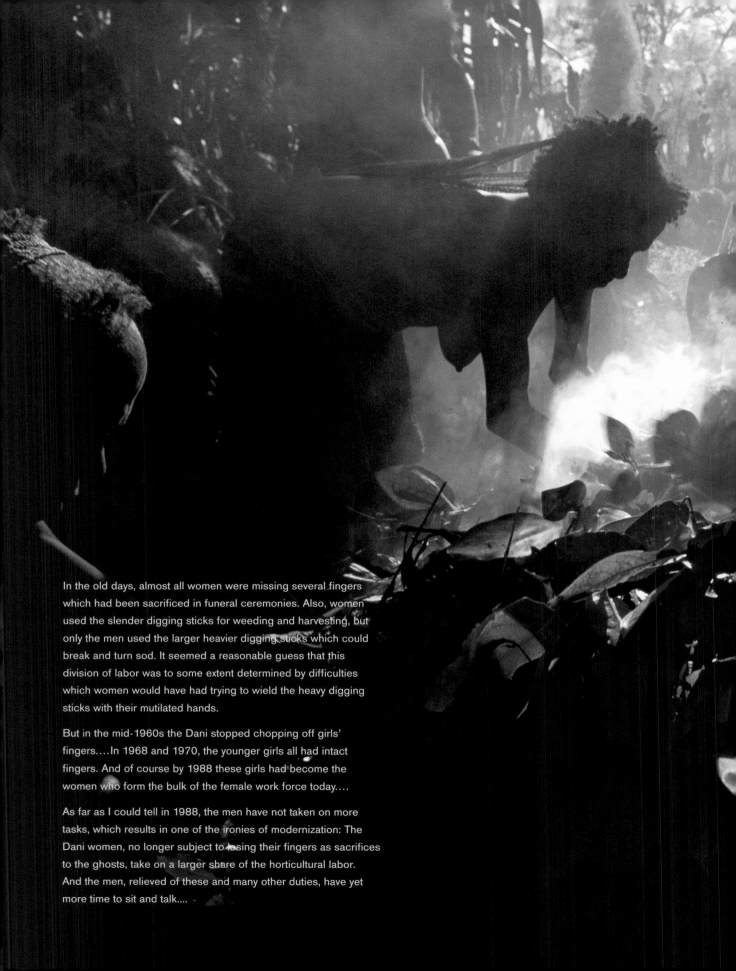

In the old days, almost all women were missing several fingers
which had been sacrificed in funeral ceremonies. Also, women
used the slender digging sticks for weeding and harvesting, but
only the men used the larger heavier digging sticks which could
break and turn sod. It seemed a reasonable guess that this
division of labor was to some extent determined by difficulties
which women would have had trying to wield the heavy digging
sticks with their mutilated hands.

But in the mid-1960s the Dani stopped chopping off girls'
fingers.…In 1968 and 1970, the younger girls all had intact
fingers. And of course by 1988 these girls had become the
women who form the bulk of the female work force today.…

As far as I could tell in 1988, the men have not taken on more
tasks, which results in one of the ironies of modernization: The
Dani women, no longer subject to losing their fingers as sacrifices
to the ghosts, take on a larger share of the horticultural labor.
And the men, relieved of these and many other duties, have yet
more time to sit and talk.…

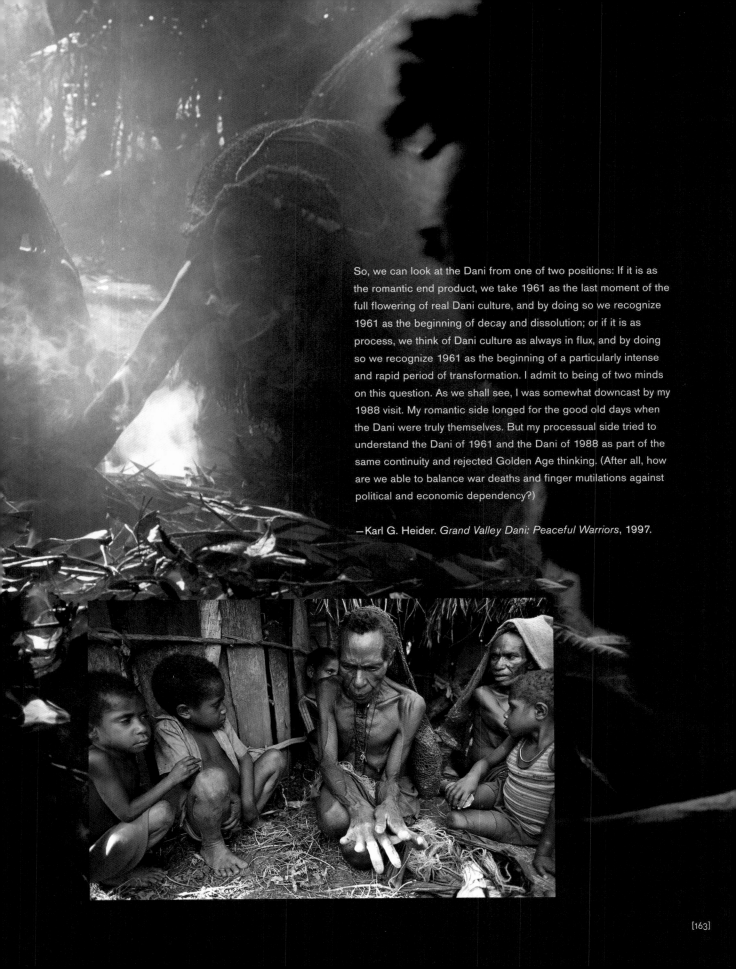

So, we can look at the Dani from one of two positions: If it is as the romantic end product, we take 1961 as the last moment of the full flowering of real Dani culture, and by doing so we recognize 1961 as the beginning of decay and dissolution; or if it is as process, we think of Dani culture as always in flux, and by doing so we recognize 1961 as the beginning of a particularly intense and rapid period of transformation. I admit to being of two minds on this question. As we shall see, I was somewhat downcast by my 1988 visit. My romantic side longed for the good old days when the Dani were truly themselves. But my processual side tried to understand the Dani of 1961 and the Dani of 1988 as part of the same continuity and rejected Golden Age thinking. (After all, how are we able to balance war deaths and finger mutilations against political and economic dependency?)

—Karl G. Heider. *Grand Valley Dani: Peaceful Warriors*, 1997.

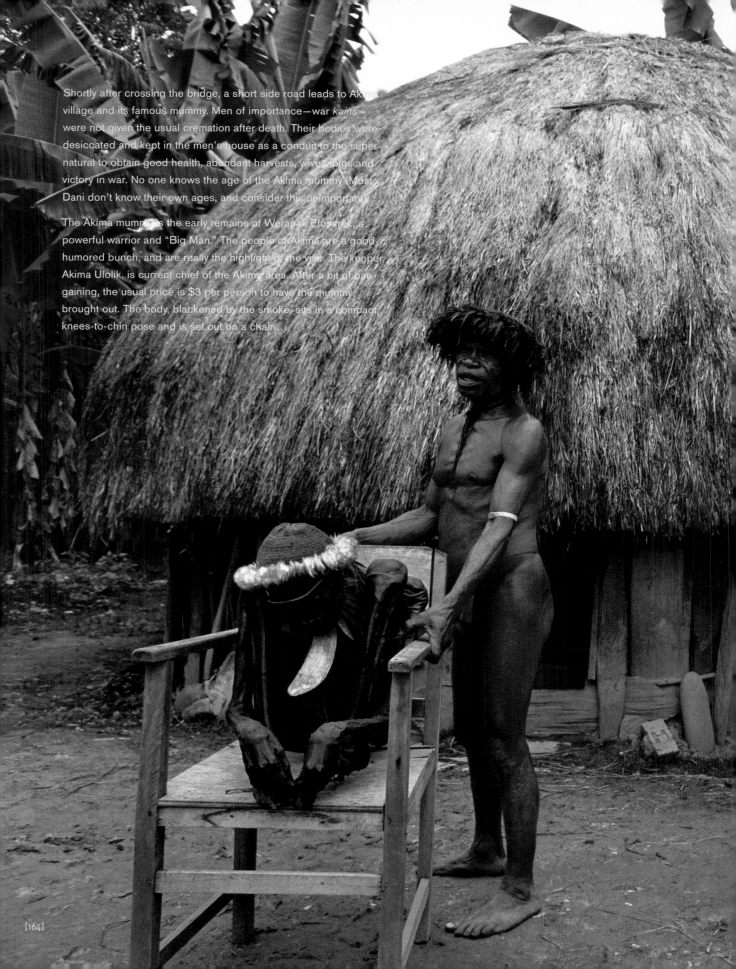

Shortly after crossing the bridge, a short side road leads to Akima village and its famous mummy. Men of importance—war *kains*—were not given the usual cremation after death. Their bodies were desiccated and kept in the men's house as a conduit to the supernatural to obtain good health, abundant harvests, wives, pigs and victory in war. No one knows the age of the Akima mummy (Most Dani don't know their own ages, and consider this unimportant).

The Akima mummy is the early remains of Werapak Elosarek, a powerful warrior and "Big Man." The people of Akima are a good-humored bunch, and are really the highlight of the visit. The keeper, Akima Ulolik, is current chief of the Akima area. After a bit of bargaining, the usual price is $3 per person to have the mummy brought out. The body, blackened by the smoke, sits in a compact, knees-to-chin pose and is set out on a chair....

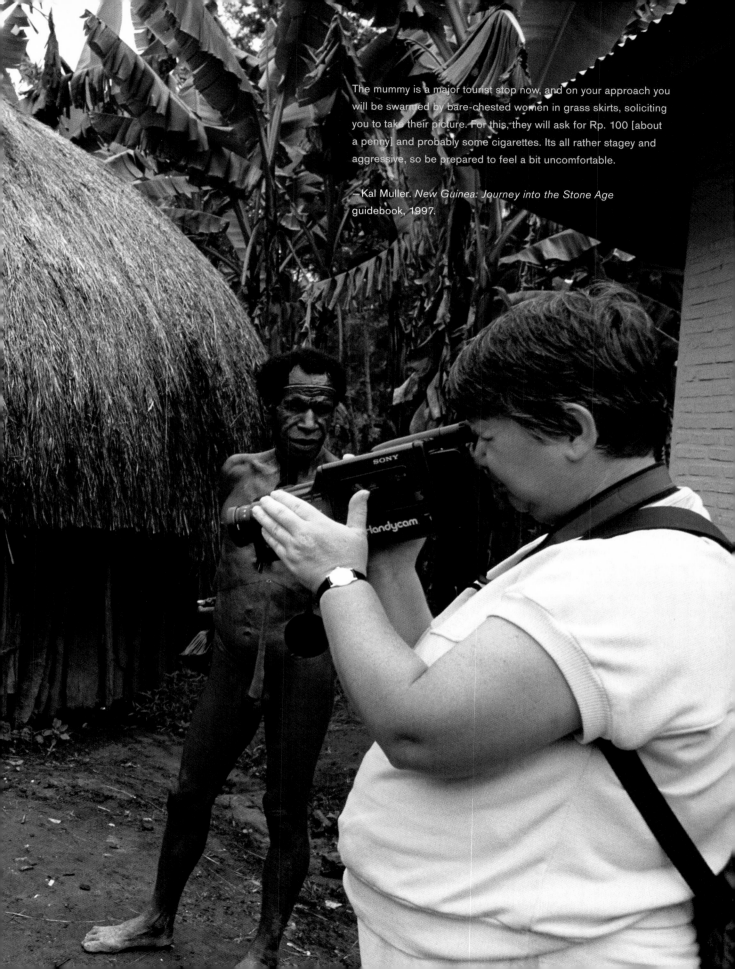

The mummy is a major tourist stop now, and on your approach you will be swarmed by bare-chested women in grass skirts, soliciting you to take their picture. For this, they will ask for Rp. 100 [about a penny] and probably some cigarettes. Its all rather stagey and aggressive, so be prepared to feel a bit uncomfortable.

—Kal Muller. *New Guinea: Journey into the Stone Age* guidebook, 1997.

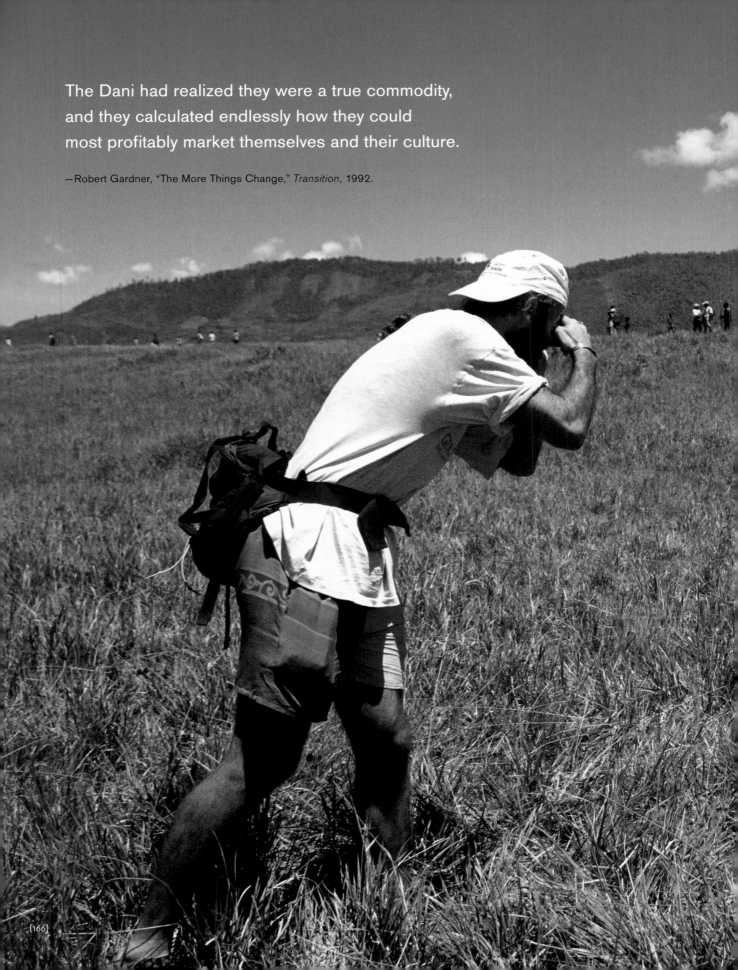

The Dani had realized they were a true commodity, and they calculated endlessly how they could most profitably market themselves and their culture.

—Robert Gardner, "The More Things Change," *Transition*, 1992.

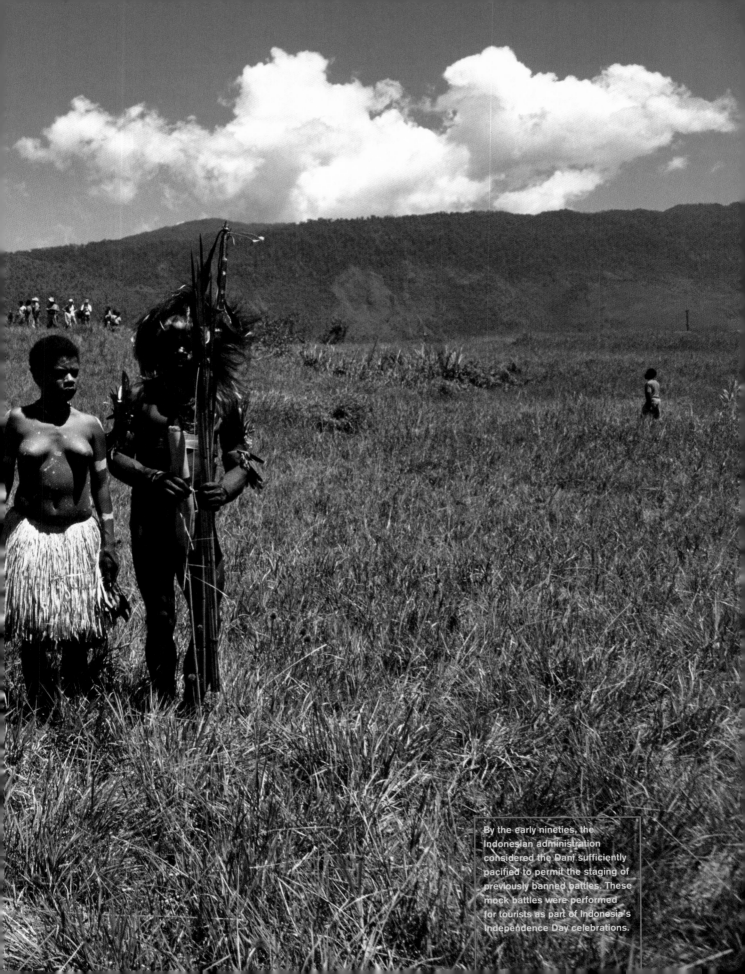

By the early nineties, the Indonesian administration considered the Dani sufficiently pacified to permit the staging of previously banned battles. These mock battles were performed for tourists as part of Indonesia's Independence Day celebrations.

How I Spent My Summer Vacation

My best vacation yet, took me to the most primitive place on earth - to the Indonesian province of Irian Jaya, on the worlds second largest island, New Guinea.

The Dani of the Baliem Valley

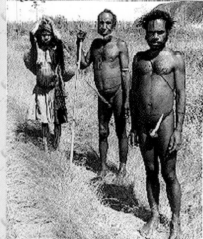

in the central highlands of Irian Jaya are among the most primitive people on earth. Unknown to the outside world before 1938, 60,000 of them lived a stone age existence when Archibald landed his Consolidated Model 28 flying boat on their lake. They still live a very independent existence, surviving on a diet consisting mostly of sweet potatoes. The traditional men wear only a penis gourd, simple jewelry such as a decorative arm band, boar's tusks through their noses, or a Cassawary feather headdress. The penis gourds (horim) are specially grown using an orchid chord and a weight to control their shape and length. They are supported by two strings, three strings in the case of an especially long one that needs extra help to maintain the appropriate angle. A wardrobe of several gourds is maintained for various occasions. The Dani men are actually quite modest and would never consider venturing out without a horim, as they would then be naked. With the modern world encroaching, fewer and fewer of the Dani men dress in the traditional manner.

The life expectancy of these gentle people was 60 years in 1938, about the same as the Western world. Dani men and women live separate lives, with the women tending the fields and performing the day-to-day manual labor. The men do the hard labor of digging irrigation ditches and erecting huts. The men (and boys over eight) sleep together in the men's hut (honnay), while the women sleep with the children and pigs in their own hut (wew umah). Wives are purchased with pigs and are deemed about equally valuable.

The lady

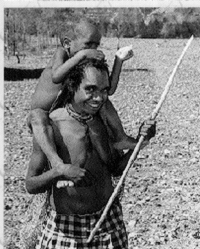

with the lovely, shy smile was walking with her mother, carrying her produce and son on her back. Living separate lives, the women seem happy, if somewhat aloof. They wear grass skirts as unmarried girls and graduate to woven skirts after they marry. The outside world, brought to them by Christian missionaries, has introduced Western clothes to many. This lady still carries her belongings in a traditional woven bag (noken) supported by a band around her forehead. The bags are woven by the women from orchid fibers. The craftsmanship is beautiful. Often the noken is a true work of art.

Children are not weaned until 4 or 5 years of age. Sex is not allowed while the woman is nursing a child. As a result, men often have multple wives. Since they live in separate huts, a man signals that he wants to have sex, and his wife then sleeps near the door of the women's hut. "Mixups" (according to rumor) easily happen and often do. Traditionally, the offending male must pay for mistakes with pigs offered to the offendee's husband.

Get to this lovely place before it loses its innocence.

Want to see some more pictures of the Dani people? Yes, tax the bandwidth Show me the pics.

If you have any interest in some totally amateur video I shot in Irian Jaya, E-mail me for details.

Two hours for $30 US. almiller@usa.net

If you like what you see or have any suggestions, email m

or enter something in my Guestbook

Page last modified May 12, 1996

For more information and some references, cli

Tourists began to play a significant role in Dani culture and economics in the late eighties, when governmental restrictions on foreign tourism in the highlands eased. In the nineties, more and more private companies offered their adventurous American and European clients package tours in the Baliem Valley. These "eco-tourists" perceived themselves to be creating a market for the preservation of traditional Dani culture.

Ecotourism (1988-2000)

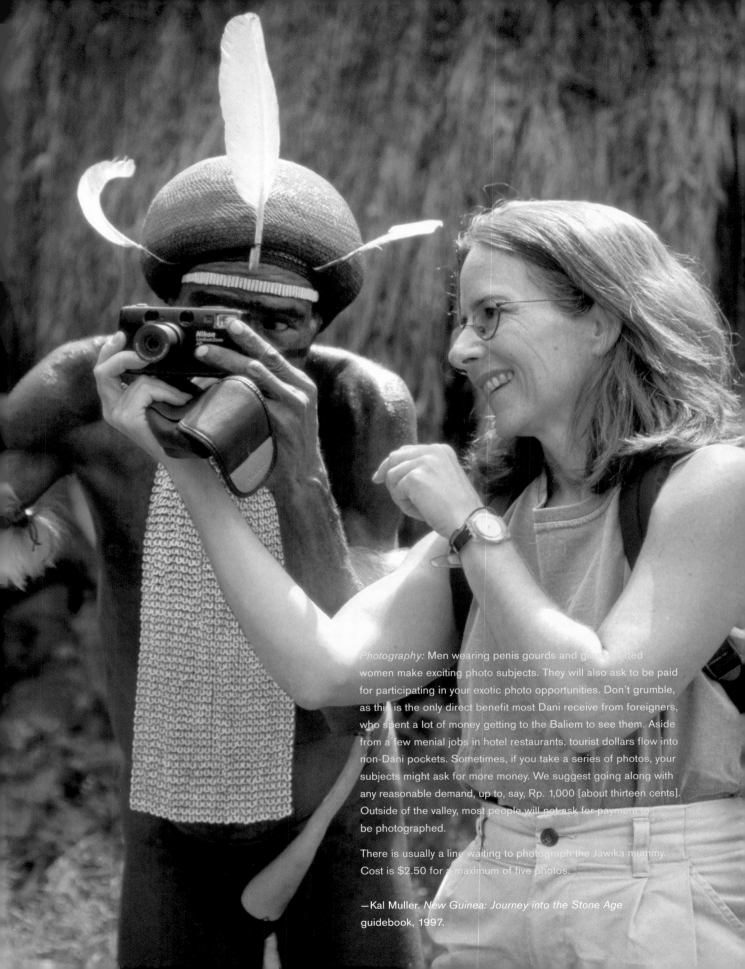

Photography: Men wearing penis gourds and grass-skirted women make exciting photo subjects. They will also ask to be paid for participating in your exotic photo opportunities. Don't grumble, as this is the only direct benefit most Dani receive from foreigners, who spent a lot of money getting to the Baliem to see them. Aside from a few menial jobs in hotel restaurants, tourist dollars flow into non-Dani pockets. Sometimes, if you take a series of photos, your subjects might ask for more money. We suggest going along with any reasonable demand, up to, say, Rp. 1,000 [about thirteen cents]. Outside of the valley, most people will not ask for payment to be photographed.

There is usually a line waiting to photograph the Jawika mummy. Cost is $2.50 for a maximum of five photos.

—Kal Muller. *New Guinea: Journey into the Stone Age* guidebook, 1997.

Hidden Cultures (namely myself and my partner, Kornelius) has high ecotourism as well as personal standards, and we really try to look for unspoiled places where the local people may use "modern things," but are committed to maintaining cultural traditions, and actively live and teach those traditions to their children. Keeping this in mind, we saw a number of villages, all of which were friendly and welcoming however they either seemed a bit "touristy," or did not have areas for setting up camp. We kept on wandering and came across Dogum. It was perfect for us. Traditional, out of the way, and very, very friendly. Kousa and Kirik (the two chiefs) were so happy to see people who are interested in their culture that they had tears in their eyes when they greeted us and told us they would be happy for us to stay with them.

In speaking to Kousa and Kirik they expressed concern at the lack of visitors (westerners) to the Baliem Valley and their village which, after all, is a pretty famous village given the books written about it [including *Gardens of War*].

Later in the afternoon we were all invited into the chief's house with all of the men of the village. There we sat in the dimly lit and smoky hut while the men talked about daily life and their hopes for the future. Their biggest concern was around who will preserve their culture when they are gone? Will someone take a village and put it in a museum somewhere? The children don't seem interested enough to carry on the full tradition. These men are watching their culture slip away, and it worries them. They also want the balance that we (Hidden Cultures) have envisioned: an educated and progressive lifestyle mixed with time to live traditionally,… to move forward without forgetting the past. Additionally, they know that tourism, managed tourism, will help to keep their culture alive. They don't want to put on a show for people,… they just want people to come and share their way of life. My feeling is that it validates them and enhances their cultural pride.

—Jill Paley, American tour guide. Email to Susan Meiselas, 2001.

Netscape: dani_people

Location: http://www.hiddencultures.com/trips/dani.html

Adventure travel specializing in the indigenous people of Irian Jaya

The Dani People: From Ritual To Laughter

"Dani" is a generic term applied to all the tribes of the Baliem Valley who are believed to have inhabited the region for more than 40,000 years.

Upon first meeting a traditional Dani, you will notice that the they reject clothing other than a woven or grass skirt worn by the women and a penis sheath by the men. The Dani are extremely fond of body ornamentation and decorate themselves elaborately with feathers, shells and paint, especially for celebrations and honored guests!

HC Home

Intro to Irian Jaya

Adventure Descriptions: Dani, Asmat, Korowai, Yali & Carstenz

What to Expect

What to Bring

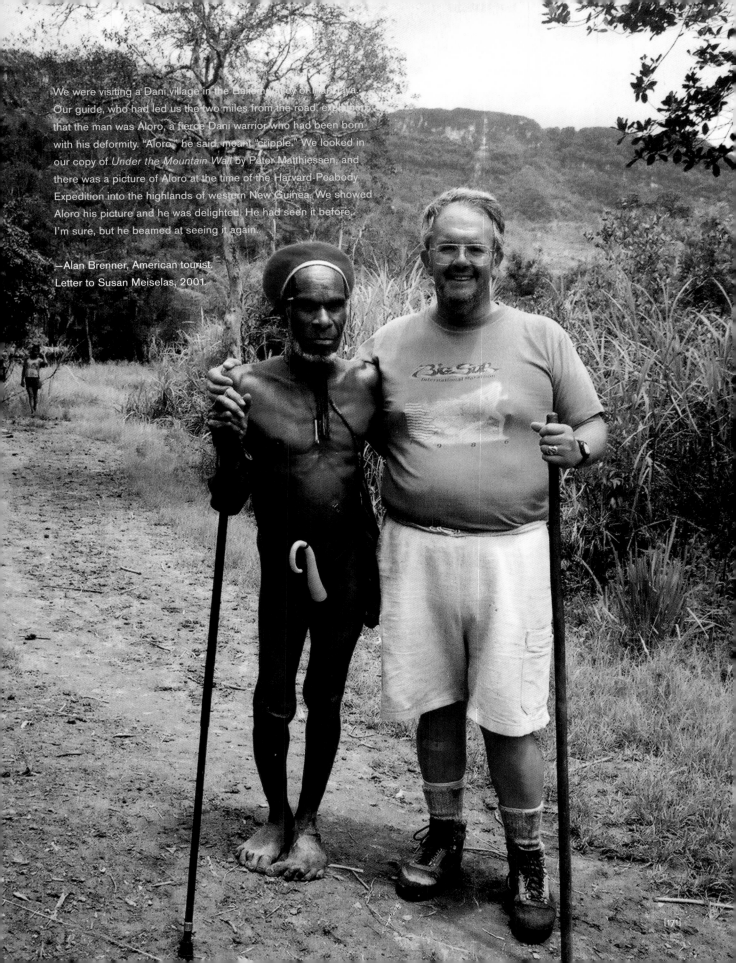

We were visiting a Dani village in the Baliem Valley of Irian Jaya.
Our guide, who had led us the two miles from the road, explained
that the man was Aloro, a fierce Dani warrior who had been born
with his deformity. "Aloro," he said, meant "cripple." We looked in
our copy of *Under the Mountain Wall* by Peter Matthiessen, and
there was a picture of Aloro at the time of the Harvard-Peabody
Expedition into the highlands of western New Guinea. We showed
Aloro his picture and he was delighted. He had seen it before,
I'm sure, but he beamed at seeing it again.

—Alan Brenner, American tourist.
Letter to Susan Meiselas, 2001.

For Gardner and his group, their first season in the Baliem Valley must have been like fishing in an aquarium loaded with exotic tropical fish. Now, some 40 years later, all that was left was a few stocked ponds at a fisherman's lodge.

I soon realized that the task for me, as photographer trying to document the life of the Dani after first contact, was to look at the conflict between the modern and the Dani worlds. Wamena is the only place where these two spheres really intersect.

—George Steinmetz, American photographer.
Email to Susan Meiselas, 2003.

Madonna
Like you've never seen her before.

IN BED WITH MADONNA

DOLBY STEREO

The movie poster advertises a heavily censored version of the Madonna movie *Truth or Dare*. Its subtitles were in Bahasa Indonesia, which many Dani do not understand.

For us to remain strong we must keep *adat* strong
to resist encroachment of newcomers. *Adat* [traditional
leadership] is still intact even if we have to become
developed. Our valley is still so fertile because of
the success of our *adat*. Keeping control of our fertility
and our land: that is the new war now.

—Agus Kossay. Interview with Leslie Butt, 2001.

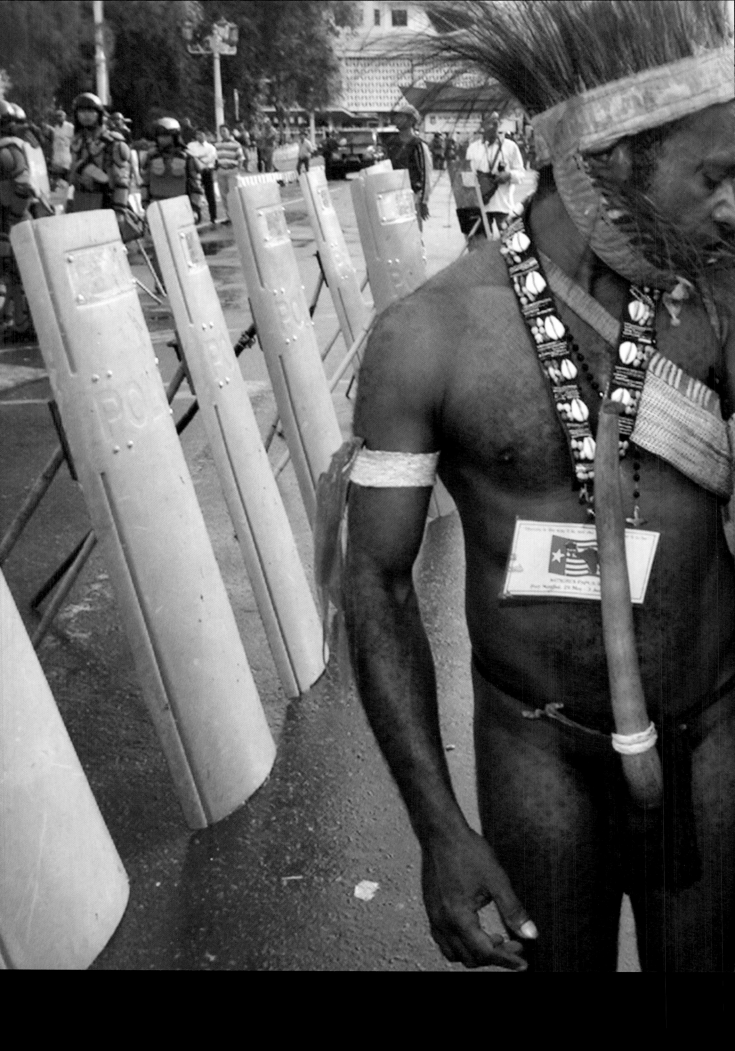

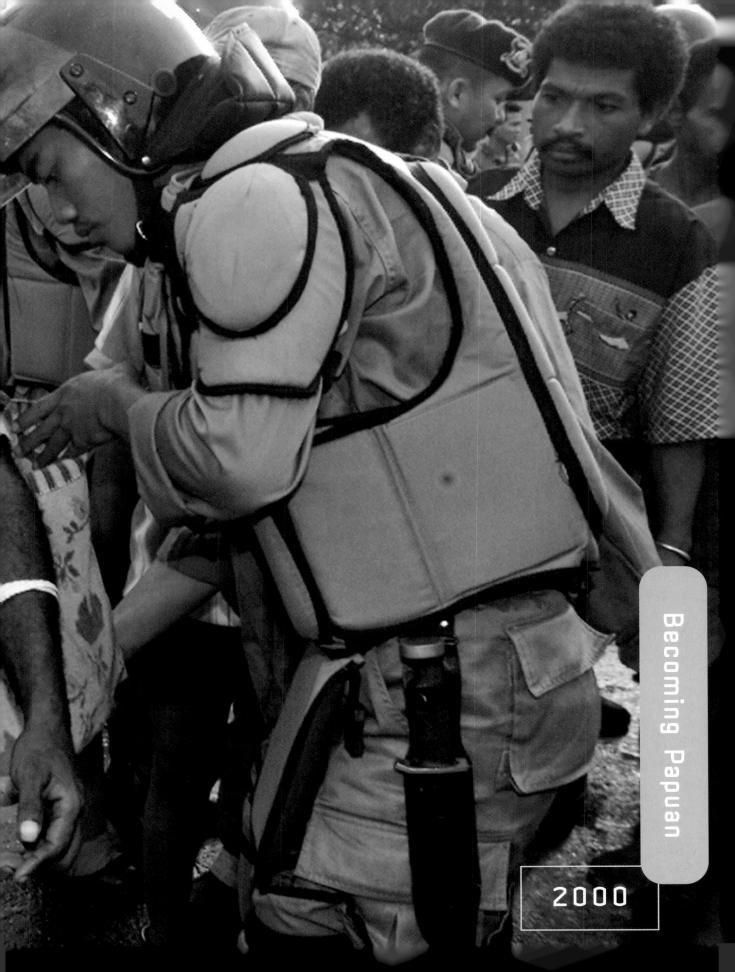

Becoming Papuan

2000

Active Resistance and the OPM (1965–2000)

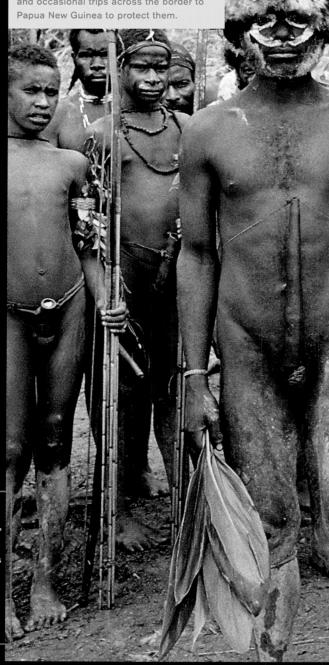

Papuan exiles in the Netherlands started organizations to lobby for Papuan independence, some promoting armed resistance while others sought the international community's attention. Low-intensity guerrilla warfare against Indonesia has continued since 1965. Several different groups—most prominently the OPM—make hit-and-run attacks on the Indonesian military and rely on the forests, the sympathetic population, and occasional trips across the border to Papua New Guinea to protect them.

We believe that when people take our lands, or exploit our lands, or move us, that is like taking plants and seeds from my land to here and saying "it can grow here because this is land, this is soil, this country has soil and that country has soil, so we can just plant here"—it is impossible. It means we are killing it, even though the plant is still alive; so it is with moving people from one village to another, one land to the other...

I myself was in some of the wars, not fighting, but when I was a child. And I saw [for] myself, people were killed. I think compared to East Timor, West Papua is worse. Worse, because the large numbers, the numbers of people killed, and the treatment is worse, and also it is never exposed because of the isolation—few people can speak English or get access to the outside world. I am the one person from the Baliem Valley abroad now. No one else...

We live in mountainous areas and from one valley to another we don't know each other. So we don't know what's happening in the other tribe.

We are just fighting back traditionally, for this is our way to disagree. In my culture, to disagree is to fight; that's what I can do, because that's what I know. And people here from this world say that this is guerrilla fighters, terrorist groups or whatever; from here, I can see myself in that situation. And that is a good lesson I am learning. That's our only way—fighting— our way of disagreeing things. Not the way that this world wants or approves.

—Anonymous OPM representative.
Interviewed in *Do or Die*, 1999.

The word many Papuans use to describe their goal—*merdeka*— means "freedom" or "liberation" in Indonesian. It is the same word that Indonesian nationalists used to describe their struggle against Dutch colonialism. In Papua, the term has taken on a profound, almost spiritual, significance.

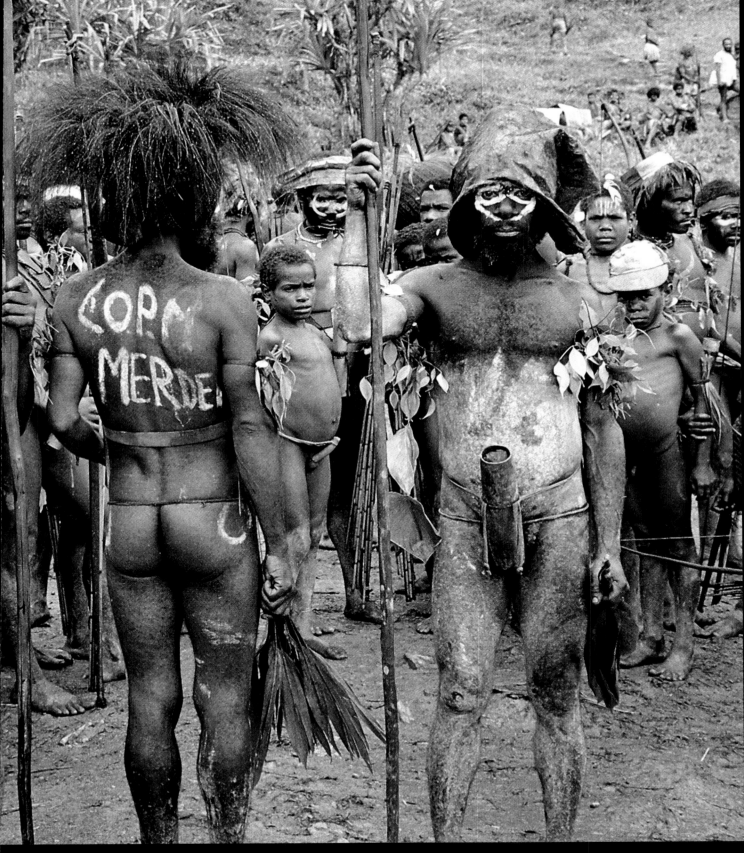

Cenderaw

MENYAMBUT PEND

Selasa, 30 Mei 2000 **TERBIT 12 HALAMAN**

KONGRES PAPUA
Membawa Keme

Agus Alua: Kongres Papua Merupakan Puncak Perjalanan Patriotis yan

Papua Congress Must Bring Victory

Papuans feel that one way to liberate the Papuan people from their suffering is "Merdeka." They have to unite for this. But how to unite? First, we tried to create unity with the Team of One Hundred, and wherever they went, they were accepted as good people. Then, we united for the MUBES (*musyawarah besar*—big meeting); when this diverse group came together as one, nationalism became our goal. Finally in 2000, there was the Congress, which agreed that the political aspiration must erase the stigmas of tribalism. At that time things began to get better, and for the first two years, no matter where people were from, they were united. By 1998 aspirations for reform began, and quickly turned into a movement.

Now, we are trying to build a "Presidium" that unites everyone. But this union is seen a as a threat by Indonesia and it has been infiltrated, causing disorder. It is our duty to organize and channel people's aspirations—using democratic methods, peaceful methods. And this is what we have been doing. We have said that the way—the *only* way—for us to pursue our struggle is through dialogue, If we, as Papuans, move away from dialogue, we will be destroyed.

Battle is part of Dani culture. The biggest challenge that we ask of the Dani and other tribes is to consolidate peacefully. We must continue to work hard, to be careful, and to not engage in violence. We cannot allow ourselves to be provoked into fighting.

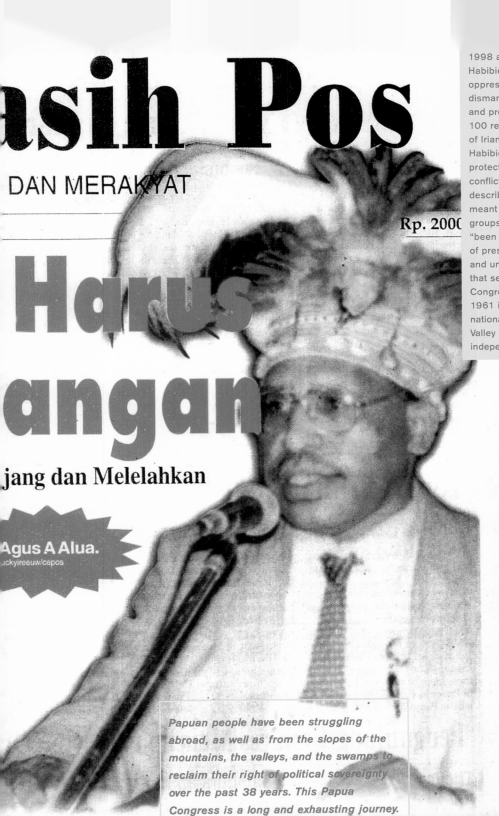

asih Pos

DAN MERAKYAT

Rp. 2000

Harus
angan

jang dan Melelahkan

Agus A Alua.
uckyireeuw/cepos

1998 and his former vice president, B.J. Habibie, took over, many of Suharto's oppressive "New Order" policies were dismantled: political prisoners were freed and press restrictions lifted. In 1999, 100 representatives from various regions of Irian Jaya came to Jakarta to talk with Habibie, in order to promote human rights protection and political solutions to the conflict. Agus Alua, a prominent Dani leader, described what Indonesian integration meant for the Dani and other indigenous groups. He told Habibie that they have "been slaughtered like beasts for the sake of preserving Indonesian political stability and unity." Alua chaired the committee that set up the Second Papuan National Congress (the New Guinea Council of 1961 is viewed as the first). Papuan nationalists—with hundreds from the Baliem Valley among them—agreed on pursuing independence through peaceful negotiation.

Papuan people have been struggling abroad, as well as from the slopes of the mountains, the valleys, and the swamps to reclaim their right of political sovereignty over the past 38 years. This Papua Congress is a long and exhausting journey.

It was late July, and the bright blue sky clear. We were on our way to Pyramid, one of many villages bombed by the Indonesian military in the 1970s, to talk to survivors of the killings. We had passed dozens of militia outposts on the road out of Wamena; spear-wielding villagers training for what they saw as inevitable "independence."

From a distance, on a sunny patch of road, we saw the warriors come towards us. They were coming down from the hills to attend pro-independence rallies. Actually, they thought Papua was already independent. They called themselves "OPM," and fearlessly vowed to fight the Indonesian military. They were happy: they whooped and hollered in their native language, "freedom!" When I saw them again down the road at a militia post, they shook hands with the local villagers, who expressed their thanks and admiration.

Days later, the military would shoot into an independence rally in Wamena. The rebels retaliated, killing many migrants from Java and neighboring islands. I don't know what happened to the men in this picture, but some of the independence activists I met in Wamena are now in jail.

Others across Papua, such as separatist leader Theys Eluay, are dead or missing. My activist friend who accompanied me that beautiful afternoon? Despite many attempts to find him, I've not heard from him again.

Today, the militia posts are gone. No one admits to be OPM. Journalists require special permits to travel the area. My peers say I was lucky: few are likely to see again what I saw that bright, sunny day.

—Dini Djalal, Indonesian journalist.
Email to Susan Meiselas, 2001.

After the Papuan National Congress, many Papuans thought *merdeka* was imminent. Papuan nationalists organized *satgas*, civilian militias, like this one drilling outside Wamena, to protect *merdeka* supporters from police brutality. Some of these *Satgas* Papua units also intimidated and extorted money from migrants.

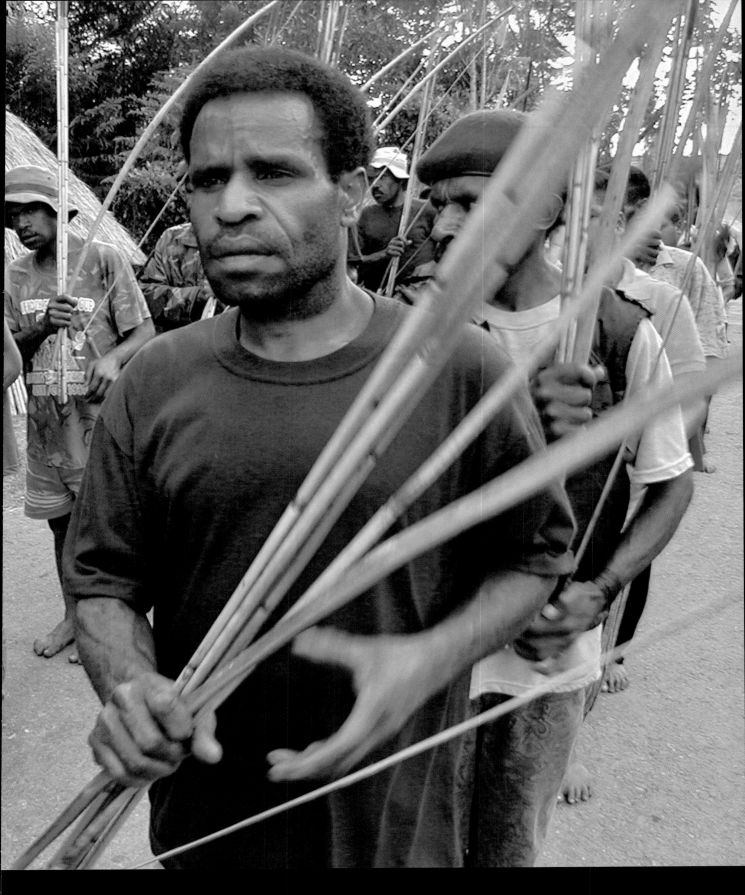

On October 3, Presidium leaders in Jayapura claimed that they had won a delay, despite heavy pressure form Indonesian authorities, in the implementation of the ban on the Morning Star flag....Three days later, however, despite the agreement, the provincial authorities launched a series of coordinated raids in and around Wamena aimed at suppressing the flag....

The events of October 6 began with a military and police roll call at the field outside Wamena police headquarters at 6:15 a.m. The first *posko* [communications post] attack was at 6:45 a.m. In each case, the posts were attacked deliberately and with considerable force. In most, warning shots were fired to disperse Papuans gathered at the *posko*, the flagpole was chainsawed and the flag torn up or confiscated....By 8:00 a.m., more than fifty people rounded up from five posts had been taken to police headquarters. Police there reportedly assaulted detainees, kicking them and beating them with rifle butts and wooden staffs....

Throughout the morning, Papuans had flocked to the town to defend the flag. By the early afternoon, a large crowd had gathered across the river from Wamena near the village of Wouma where the Morning Star flag was still flying....Starting at about 3:00 p.m., the crowd crossed the river and took to the streets to protest, burning and looting shops as they went. Shortly thereafter, troops arrived in tow trucks. The troops opened fire into the air and at the ground to disperse the crowd and clear the road, but then withdrew in the direction of the town, followed by the Papuan crowd in hot pursuit. At a market-place, shots were fired at the crowd from a nearby migrant residential neighborhood. Seeing that the troops were now using the houses of non-Papuans, the crowd attacked the homes and their inhabitants. In the ensuing melee, at least seven Papauns were shot and killed and twenty-four non-Papuans were killed....

On October 11, senior military police and civilian officials reached an agreement with local independence leaders, including the Reverend Obet Koma [Obeth Komba], a Presidium member, and four people who had represented Wamena at the Mubes and congress....On December 13, 2000, two months after the violence, with none of the perpetrators apprehended, the five were arrested....In essence...the leaders were made scapegoats for the Wamena violence.

—Human Rights Watch, July 2001. *Violence and Political Impasse in Papua*, 2001.

Flag Raising in Wamena (July 14–October 6, 2000)

On July 14, 2000, on the anniversary of the Act of Free Choice, Wamena residents raised the Morning Star flag. In Sukarno and Suharto's Indonesia, flying the Morning Star was considered treason. Since Suharto's resignation, the status of the Morning Star has been ambiguous. During his brief term in office, President Wahid approved the flying of the Morning Star, despite the opposition of military leaders. The police, reportedly acting on an order from the vice president, Megawati Sukarnoputri—Sukarno's daughter and an opponent of Wahid's conciliatory policies towards the Papuan nationalists—ordered the flags taken down. On October 6, 2000, the Indonesian police and troops, carrying assault rifles, went in to take down several Morning Star flags flying in Wamena by force. Hundreds of Dani, carrying bows and arrows, came out to stop them. In the riots that followed, police murdered Papuans, and Papuans murdered Indonesian migrants living in Wamena.

There was any legal reason for us to be detained. But they couldn't figure out who was behind the October 6 incident, so they had to imprison us. The police engineered this event. They were aware that there would be a reaction to their action. The people cannot be blamed for what took place.

—Obeth Komba, Dani religious leader.
Interview with Eben Kirksey, 2003.

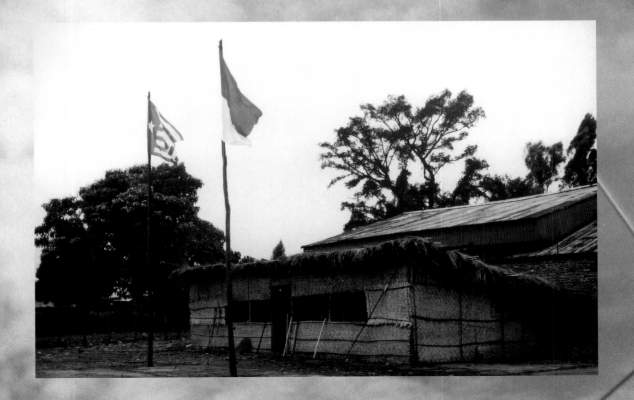

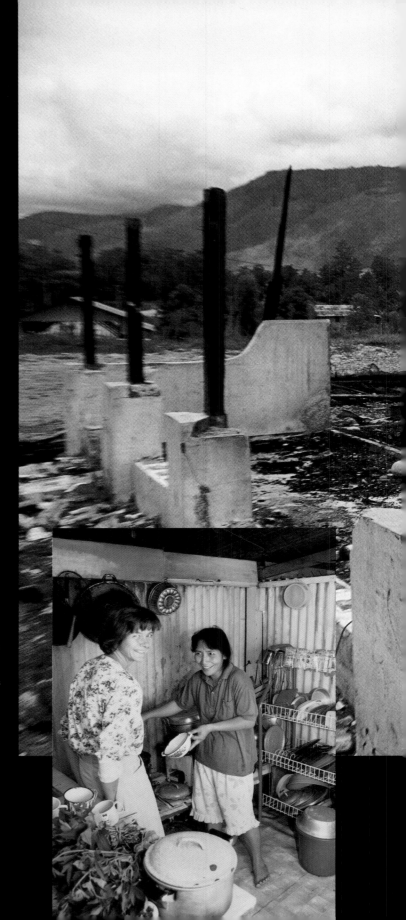

Rose and her family stayed on in the same house for years, even after the Wouma market started a moonshine distillery in 1998, and even after many thousands of other migrants had left the valley. And Rose stayed on even when on October 6, 2000, a large number of angry Papuans gathered on the bridge over the Ue river. They were organizing a revenge attack for the murder of a Papuan man who had refused to take down the Morning Star flag. When confronted by police, the group ran along the road between the Ue River and the Wouma market, entering houses and killing or maiming each migrant and each migrant policeman they found. The migrant family with the fancy house, right on the river, was the first to be killed. Rose's house was about 5 doors down from the river. Rose was killed, decapitated as she prayed. Her daughter Trini had her back hacked open, and her son David's tongue was cut out. Kiki, who wasn't there, was unharmed. The killings continued all along that side of the street and up to the Wouma market. Apparently, the plan had been to turn around and kill everyone on the other side of the street as well, but soldiers dispersed the group.

I was able to return to Wamena on September 12, 2001 and my friend and former housemate Pebe took me to see the ruins on the north side of the road. We walked up and down the road. On the one side, there was a burned shell of a home and a broken up pile of rocks to remind us where Rose's house had been. Violence piled on violence. It still jangles me, and I take little consolation in analyzing the Wamena massacre from the viewpoint of Indonesian politics, legacies of colonialism, or decades of deeply-etched racism. I don't fault Papuans for their anger or their desire for revenge. It just strikes me it might be nice to find a way to honor those who died just for trying to build themselves a modest life, for being good neighbors, and for doing the work of making it through.

—Leslie Butt, Canadian anthropologist.
Email to Susan Meiselas, 2003.

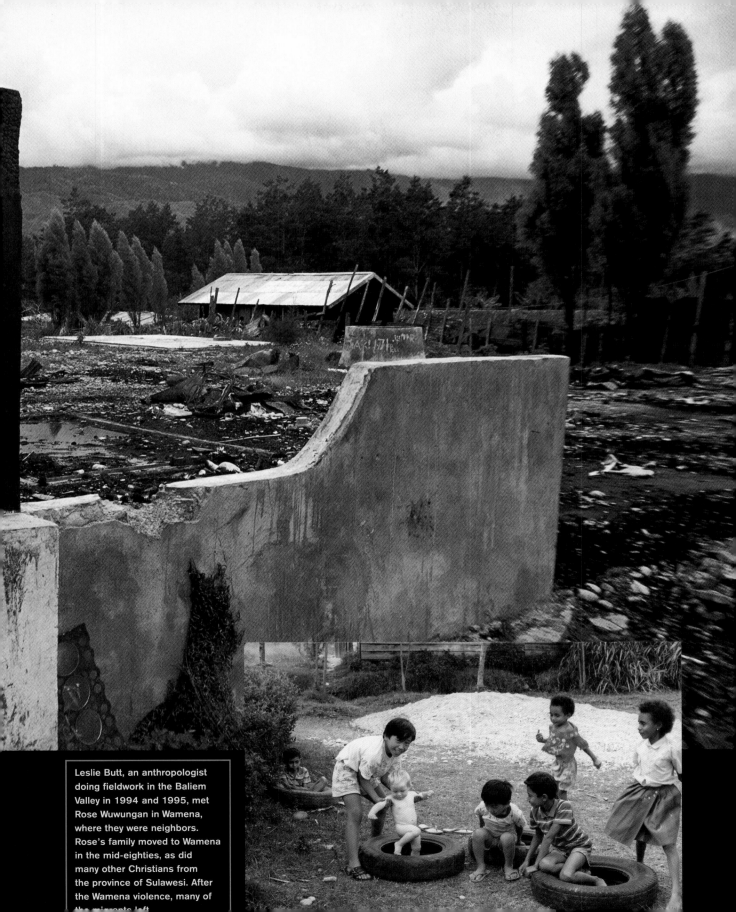

Leslie Butt, an anthropologist doing fieldwork in the Baliem Valley in 1994 and 1995, met Rose Wuwungan in Wamena, where they were neighbors. Rose's family moved to Wamena in the mid-eighties, as did many other Christians from the province of Sulawesi. After the Wamena violence, many of the migrants left

There's a lot of hatred flowing around here.
But when the army attacked us and we retreated
that day, going into people's houses and killing
them and burning their houses, it wasn't hatred
for *pendatang* [newcomers] that made us do it.
That day it was all about a Free Papua—those
people just had to be gotten out of the way as
they were an obstacle to us getting a Free Papua.
All we wanted that day was freedom.

—Anonymous participant in the Wamena violence. Interview with Leslie Butt, 2000.

Memoria Passionis is the memory of suffering—
suffering due to violations of human rights, due
to economic development, due to the domination
of Javanese culture. This collective memory is
pushing us to be free.

—Agus Alua. Interview with Brigham Montrose Golden, 2003.

Notes

The sources of images and texts are listed left to right for each double-page spread. Short titles have generally been used. The following abbreviations identify frequently cited sources:

AC Archbold Collection, Department of Mammalogy Archives, American Museum of Natural History, New York
AP Associated Press
FSC Film Study Center, Harvard University, Cambridge, Massachusetts
KITLV Royal Netherlands Institute of Southeast Asian and Caribbean Studies, Leiden, The Netherlands
PFA Provincialate Franciscan Archive, Utrecht, The Netherlands
RMV Collection Van Arcken, Rijksmuseum voor Volkenkunde, Leiden
SF Spaarnestad Fotoarchief, Haarlem, The Netherlands
UPI United Press International
VEM Vereinte Evangelische Mission Bildarchiv, Wuppertal, Germany

We would like to thank the following individuals and archivists who kindly made their collections available to us:

Jan Beiboer
Myron Bromley
Leslie Butt
Robert Gardner/Film Study Center
Larry M. Lake
Mrs. Betty McCollom and Jane Deuser
Larry Naylor
John Saltford
Carel Schneider
Frits Veldkamp
Nico Verheyen
Annegriet Wietsma
Siegfried Zöllner

Carmel Budiardjo/TAPOL, London
Ramona Hedtmann/Vereinte Evangelische Mission, Wuppertal
Dr. Gerrit Knaap/KITLV, Leiden
Marla Krauss/American Museum of Natural History, New York
Rob Mast & Rob Molenkamp/Spaarnestad Fotoarchief, Haarlem
Wim Rosema/Rijksmuseum voor Volkenkunde, Leiden
Bob Schijns/Franciscan Comunidad, Leiden
Mike Sohn, The Christian and Missionary Archive, Colorado Springs

Page 1: Aerial view of the Baliem Valley, 1938, courtesy of AC.
Page 2: Peter Sutcliffe, "The Day the Dani People Become Civilized, the Sun Will No Longer Rise!" *Papua New Guinea Post-Courier* (Port Moresby), July 27, 1972.

Expeditions and Accidents of Discovery

Pages 4–5: Aerial view of the Baliem Valley, 1938, courtesy of AC.
Pages 6–7: Richard Archbold, "Seaplane Alights on Lake 2 Miles Up," *New York Times*, July 24, 1938, sec. 2, courtesy of AC. Archbold to Van Arcken, courtesy of RMV. Aerial view of the Baliem Valley, 1938, courtesy of AC. Archbold and A.L. Rand, "With Plane and Radio in Stone Age New Guinea," *Natural History* 40, no. 3 (October 1937): 568, courtesy of Department of Mammalogy Archives, American Museum of Natural History.
Pages 8–9: Patrol photographs courtesy of RMV.
Pages 10–11: Photograph courtesy of AC.
Pages 12–13: Van Arcken, field report, August 8–11, 1938, courtesy of RMV. Translation by Don Mader.
Pages 14–15: Archbold, telegram to *New York Times*, August 22, 1938, courtesy of AC. Archbold, "Natives Friendly Archbold Finds," *Philadelphia Bulletin*, August 26, 1938, courtesy of AC. Van Arcken, map of the Baliem Valley, courtesy of RMV.
Pages 16–17: Margaret Hastings, "Begin Painful Trek to Glider," from "Shangri-La Diary" serial, *Chicago Herald American*, 1945, courtesy of Betty McCollom, Dayton, Ohio. Scrapbook page courtesy of McCollom.
Pages 18–19: Scrapbook pages courtesy of McCollom.
Pages 20–21: Scrapbook pages courtesy of McCollom.
Pages 22–23: Scrapbook page courtesy of McCollom. Alexander Cann, "Describes Valley of 'Shangri-La,'" *Boston Daily Record*, July 2, 1945, courtesy of AC.
Pages 24–27: Jane Deuser to Susan Meiselas, 2003. Scrapbook pages courtesy of McCollom.
Pages 28–29: Photograph courtesy of McCollom. Edward T. Imparato, *Rescue from Shangri-La* (Paducah, Ky.: Turner Publishing Company, 1997). "WAC in Shangri-La" comic book, 1945, courtesy of McCollom.
Pages 30–31: "WAC in Shangri-La.", courtesy of McCollom.

Missions of Conversion and Control

Pages 32–33: Map of missions and government posts in the Baliem Valley, ca. 1956, courtesy of KITLV.
Pages 34–35: Photograph of the Baliem River and the CAMA Sealand aircraft by Edward W. Ulrich, 1954, courtesy of Larry Lake, Camp Hill, Pennsylvania. Ulrich and Larry Lake, *Out There Beyond* Beyond: *The Story of Ed and Elaine Ulrich* (Camp Hill, Pa.: Christian Publications, 2000), 5. Clarence W. Hall, "The White Man Comes to Shangri-La," *Reader's Digest*, February 1957; reprint (New York: Christian and Missionary Alliance, 1957), 2–5, courtesy of Larry Lake.
Pages 36–37: "There's a Light in this Valley" (New York: The Christian and Missionary Alliance, 1955), courtesy of Larry Lake. Hall, "White Man Comes," 2–5. Myron Bromley, email to Meiselas, August 6, 2003.
Pages 38–39: Einar H. Mickelson, *God Can: Story of God's Faithfulness to a Pioneer Missionary Explorer in New Guinea* (Manila: Far East Broadcasting Company, 1966), courtesy of Christian and Missionary Alliance, Colorado Springs, Colorado.
Pages 40-41: First primer in the Dani language, ca. 1965, courtesy of Bromley. Translation by Bromley. Bromley, "Writing Lower Grand Valley Dani: the Circuitous Development of an Irian Jaya Orthography," in *Language, Culture, Society, and the Modern World*, vol. 3 of New Guinea Area Languages and Language Study, ed. Stephen A. Wurm (Canberra: Australian National University, 1977). Bromley, email to Meiselas, August 6, 2003.

Pages 42–43: Photograph by Claudius van de Westelaken, 1962, courtesy of PFA. Nico Verheyen, memoir, 1999. Verheyen, "Leven met Baliemers," (Woerden: Adminstratie Franciscanen, 1964), 72, courtesy of Verheyen, Stanwell, England. Translation by Mader.
Pages 44–45: Photograph of a 55-gallon drum dropping from a plane by Jan Schultz, ca. 1957, courtesy of Frits Veldkamp, Heemstede, the Netherlands. Veldkamp, "De bestuurlijke dilemma's bij de openlegging van de Baliem," in *Besturen in Nederlands-Nieuw-Guinea (1945–1962)*, ed. J.W. Schoorl (Leiden: KITLV Press, 1996), 77–79. Translation by Mader.
Pages 46–47: Aerial view of government post in Wamena and "no-man's-land," ca. 1957, courtesy of Veldkamp. Scrapbook page, ca. 1957, courtesy of Veldkamp. "Ex-Shangri La," *Dutch Australian Weekly*, February 8, 1957, courtesy of Annegriet Wietsma, Amsterdam. Veldkamp, interview by Meiselas, February 22, 2001.
Pages 48–49: Inquisitive people pouring in to see the strangers visiting their village, ca. 1957, courtesy of Veldkamp. Scrapbook page, ca. 1957, courtesy of Veldkamp.
Pages 50–51: Veldkamp, "De bestuurlijke dilemma's," 83, and emails to Meiselas, March 4, 2001 and April 30, 2003. Photograph of Van der Goot and Wil Hamers in Hitigima by Schultz, 1957, courtesy of Veldkamp.

Documentation and Its Impact

Pages 52–53: Photograph of Dani battle by Michael C. Rockefeller, 1961, courtesy of FSC.
Pages 54–55: Homer Bigart, "Harvard Expedition Discovers A Tribe of War in New Guinea," *New York Times*, April 5, 1961. Photograph by Jan Broekhuijse, 1961, courtesy of FSC. Photograph of Rockefeller and Dani child by Robert Gardner, 1961, courtesy of FSC. Gardner, journal, 1961.
Pages 56–57: Photograph by Eliot Elisofon, 1961, courtesy of FSC. Gardner, journal, 1961, and forward to *Gardens of War: Life and Death in the New Guinea Stone Age*, by Gardner and Karl G. Heider (New York: Random House, 1968), xi. Heider, *Grand Valley Dani: Peaceful Warriors* (Fort Worth: Harcourt Brace College Publishers, 1997), 1.
Pages 58–63: "The Ancient World of a War Torn Tribe," *Life*, September 28, 1962, 74–79, courtesy of FSC.
Pages 64–65: Gardner, journal, 1961. Gardner, "On the Making of *Dead Birds*," in *The Dani of West Irian*, ed. Heider (New York: Warner Modular Publications, 1972), 33.
Pages 66–67: *Dead Birds* poster, courtesy of FSC. Publicity material for *Dead Birds*, courtesy of FSC.
Pages 68–69: *Gardens of War* book jacket, courtesy of Random House/FSC.
Pages 70–71: Photograph of Broekhuijse (right) interviewing Husuk (left) while Abututi (center) helps translate in Homoak by Elisofon, 1961, courtesy of FSC. Broekhuijse, "De Harvard-Peabody expeditie in de Baliemvallei" in *Besturen in Nederlands-Nieuw-Guinea*, 145–146. Translation by Mader. Broekhuijse, interview by Meiselas, February 21, 2001. Photograph of Broekhuijse by Gardner, 1961, courtesy of Broekhuijse, Nieuwkoop, the Netherlands.

Development and Pacification

Pages 72–73: Photograph of the new Dutch post at Asologaima by B. van Rheenen, 1961, courtesy of Carel Schneider, The Hague.
Pages 74–75: Photograph of bridge over the Baliem River at Pikhe, by Jos Donkers, 1974, courtesy of PFA. Verheyen, memoir, 1999.
Pages 76–77: Photograph by Van de Westelaken, 1962, courtesy of PFA. Verheyen, memoir, 1999. Photograph of Verheyen's moped in the Baliem Valley by Office of Information and Radio Broadcasting, Hollandia, ca. 1960, courtesy of PFA.

Pages 78–79: Verheyen, memoir, 1999. Photograph of Verheyen and Dani weighing cabbages in Pikhe by Van de Westelaken, 1964, courtesy of PFA.

Pages 80–81: Chain gang, courtesy of J.W.A. van der Scheer, Bergeijk, the Netherlands. Van der Scheer, interview and translation by Rachel Corner, March 5, 2001. Van der Scheer and Dani, courtesy of van der Scheer.

Pages 82–83: Photographs by Van Rheenen, courtesy of Schneider. Schneider, interview by Meiselas, February 21, 2001.

Pages 84–85: Photograph of Kamma, Schneider, and Dani by Van Rheenen, courtesy of Schneider. Schneider, interview by Meiselas, February 21, 2001. Schneider, "Controleur Baliem (maart 1960–februari 1962): Enige impressies" in *Besturen in Nederlands-Nieuw-Guinea,* 121–122. Translation by Mader. Kamma and Dani leader, courtesy of Schneider.

Pages 86–87: Gonsalves at a Dani meal, ca. 1960, courtesy of Algemeen Rijksarchief, The Hague. R.A. Gonsalves and G.J. Verhoog, *Mr. Gonsalves Memoires* (Amsterdam: Uitgeverij De Arbeiderspers, 1999). Translation by Mader. Gonsalves with gun, courtesy of Harm Ede Botje/Foto ANP. Eibrink Jansen, memorandum to Gonsalves, January 27, 1960, quoted in Michiel Kruijt and Jos Slats, "Herbenoeming van Gonsalves in 1960 was omstreden," *De Volkskrant* (Amsterdam), June 21, 1994. Translation by Mader.

Pages 88–89: Family photographs, courtesy of Jan Luitzen and Paul Beiboer, Amstelveen, the Netherlands. Jan Luitzen Beiboer, interview and translation by Wietsma, March 31, 2003.

Pages 90–91: Machiel Schregardus's scrapbook page, courtesy of KITLV. Mary Schregardus Simmers, interview by Meiselas, February 25, 2001.

Pages 92–93: Larry Lake, memoir, 2003. Kurelu and Larry Lake, 1963, courtesy of Hi Lake, Rochester, Minnesota. Dani and Hi Lake, 1961, courtesy of Hi Lake. Hi Lake, email to Meiselas, August 1, 2003.

The Cold War and the Valley

Pages 94–95: Stamped envelope and stamps released by Netherlands New Guinea, Indonesia (the first stamp after Indonesian independence), and UNTEA, courtesy of Andrew P. Blanchard, Victoria, Canada.

Pages 96–97: Photograph of New Guinea Council, *Triton*, May–June 1961, courtesy of Wietsma.

Pages 98–99: *Triton*, January 1962, courtesy of Wietsma. Schneider, "Controleur Baliem," 127. Agus Alua, interview and translation by Brigham Montrose Golden, 2003.

Pages 100–101: Photograph and caption, UPI, courtesy of SF. "Sukarno Sets Mobilization For Attack on New Guinea," *New York Times*, December 19, 1961. Schneider, "Controleur Baliem," 124–125.

Pages 102–103: Photographs and captions, UPI, courtesy of SF.

Pages 104–105: "Voor de vrijheid van vrienden," *Panorama*, July 14, 1962, 23–24, courtesy of SF. Translation by Wietsma and Eelco Wolf.

Pages 106–107: John F. Kennedy to Jan Eduard de Quay, telegram, April 2, 1962, courtesy of the John Fitzgerald Kennedy Library, Boston.

Pages 108–109: Photograph, Foto ANP, August 1962, courtesy of SF. Distribution text accompanying photographs of "New Guinea Exodus," UPI, October 20, 1962, courtesy of SF.

Pages 110–111: Schneider, "Controleur Baliem," 127. Photograph and caption, UPI, courtesy of SF.

Pages 112–113: Gardner to McGeorge Bundy, August 10, 1962, courtesy of FSC. Gardner, journal, 1961.

Pages 114–115: Bundy to Gardner, August 18, 1962, courtesy of FSC. A.M. Rosenthal, "Flags Are First Issue for U.N. in New Guinea," *New York Times*, September 30, 1962. U.N. flag raising at the former residence of the Dutch governor in Hollandia, October 1, 1962, courtesy of AP.

Pages 116–117: U.N. security force on board a Pakistani ship in Sorong harbor, UPI, October 20, 1962, courtesy of SF. Photograph and caption, UPI, September 21, 1962, courtesy of SF.

Pages 118–119: Papuans demonstrating in The Hague, ANP Foto, November 9, 1969, courtesy of SF. Map and caption, UPI, July 8, 1969, courtesy of SF.

Pages 120–121: Geoffrey Hutton, "A Shoddy Script for the 'Act of No Choice,'" *Sydney Morning Herald*, July 26, 1969. Kulok Wenda, interview and translation by Eben Kirksey, May 25, 2003.

Indonesianization

Pages 122–123: Elvy Sukaesih (center), "queen of *dangdut* music," performs with Dani for Indonesian troops during the Indonesian Independence Day celebrations in Wamena, September 9, 1972, courtesy of Larry Naylor, Department of Anthropology, University of North Texas, Denton, Texas.

Pages 124–125: Acub Zainal, "Distribution of Responsibilities and Work Rules for the 'Koteka' Operation Command," July 15, 1971, courtesy of Naylor. Dani men working on the Trans-Irian Highway paid in clothes by the Indonesians, courtesy of Naylor. Ibu Tien, wife of Suharto, visits Wamena and members of her entourage give clothes to Dani school-children, courtesy of Naylor. Alua, interview by Golden and translation by Zulfikar Atmosudirdjo, 2003.

Pages 126–127: Naylor, notes, January 1972. Catholic mission school in Jiwika, February 1972, courtesy of Naylor.

Pages 128–129: Naylor, notes, January 1972. Photographs of Wamena market and money, ca. 1972, courtesy of Naylor.

Pages 130–131: Confiscated Dani spears at the police station in Wamena, March 12, 1972, courtesy of Naylor. Dani men at an *edai* dance near Hunilama, 1972, courtesy of Naylor. Naylor, notes, January 10 and March 13, 1972.

Pages 132–133: Wyn Sargent, *People of the Valley* (New York: Random House, 1974), 180–182. Niall McDermot quoted in "Catatan Harian Wyn Sargent," *Tempo*, June 2, 1973, 44. Translation by Supriyono Yono. Cover, *Tempo*, June 2, 1973, courtesy of the Library of Congress, Washington, D.C.

Pages 134–135: Judy Klemesrud, "She Tells Why She Married a Tribal Chief," *New York Times*, December 2, 1974, courtesy of *New York Times*. Sargent and Obaharok, courtesy of Naylor. Paskalis Matuan, quoted in Leslie Butt, "The Social and Political Life of Infants Among the Baliem Valley Dani, Irian Jaya" (Ph.D. diss., McGill University, 1998), 59–60.

Pages 136–137: Hanna Kessler, interview by Meiselas, June 2003. Photograph of "Chief" Muliason by Kessler, July 1974, courtesy of VEM. Photograph of evangelized Papuans from the coast baptizing Dani converts by Kessler, July 1974, courtesy of VEM. Photograph of Bromley preaching following a Dani baptism at Ibiroma by Kessler, July 1974, courtesy of VEM.

Pages 138–139: Jack T. Chick, *Wordless Gospel: New Guinea* (Chino, Calif.: Chick Publications, 1987). Lake, email to Meiselas, August 1, 2003.

Pages 140–141: Robert Mitton, *The Lost World of Irian Jaya* (Melbourne: Oxford University Press, 1983), 220–234. Photograph by Mitton, courtesy of Sue Galley, Melbourne.

Pages 142–143: Toni Mellive, "Indonésie: la révolte des Papous," *Le Monde* (Paris), January 3–4, 1978. Translation by Annie Bourneuf. Agus Kossay, quoted in Butt, "Social and Political Life," 14. Stakes planted on an airstrip by Dani, reprinted from Robin Osborne, *Indonesia's Secret War: The Guerilla Struggle in Irian Jaya* (Sydney: Allen and Unwin, 1985), courtesy of Osborne, Lismore, Australia.

Pages 144–145: Indonesia Christian Church (GKI), "For Justice and Peace: A Historical Responsibility" (report presented to the Communion of Churches in Indonesia [PGI], April 1992), 2. Translation by Yono. Kossay, interview and translation by Butt, June 2003. GKI report on events of 1977, courtesy of Siegfried Zöllner, Schwelm, Germany. Translation by Bourneuf. Photograph courtesy of Klaus Reuter, Schwelm, Germany.

Pages 146–147: Photograph courtesy of Zöllner. Zöllner, email to Meiselas, July 24, 2003.

Pages 148–149: Suriadi Gunawan, interview in *Higine*, April 30–May 3, 1984, translated, abridged and reprinted in *TAPOL Bulletin*, May 1984, 18, courtesy of TAPOL, Thornton Heath, England. Gunawan and Dani patient, courtesy of KITLV. Photograph courtesy of Annette Kentie, Loenen aan de Vecht, the Netherlands.

Pages 150–151: Soeharini Soepangat, "Indonesian School as Modernizer: a case study of the Orang Lembah Baliem Enculturation (Indonesia)" (Ph.D. diss., Florida State University, 1986), courtesy of KITLV.

Pages 152–153: "The Improvement of Village Economy" and "The Improvement of Security, Safety, and Order of Society," pamphlets published by the provincial government of Irian Jaya, 1992, courtesy of Butt, Department of Pacific and Asian Studies, University of Victoria, Canada. Translation by Yono.

Cultural Survival

Pages 154–155: Dani overlooking the Baliem Valley, 1989, courtesy of Meiselas/Magnum Photos.

Pages 156–157: First days back in the Baliem, 1989, courtesy of Meiselas/Magnum Photos.

Pages 158–159: The road near Akima, 1989, and Woman covered in yellow clay, mourning a recently dead relative, 1989, courtesy of Meiselas/Magnum Photos. Gardner, journal, January 6, 1989.

Pages 160–161: The road beyond Jibika, 1989, and Statue of Kurelu in Wamena, 1989, courtesy of Meiselas/Magnum Photos. Heider, *Grand Valley Dani: Peaceful Warriors* (Fort Worth: Harcourt Brace College Publishers, 1997), 169–171.

Pages 162–163: Traditional steaming of pork and sweet potatoes in Wuparainma, 1988, courtesy of Meiselas/Magnum Photos. Heider, *Grand Valley Dani*, 159, 155–156.

Pages 164–165: French tourist in Akima, 1989, courtesy of Meiselas/Magnum Photos. Kal Muller, *New Guinea: Journey into the Stone Age*, ed. David Pickell (Lincolnwood, Ill.: Passport Books, 1997), 125–126.

Pages 166–167: Cultural festival and war reenactment in Pyramid, 1996, courtesy of Meiselas/Magnum Photos. Gardner, "The More Things Change," *Transition* 58 (1992): 58.

Pages 168–169: Web page courtesy of Al Miller/www.pedropoint.com. Photograph courtesy of Will Weber, Journeys International, Ann Arbor, Michigan. Muller, *New Guinea*, 209.

Pages 170–171: Web page courtesy of Jill Paley/www.hiddencultures.com. Paley, email to Meiselas, January 8, 2001. Aloro and Alan Brenner near Dugum, October 30, 1989, courtesy of Brenner, Carmel, California. Brenner, email to Meiselas, March 5, 2001.

Pages 172–173: Wamena, June 1993, courtesy of George Steinmetz, Ridgewood, New Jersey. Steinmetz, email to Meiselas, 2003.

Pages 174–175: Wamena market, June 1993, courtesy of Steinmetz. Kossay, quoted in Butt, "'KB Kills': Political Violence, Birth Control, and the Baliem Valley Dani," *Asia Pacific Journal of Anthropology* 2, no. 1 (April 2001).

Becoming Papuan

Pages 176–177: Separatist demonstrator and police in Jayapura, December 1, 2000, courtesy of Charles Dharapak/AP.

Pages 178–179: "Rumble in the Jungle: Fighting for Freedom in West Papua with the OPM," *Do or Die* 8 (June 18, 1999), 229–244. A flag-raising ceremony in the highlands, courtesy of Ben Bohane/Contact Press Images.

Pages 180–181: *Cenderawasih Pos* (Papua), May 30, 2000, courtesy of the Asia Collection at the University of Hawaii at Manoa. Translation by Yono. Alua, interview by Golden, translation by Atmosudirdjo, 2003.

Pages 182–183: Dini Djalal, email to Meiselas, March 2001. A *Satgas Papua* unit outside Wamena, courtesy of Djalal/AP.

Pages 184–185: Photograph of the Morning Star flying in Wamena, courtesy of Sekretariat Keadilan dan Perdamaian, Jayapura, Indonesia. Human Rights Watch, Indonesia: Violence and Political Impasse in Papua, 2001. Obeth Komba, interview and translation by Kirksey, May 25, 2003. A *posko* in Wamena, August 2000, courtesy of Zöllner.

Pages 186–187: Butt, email to Meiselas, May 7, 2003. Wamena, March 31, 2001, courtesy of Kirksey, Wolfson College, University of Oxford. Photograph of Butt and Rose Wuwungan in Butt's kitchen in Wouma by Blanchard, 1994, courtesy of Butt. Wuwungan's children with Butt's child and neighbors, courtesy of Butt.

Pages 188–189: Dani participant in the Wamena violence of October 2000, interview and translation by Butt. Alua, interview by Golden, translation by Atmosudirdjo, 2003. Dani in Wamena, 2003, courtesy of Butt.

Page 195: Dani in Wamena, 2003, courtesy of Butt.

Acknowledgments

The journey that led to the making of this book began when I first traveled to the Baliem Valley with Robert Gardner, on his return visit to the Dani in 1988. A small team, including my partner Dick Rogers, and cinematographer Robert Fulton, set out to find Bob's old friends Pua, Weyak, and Kurelu, who were central to his 1964 film *Dead Birds.* We wanted to record what we could of the changes that had occurred in the valley since the film was made. However, it was not until our followup trip in 1996 that I personally felt the enormity of the impact time had revealed.

This project of reconstruction and stitching together stories from the Baliem Valley was initiated by an invitation from Nathan Lyons to submit a proposal to the Nederlands Foto Instituut (NFI) as part of the Photoworks-in-Progress series "Constructing Identity." In my 1999 proposal, I wrote that I wanted to "explore the ways in which the Dani have been seen by travelers, anthropologists, missionaries, colonialists, and perhaps themselves, throughout this century, and, through available technology, create access to that work and a dialogue with the Dani about that representation." At that time, I criss-crossed Holland seeking those who had played significant roles in the shaping of the Baliem under the Dutch colonial administration, while continuing to search the extensive national archives for material that would open up the history of early explorers' encounters with the Dani. Assembling the found materials involved a process familiar to me. Much like my earlier book *Kurdistan: In the Shadow of History,* I collected images and sought to contextualize them with personal testimony and published accounts.

I am enormously grateful to the generous support from the NFI, who sponsored the commission and the February 2001 exhibition. Several people in Holland helped sustain my efforts. While Linda Roodenburg fed me both ideas and meals in her wonderful home, Frits Gierstberg had great faith that I would find shape for the fragmented history I was gathering. I am especially thankful for the warm welcome I received from Frits Veldkamp, Carel Schneider, Nico Verheyen, and Annegriet Wietsma, who kindly shared their

personal collections, encouraging me at that early stage. The initial work of colonial remembrance done by Pim Schoorl was central to developing my understanding of that period, and I also thank Don Mader, who did not tire of my incessant need for translations.

The exhibition would not have traveled onward without the passionate energy of Maria Antonella Pelizzari, who brought the work to Montreal's "Mois de la Photo," where it was installed at the Maison de la Culture Frontenac in September 2001; and the commitment of both Kristen Lubben, who introduced the project to the ICP Triennial curatorial team, and Melissa Harris, who was key to rethinking this material in book form.

Thus began an intensive collaboration initiated by the ICP opportunity. Within the tight timeline necessitated by the exhibition, the book could not have been realized without the internet and the support of an elaborate network of scholars. From the Papua Resource Center: Brigham Golden offered an invaluable overview, Eben Kirksey challenged some preconceptions, Leslie Butt shared her intimate field experience in the Baliem, and Octo Mote provided a sensitive Papuan perspective. They all contributed their own research and critical insights whenever called upon. At a greater distance, though of no lesser importance, the project depended upon the resourcefulness of Denise Leith, who tracked down sources throughout the Pacific; Larry Lake and Siegfried Zöllner, who helped link me to the missionary communities in the United States and Europe; and John Rumbiak, who connected the project to a larger community of people pursuing peace in Papua.

The core team remained persistent in the pursuit of new material for seven months. It is impossible to express the depth of my gratitude for their dedication to the project. My invaluable assistant Meryl Levin single-handedly managed all of the incoming bits and pieces of text and image, helping with rigorous broad edits and endless followup correspondence. Annie Bourneuf began in the library and became

concept and his advocacy on its behalf; Phil Block for his sincere efforts to facilitate the project; Karen Hansgen for bringing it to Steidl and helping to see it through; and Buzz Hartshorn, the Director of the ICP, for his ongoing support.

This book would not have been possible without the much appreciated flexibility and expertise of Gerhard Steidl and his committed and talented team.

My sincere disappointment is only that the larger Dani community was unable to respond to this work in its making, but I am particularly grateful for those Papuans who have spoken and willingly shared their recollections of history through various intermediaries.

It is with great admiration that I would like to thank Robert Gardner, whose friendship sustained me throughout this project. I am deeply indebted to him for giving me the extraordinary opportunity to "discover" the Dani over the last decade. And finally, *Encounters with the Dani* is dedicated to Dick Rogers, with whom I began, but without whom I have had to finish this chronicle.

SCM
August 2003

Encounters with the Dani

By Susan Meiselas

Editor: Kristen Lubben
Project Manager: Meryl Levin
Design: Bethany Johns
Senior Researcher: Annie Bourneuf
Research Assistants: Michelle Cheiken, Rachel Corner,
Ignatius Krishna Dharma, Annegriet Wietsma
Production: Pedro Linger, Magnum Photos
Translators: Zulfikar Atmosudirodjo, Don Mater, Supriyono Yono
Advisors: Leslie Butt, Brigham Montrose Golden, Eben Kirksey,
Larry Lake, Octovianus Mote

For the International Center of Photography Publications Staff:
Publications Manager: Karen Hansgen
Publications Intern: Julia Koprak
Copyeditor: Erin Barnett
Scanning: Christopher George

This publication was produced in conjunction with the exhibition
Strangers: The First ICP Triennial of Photography and Video
organized by the International Center of Photography.
Exhibition Dates: September 13, 2003 through November 30, 2003.

First edition

Copublished by:

International Center of Photography

International Center of Photography
1114 Avenue of the Americas
New York, NY 10036
www.icp.org

STEIDL

Steidl Publishers
Düstere Str. 4 / D-37073 Göttingen
Phone +49 551 49 60 60 / Fax +49 551 49 60 649
E-mail: mail@steidl.de
www.steidl.de

Scans: Steidl's digital darkroom
Printing and production by Steidl, Göttingen

ISBN 3-88243-930-0
Printed in Germany

On the cover:
Front: Dani in the gardens of the Baliem Valley, 1989. Photograph by Susan Meiselas.
Courtesy Meiselas/Magnum Photos.
Ritual Warfare on the Warabara, 1961. Photograph by Karl G. Heider. Courtesy
Heider/Film Study Center.
Front, background image: Cover of the first primer in the Dani language, ca. 1965.
Courtesy of Myron Bromley.
Back: Indonesian army on operation outside Wamena, 1984. Photograph by
Siegfried Zöllner. Courtesy Zöllner.